CW00591525

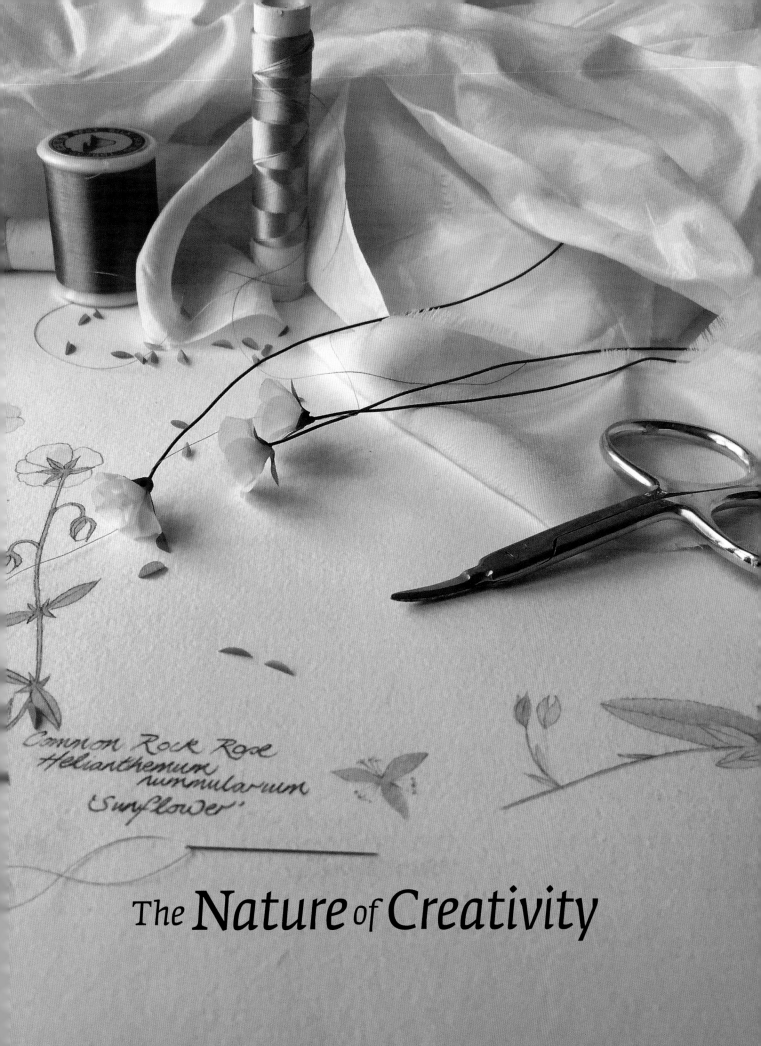

Common Rock Rose
Helianthemum
nummularium
Sunflower'

The Nature of Creativity

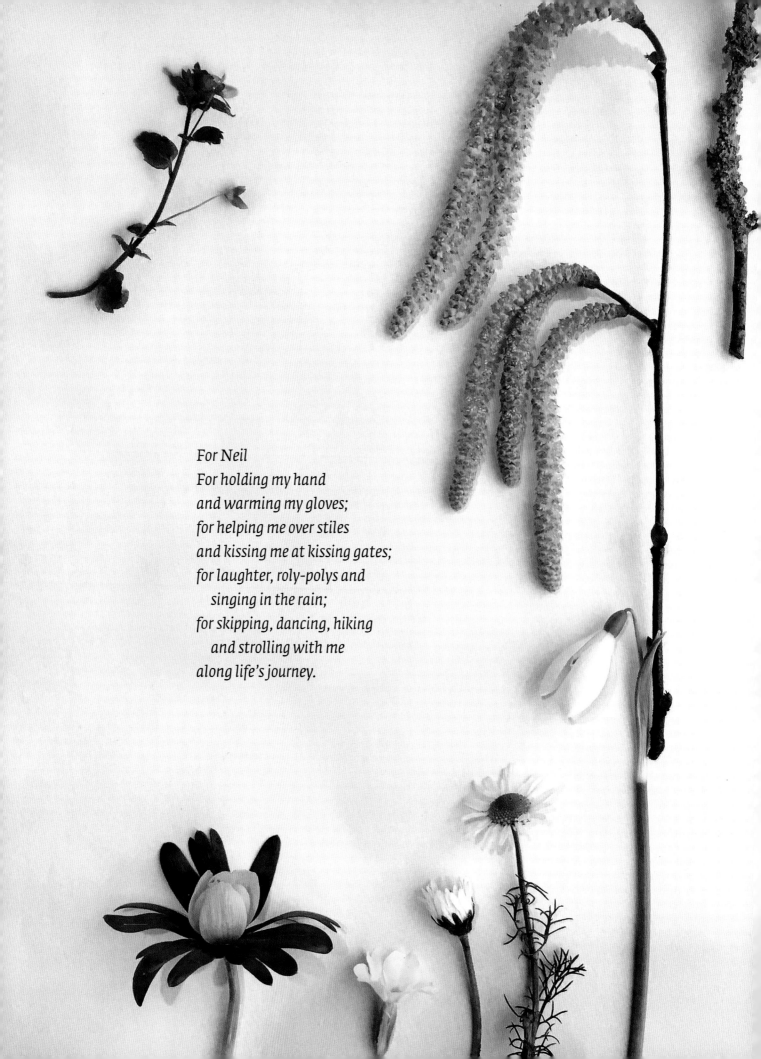

For Neil
For holding my hand
and warming my gloves;
for helping me over stiles
and kissing me at kissing gates;
for laughter, roly-polys and
 singing in the rain;
for skipping, dancing, hiking
 and strolling with me
along life's journey.

Jane E. Hall

The Nature of Creativity
A Mindful Approach to Making Art and Craft

FOREWORD BY
Brigit Strawbridge Howard

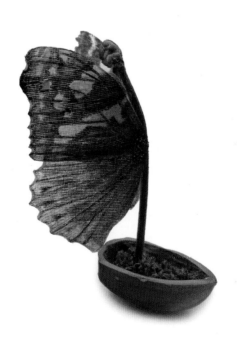

MERRELL
LONDON · NEW YORK

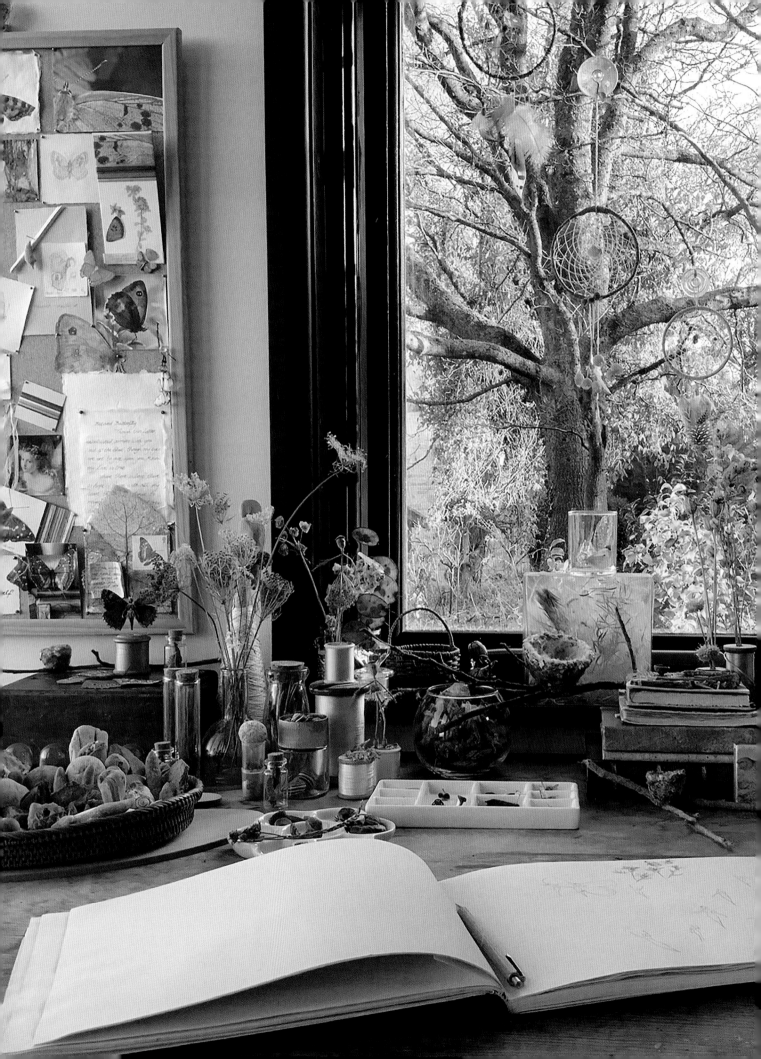

Contents

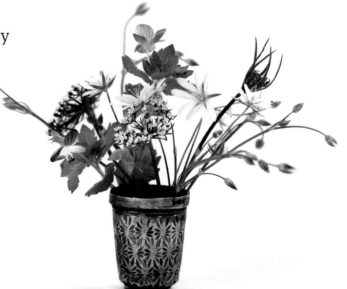

Foreword *Brigit Strawbridge Howard*

My favourite day of the school week, when I was little, was Monday. This was the day we children were invited to bring something in for the Nature Table, and encouraged to talk about our finds if we wished. I wasn't so keen on the 'talking' bit, but I did *so* enjoy gathering the nuts, berries, haws, pebbles, shells, autumn leaves and other such treasures that would fit easily into my pocket, or a small paper bag. These are the things that dreams – and memories – are made of.

Throughout my childhood, the natural world filled me with awe and wonder. I believed in magic and fairies, and found signs of both wherever I went. I remember leaving gifts among the tangled roots of trees – tiny morsels of food, arranged on plates made from carefully chosen leaves, or piled inside the largest horse-chestnut shells and acorn cups I could find. I'd make beds, too, from soft grey lichen and dark green moss, and my delight knew no bounds when I returned the following day to find that my offerings had been disturbed or removed.

But then I grew up. 'Life' got in the way, and, as have so many other adults, I somehow lost the awe, the wonder, the magic …

Happily (for me), I have lately rediscovered the child within, and I now spend most of my waking hours making up for lost time. My own personal reconnection came through a growing interest in native wild bees, but it could

just as easily have been wild flowers, birds, butterflies, beetles, falling leaves … anything, really. All it takes is making time to stop and notice your surroundings, and learning to marvel once again at the wonder and beauty of the natural world.

Some folk never lose their innate connection with nature. Jane, the author and creator of this glorious book, is such a person. She is one of those rare individuals who behold beauty and magic in everything they see. Artist, master embroiderer, writer, poet, collector of treasures, butterfly-watcher and guardian of all things wild – Jane has a great love of the natural world, and the joy and inspiration she draws from it are infectious. I feel very fortunate to call her my friend.

My first meeting with Jane was a little like a blind date. Her mother, Julia, had attended a talk I'd given on bumblebees, and (sensing that her daughter and I had much in common) urged Jane to get in touch with me. I duly received an email from Jane inviting me to visit. She was 'sure', she said, that 'we would find lots to talk about over a cup of tea in the Fairy House'. *Tea, in a fairy house?* How could anyone resist such an invitation?

If I had a thousand words I could not begin to describe that first foray into Jane's world – a world in which a seamless melding of extraordinary creative talent with a deep, enduring love of nature left me feeling

enchanted. Fortunately, I have no need for those words, since Jane has brought her world to life in this book – and what a book it is. The projects are inspiring, the stories behind them touching and the photographs stunning. But what makes it so very special and unique is Jane's voice. I don't know how she manages it, but her choice of words, and the way she weaves them together with such lightness of touch, breathes light, life and playfulness into everything she writes.

I hope you enjoy this beautiful book as much as I have, and that you, too, are inspired to try some of the wonderful projects within its pages. My favourite chapter is the one on nature mandalas. I wonder what yours will be …

Cornwall, October 2021

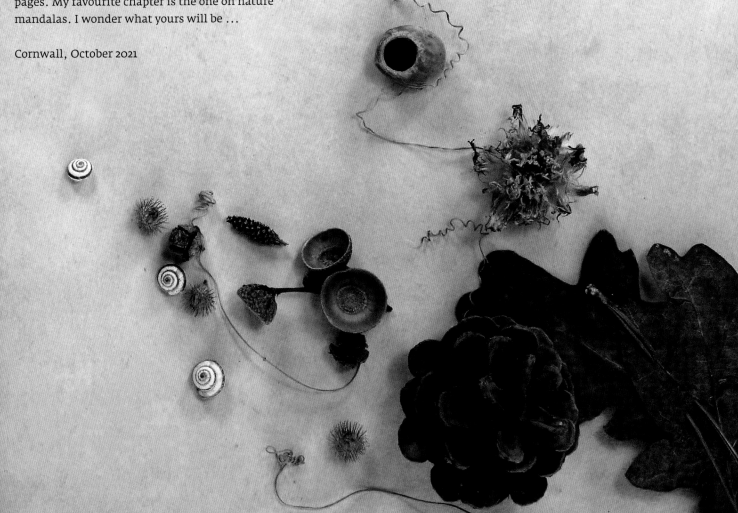

Introduction

▶ A wild-flower mandala celebrating the month of May: apple blossom, herb Robert, cowslips, forget-me-nots, hawthorn blossom, primroses, yarrow leaves, wild garlic, daisies, honesty and red campion.

For as long as I can remember, I have loved making things and make-believe. When I was a child, playing out of doors was my favourite pastime. I would while away hours making camps in the tiny copse at the bottom of our garden, or searching for fairies. My mud pies were celebrated, mostly by myself. My range of homemade perfumes – more odorous than aromatic, I fear – was extraordinary. I was fond of making patterns with sticks, stones, leaves and flowers, but perhaps the greatest indication of my future artistic career was my love of making daisy chains. A more personal speciality was bamboo-leaf bookmarks. With the conviction of a seven-year-old, I believed that the giant clump of bamboo growing near the vegetable patch was an enchanted forest. I would wade in, often cutting my knees, to harvest the very best leaves. Every bookmark was magical; you see, they actually read my books for me, since I rarely stopped fidgeting for long enough to do it myself.

Then there were the tea parties that I would lay on for the birds and the bumblebees, with offerings of crumbled biscuit and snail shell served on leaf plates. I would stage altogether more dainty parties for the fairies, carefully balancing acorn cups on leaf saucers atop picnic blankets of scattered petals and leaves.

Playtime seemed endless to me then, and somehow it still does. As a professional artist inspired by the natural world, I still feel creatively playful, and indeed, I am still making things. Perhaps artistic inspiration is no more than the sophistication of play and make-believe.

Playing out of doors remains my favourite activity, and nature my abiding inspiration. But my playtime has become more sophisticated. I now find myself fascinated by botany, natural history, folklore and fable; by the interconnectedness of things. My play indoors has evolved, too, although it remains remarkably similar to that of years gone by. In my childhood, my most beloved indoor playthings were my sewing box and my modelling, drawing and painting things,

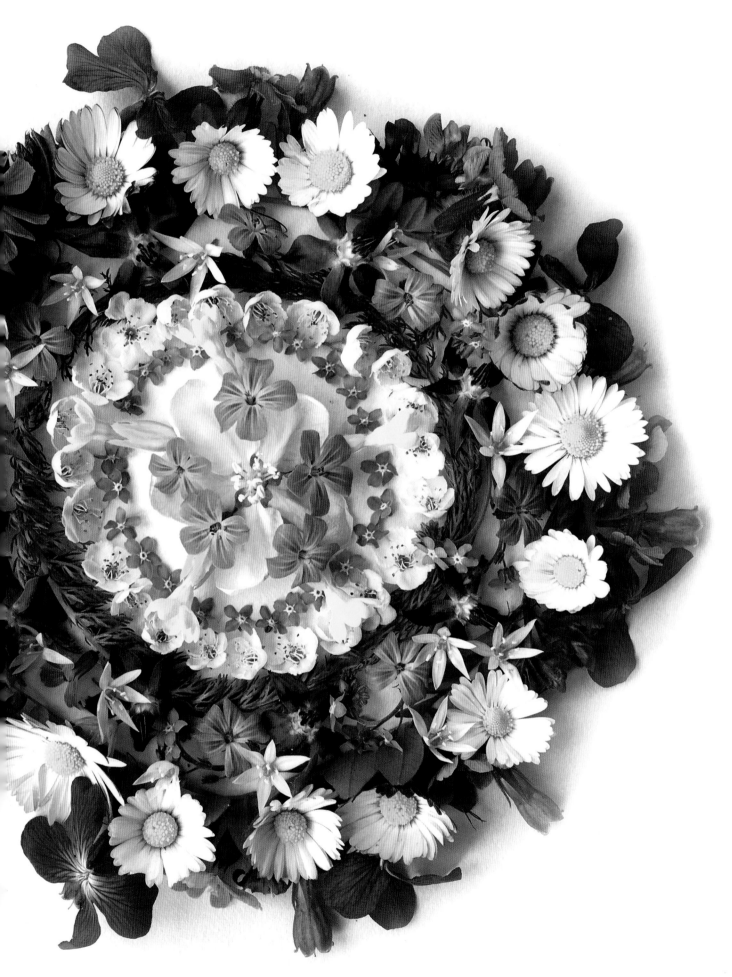

and they still are. These days, however, I have countless sewing boxes, a plan chest full of paper, paints, fabrics, dyes and much more. I suppose it would be true to say that I am still 'playing in my room', only now it has the superior title of 'studio'.

Happiness, it transpires, is contagious. Studies have shown that sharing this feeling boosts the well-being of others. I seek to explore how imagination and creativity inspire, console and promote contentment. My aspiration is to encourage others to attune to the beauty of the natural world around them, and to escape into the wild world of imagination. By following gentle, creative processes, I hope to nurture a sense of playfulness and wonder, leading to happiness.

In this book I hope to encourage you to explore your own creativity through observing, cherishing and being inspired by the natural world. First we will look at the special places that help me to be myself creatively, and then I will show you my sources of ideas and artistic materials, through stories, make-believe, contemplation and reminiscence. I will explore with you some of my artistic endeavours through step-by-step projects and diary entries, so that you can both follow some of my projects and be inspired to create your own.

Art is a natural way to practise mindfulness, no matter how skilled or unskilled you believe yourself to be. Creativity should feel free and playful, and focus should be on the process rather than the outcome. Pay attention to the activity and engage your senses. How are you holding your pencil, pen, brush or needle? Are the marks you're making soft and dainty or heavy and bold? Is the paper or fabric smooth or rough, light or heavy? Does your action glide or falter? Approach the process of creating art with curiosity and acceptance, and observe your achievements without judgement.

My creative perception of the natural world balances me emotionally; it brightens my outlook and colours my mood. My artistic practice is meditative, or 'mindful', soothing me when I am troubled and raising my spirits when I feel low. Even when I am on good form – which I generally am, thanks to feeling 'nature-blessed' and creatively balanced – my practice brings me greater joy. In brief, one could say that nature, and 'making something of it', makes me happy. I hope you find this true for yourself.

For Dad

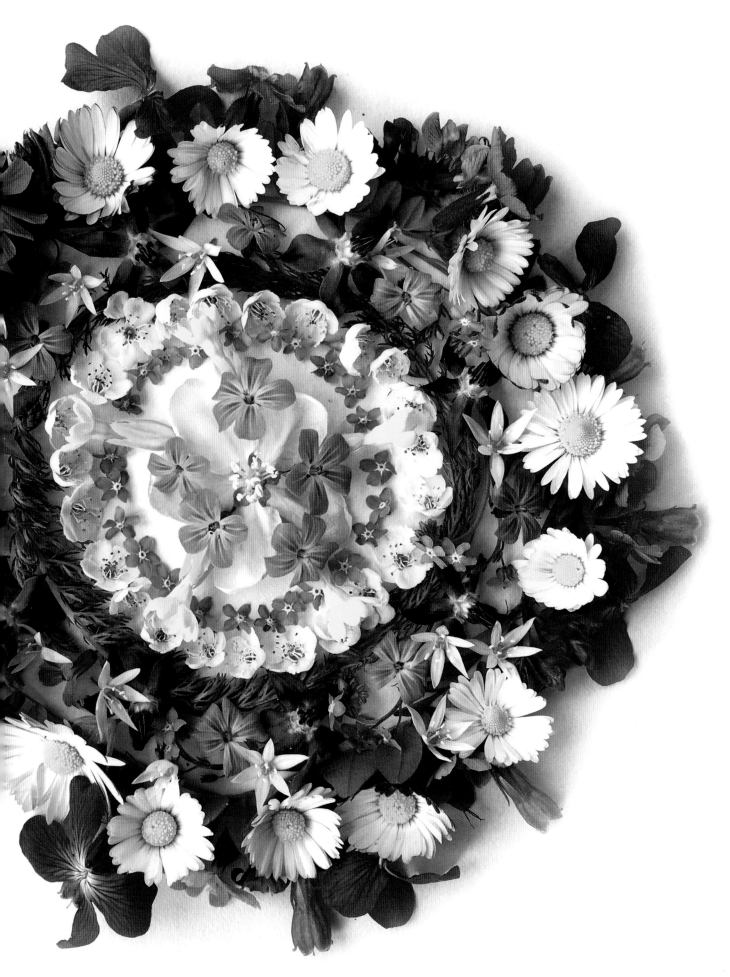

and they still are. These days, however, I have countless sewing boxes, a plan chest full of paper, paints, fabrics, dyes and much more. I suppose it would be true to say that I am still 'playing in my room', only now it has the superior title of 'studio'.

Happiness, it transpires, is contagious. Studies have shown that sharing this feeling boosts the well-being of others. I seek to explore how imagination and creativity inspire, console and promote contentment. My aspiration is to encourage others to attune to the beauty of the natural world around them, and to escape into the wild world of imagination. By following gentle, creative processes, I hope to nurture a sense of playfulness and wonder, leading to happiness.

In this book I hope to encourage you to explore your own creativity through observing, cherishing and being inspired by the natural world. First we will look at the special places that help me to be myself creatively, and then I will show you my sources of ideas and artistic materials, through stories, make-believe, contemplation and reminiscence. I will explore with you some of my artistic endeavours through step-by-step projects and diary entries, so that you can both follow some of my projects and be inspired to create your own.

Art is a natural way to practise mindfulness, no matter how skilled or unskilled you believe yourself to be. Creativity should feel free and playful, and focus should be on the process rather than the outcome. Pay attention to the activity and engage your senses. How are you holding your pencil, pen, brush or needle? Are the marks you're making soft and dainty or heavy and bold? Is the paper or fabric smooth or rough, light or heavy? Does your action glide or falter? Approach the process of creating art with curiosity and acceptance, and observe your achievements without judgement.

My creative perception of the natural world balances me emotionally; it brightens my outlook and colours my mood. My artistic practice is meditative, or 'mindful', soothing me when I am troubled and raising my spirits when I feel low. Even when I am on good form – which I generally am, thanks to feeling 'nature-blessed' and creatively balanced – my practice brings me greater joy. In brief, one could say that nature, and 'making something of it', makes me happy. I hope you find this true for yourself.

For Dad

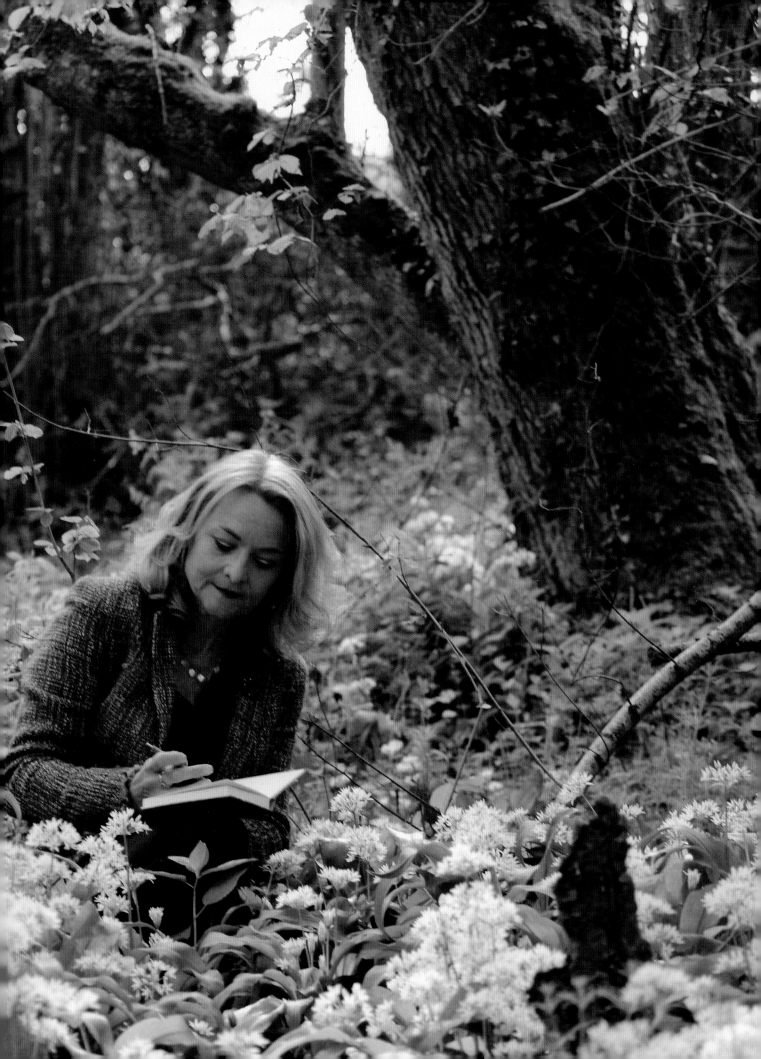

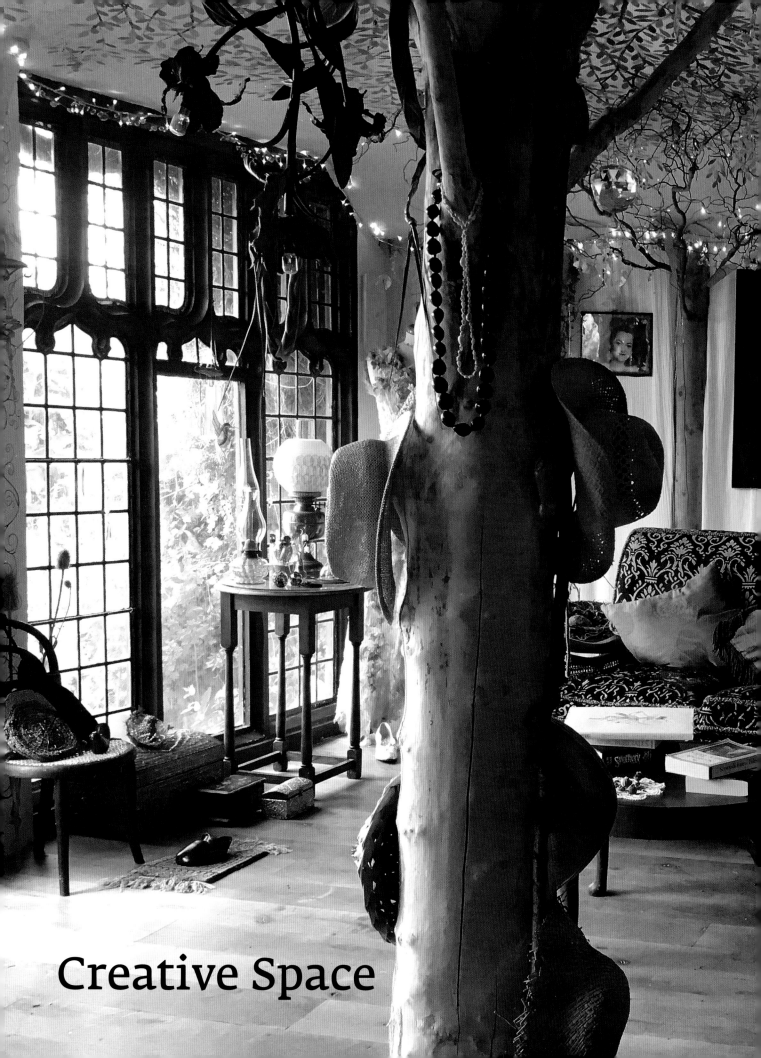

Creative Space

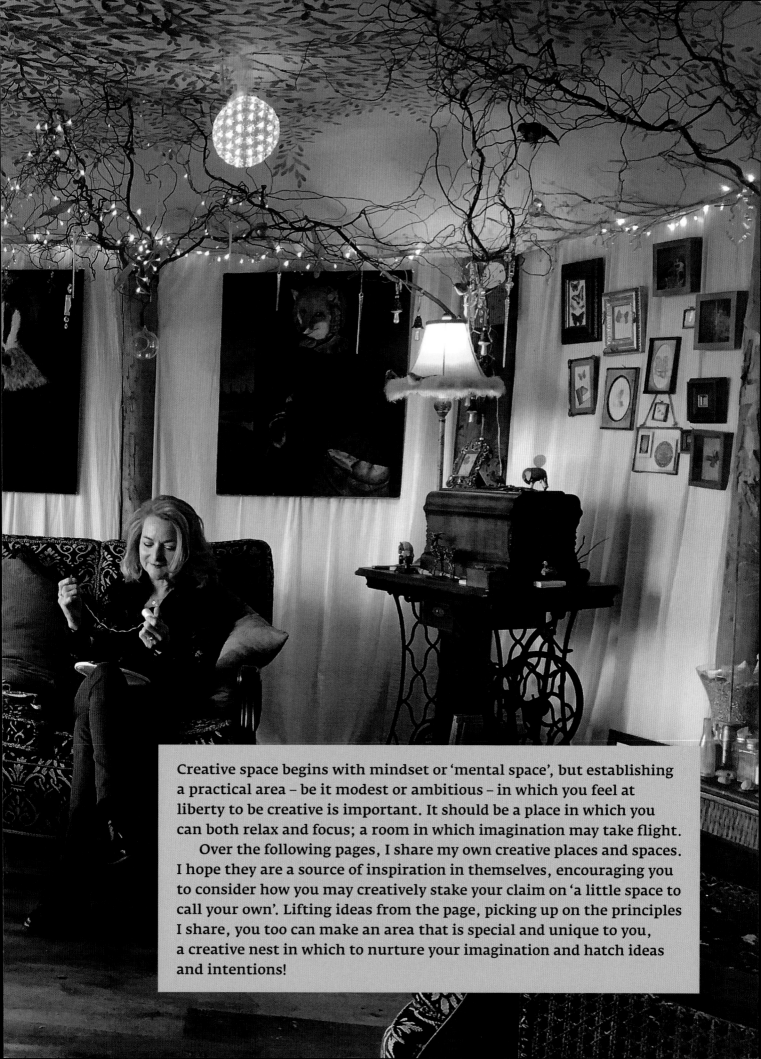

Creative space begins with mindset or 'mental space', but establishing a practical area – be it modest or ambitious – in which you feel at liberty to be creative is important. It should be a place in which you can both relax and focus; a room in which imagination may take flight.

Over the following pages, I share my own creative places and spaces. I hope they are a source of inspiration in themselves, encouraging you to consider how you may creatively stake your claim on 'a little space to call your own'. Lifting ideas from the page, picking up on the principles I share, you too can make an area that is special and unique to you, a creative nest in which to nurture your imagination and hatch ideas and intentions!

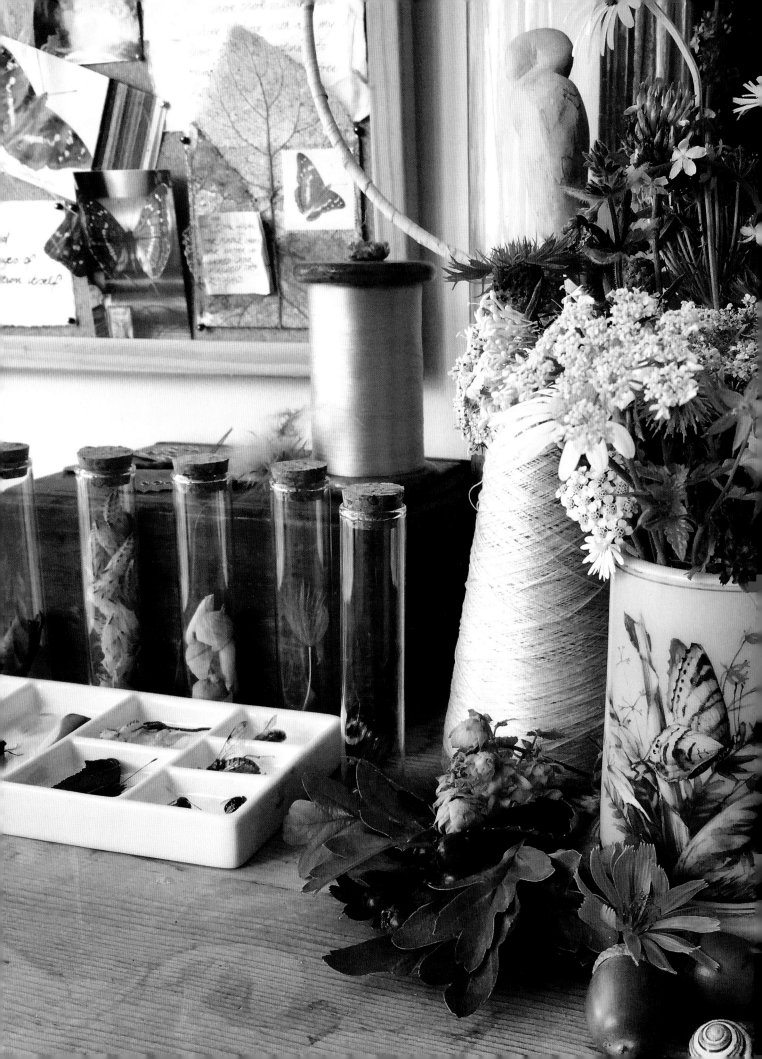

Studio *I don't need much, just a little space to call my own*

It's a familiar phrase, so much so that it reads like a famous quotation. I've even found myself pondering who it is most notably associated with. A famous author, perhaps, or a poet – or a politician? The answer is, none of these! It seems that it's associated with us all, a human predicament that, on some level, we can all relate to.

Creative space is no less important, although to achieve it one must begin with the mental space within which imagination may flourish. If it were not for its rich context, the wardrobe in C.S. Lewis's celebrated story *The Lion, the Witch and the Wardrobe* (1950) would have been simply that, a tall cupboard in which clothes were hung. Instead, those familiar with the tale will know that the wardrobe was 'in fact' a magical portal leading to the hidden realm of Narnia.

Realizing the mental space within which imagination flourishes leads one to discover a world of creative possibilities. Although today I have a professional studio space, that has not always been the case. My first creative space (if we don't count playing out all manner of make-believe and making things in my bedroom when I was a child) was a box: a 'magical' box.

I was diagnosed with type 1 diabetes at the age of seven, and this magic box was my portal to another world, particularly when the real world – beset with medical challenges – proved difficult terrain. This box, in everyday understanding, was simply a sewing box. In it were stored felt, open-weave fabric, wide-eyed needles, threads, glue and countless other bits and bobs. There was no finer therapy for me than making things. In a way, perhaps this was my earliest demonstrable experience of 'the art of distraction'. Of course, within that tangle of sewing threads, I undoubtedly first discovered imaginary ones: the yarns with which stories are woven, stories defining ways of exploring the world of make-believe more deeply. That simple box created a special space around me wherever

I set it down, even at the foot of a hospital bed, which, from time to time, was necessary.

The wonder of this particular magic is its universal availability. Many reading this will be familiar with staking a claim on space with a sewing box or an art case. The kitchen table can be yours, at least for a while, if you bagsy it with a box! Over the years I have worked on various kitchen and dining-room tables, or sprawled my world of creativity across sofas and carpets. Now I enjoy the luxury of a bespoke studio, within which my creativity truly flourishes, but I maintain that it's crucial to find that mental space first, then the magic of creativity becomes accessible anywhere and everywhere.

If you have a little space you can call your own, a permanent one, without having to re-stake your claim perpetually, that's wonderful. Here we will explore mine, 'my studio', but I am hopeful that you will soon begin to appreciate that it is actually just a big box – albeit a rather beautiful one. It is what lies within that defines it. As we explore my creative space, gently begin to consider what might define yours, be it a box, a box room or an altogether more expansive environment like mine.

My studio sits in a large piece of land that is managed for nature. My husband, Neil, and I consider it our

◀ *On one corner of my drawing desk is a constantly changing array of treasures discovered in our garden or while sauntering through the wider world.*

▶ *Daisy the wild-flower fairy dances atop a bobbin of silk.*

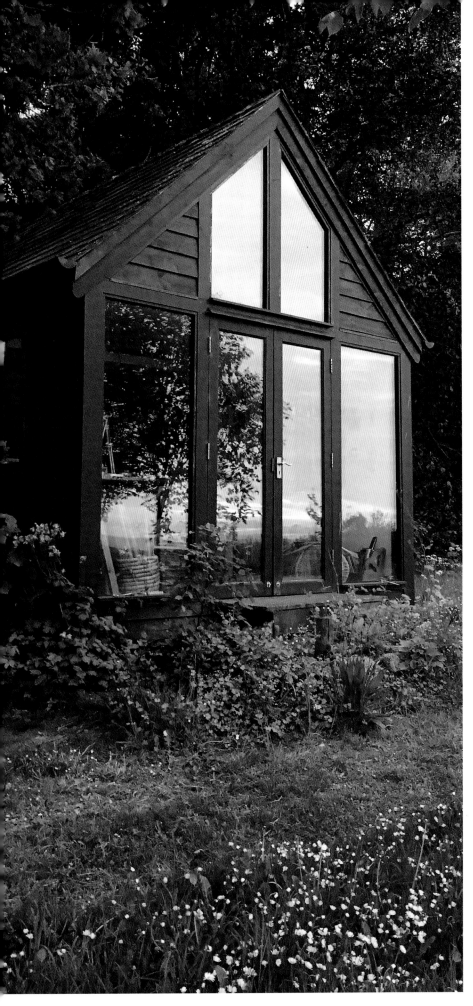

heartland. Once an intensively managed agricultural field, it is now nature's garden as much as it is our own.

Inspiration rests, quite literally, on my doorstep. Much to my delight, a micro-habitat has evolved beside my studio steps, largely germinated from wild-flower seeds gathered in the garden or on saunters through the countryside and scattered just beyond the opening swing of the door.

Stepping in, my 'treasure chest', an old double plan chest, makes its 'magical' presence felt instantly, taking up a handsome quarter of the floor. Such treasures lie within! Their stories are shared throughout this book, some of them in its very own chapter, 'Treasure collection' (see page 29).

My drawing desk sits in the best light, just inside the door. Cobbled together, it is an old drawing board attached to the base of an ancient treadle sewing machine. It's more of an old friend to me than a piece of furniture, really. I pull a sitting/kneeling chair up to it, enabling me to sit comfortably for hours.

Importantly, a ring-lit magnifying work lamp on an extendable anglepoise arm is fixed

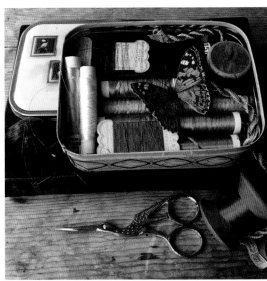

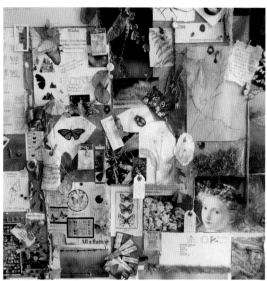

Sitting at my floor-standing embroidery frame, stitching minute silk scales on to painted silk butterfly wings.

to the side of the drawing board. Without it I would struggle with my intricate creative pursuits such as embroidering silk butterfly wings and cutting silk petals or mermaids' scales.

Bookcases stand along one wall, holding a personal library of natural-history books, fairy tales, poetry, children's stories and so on. Spaces between the books, and on the narrow ledges in front of them, are dotted with treasures or stacked with trinket boxes containing all manner of things. From time to time even I forget what is in them. To that end, some have labels, marked with curious titles such as 'Chrysalis', 'Fairy Rings', 'Thistledown' or 'Leafy Greens'. I rarely dust!

Picnic hampers are piled high in one corner, with parcel tags attached that vaguely identify their contents. These are mostly silk of various colours and hues, although one or two of the hampers hold art materials such as silk dye, modelling tools and glue. I know which ones these are; they have a certain character, shall we say. The photographs on these pages identify all manner of repositories for all manner of 'stuff' (and, some might argue, nonsense): miniature chests of drawers, jars,

boxes, bottles and glass domes rest wherever whimsy dictates. Just as a wizard knows his apothecary, I 'mostly' know where things are. It is just that they are not always where they belong! The walls are hung with pinboards and more treasures still, displayed in box frames.

If you aspire to 'a little space to call your own', I suggest that you begin by gathering things that inspire you. Then, perhaps, if you haven't done so already, accumulate some tools and materials that enable you practically. Organize them into boxes and jars, drawers and trays, and if you do not have the luxury of your own room, literally liberate 'just a little space'. Even a sewing box or art caddy will do. Perhaps a spare drawer, in lieu of a spare room. Your dream space may come, as mine has for me. But always remember, 'the very best place to work is in one's head.' I'm sure somebody famous once said that!

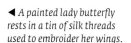

◀ *A painted lady butterfly rests in a tin of silk threads used to embroider her wings.*

▶ *A collection of vessels containing natural elements sits on my drawing desk.*

▶▶ *On my studio walls hang pinboards, to which I affix visual resources, ephemera and information.*

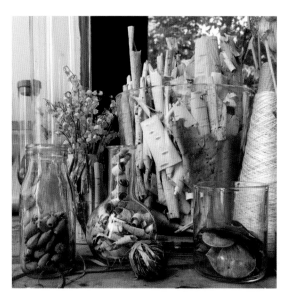

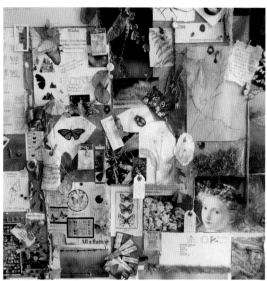

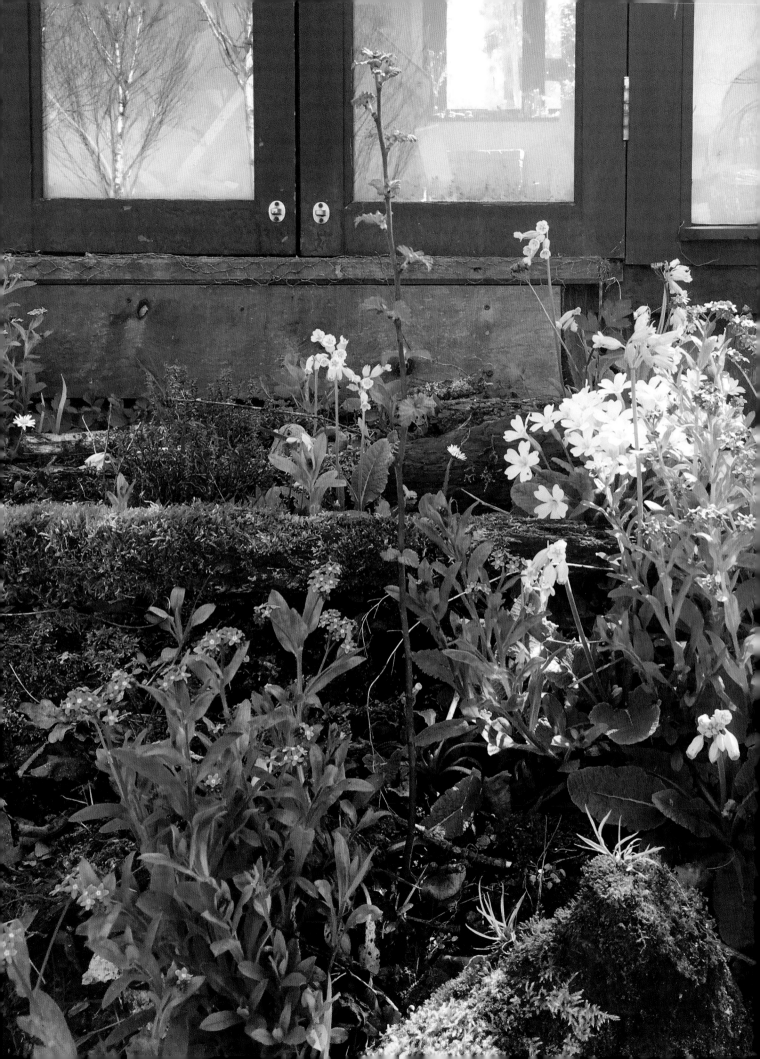

Wild habitat *Inspiration on my doorstep*

My studio stands on the hem of a giant's pocket handkerchief of land: 2½ acres (1 hectare) of re-wilded farmland tucked between working dairy fields to the north, east and west, with land managed sympathetically for nature to the south.

Following the country lanes that meander away from here like giant snail trails leads one to discover coppices and woodlands, watched over by wildlife angels the Woodland Trust and Wildlife Trusts. Further woodlands are privately owned by landlords keen to protect the habitats over which they stand guardian.

A haven for nature and for me, I believe that our garden is one of the happiest places on Earth. Here my creative nature can be wild and free!

Retrieving nature's liberty from its previous tenure under modern farming practices demanded doggedness and determination. When we first moved here, the only wild flowers thriving in the 'agriculturally improved' land were dock, creeping thistle and dandelion. Even the dandelions, for which I have a fond, everyday kind of love, struggled in the sparse, open ground.

Much landscaping, removal of topsoil, importing of substrate, deep ploughing, re-sowing and plug-planting later, native trees, plants and wild flowers now thrive here. Recently I counted 150 different species on a single day. Doubtless far more in number are the creatures, great and small, that now thrive here in symbiosis with one another and the flora.

When seeking inspiration, I can now find it literally on my doorstep or, at a stretch, just along the garden path. One such path even leads to a fairy house. But that, as they say, is another story, to be shared a little later in the pages of this book.

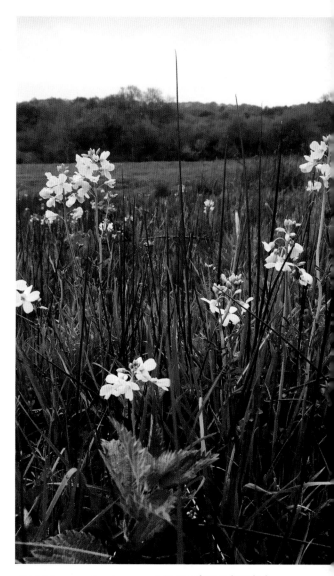

◀ *Dried flowers and seed heads, swept out of my studio or dropped there after a country walk, have germinated and flourished around the door, forming a micro-habitat.*

▲ *In a nearby meadow I look for orange-tip caterpillars feasting on the buds and seed pods of lady's smock, which flourishes there.*

Delight in nature and a creative sense of curiosity can lead one along the garden path. Here you see the very garden paths I wander along, in playful pursuit of creativity and mindful relaxation. I may pause to admire a butterfly or delight in a particular wild flower. I may settle to sketch or write for a while. I may even skip over the garden fence following butterflies or daydreams out into the wider, wild world.

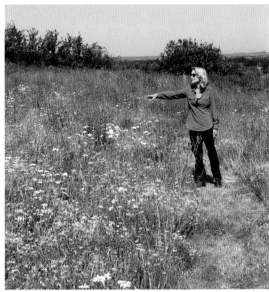

Now, should I need to reference a particular wild flower or butterfly species that I am studying, I can look to the wild as well as the wordy. Reference rests in the garden as well as on my bookshelves.

Whimsy and imagination also abound in our garden, if, that is, one looks playfully enough. And who doesn't like playing in the garden? I would suggest that those who say otherwise are simply not playing light-heartedly enough, or not using their better, more creative nature.

If you have a garden or steps to plant beside, or even a windowsill planter, do consider inviting nature in to play. Clear a little ground, cheerfully scatter some wild-flower seed or plug-plant some joy in your lawn. Then relax and be slow to mow ... Just once or twice a year suits nature's pace, granting you more time to spend cultivating your creative nature too.

▼*A small tortoiseshell butterfly, spotted in the meadow, is encouraged to alight on my fingertip.*

▼*A male orange-tip butterfly visits forget-me-nots in our garden. By and by he will lead me astray as I follow him along the lanes in pursuit of his partner. Demurely grey-tipped, the females are frequently to be discovered dancing along the hedge banks and about the meadows where their larval food plants thrive.*

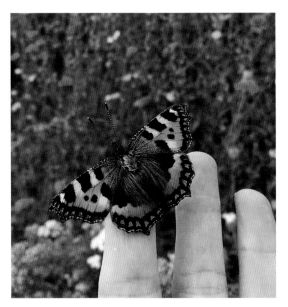

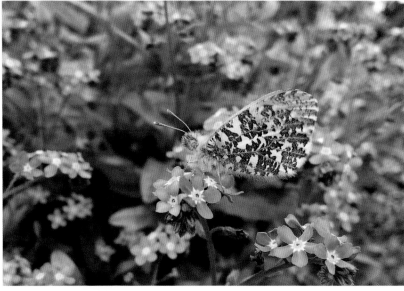

If it's true to say that all roads lead to Rome, it is also true to say that all paths and lanes lead me to my studio ... eventually!

Content to rest a while in the sunshine and sketch.

The Fairy House

The Fairy House is my creative hideaway, a special place where I relax, daydream and rarely if ever feel obliged to do anything. Naturally, I have collected about me all manner of things that I consider beautiful or precious. I urge you to inhabit a place too, to make it your very own space, be it a spare room, a garden shed or even an old wardrobe.

Habitat leads to Fairy House as naturally as following the garden path.

There are fairies living at the bottom of our garden; well, more accurately, just along the garden path, two thirds of the way down. According to folklore, fairy folk build their homes within hollow hills. These dwelling places are referred to as *sidhe*, pronounced 'she'. (If you're harbouring any doubts as to the real existence of fairies, or their houses, I hope the fact that their dwellings have a dictionary-defined name will reassure you.)

So, we have our very own *sidhe*. True enough, the fairy folk did have a little human help with this one. They enchanted Neil, compelling him to fashion a palatial space for them. It has a tree at its centre, a heavy oak door (which they insisted must creak on opening and closing), gothic windows facing north to the meadow (known as The Stray) and stained-glass windows facing south. Only, they were also most insistent that the dwelling not really have sides at all. That it was to be circular inside, for dancing fairy reels, setting out toadstool circles for important meetings and the like. Fairies can be so contrary.

The trouble Neil had! The hefting and the heaving, the mud-puddling, sawing and hammering, until, with the able help of one or two equally deluded (I mean enchanted) friends, his work was done. At that point the fairies cast a spell on me.

I've decorated the ceiling for them, with a certain fairy aplomb, painting leaves and branches that radiate from the trunk of the tree. I've hung sparkles and 'tinkle bobs' from silken cobwebs spun out across the painted leafy canopy. I've dotted crystals 'hither and thither' (I think I know what they meant by 'hither and thither', although I cannot be entirely certain). They insisted on the latest fairy trend in wall finishes, too: honesty seed-pod papering and pine-cone tiling.

I remain spellbound. To this day, you may well find me 'off with the fairies', sticking crystals to the ceiling or drawing on the walls. I simply cannot help myself; you must believe me when I say that I'd much rather be doing something serious-minded such as working or catching up with household chores.

Anyhow, I thought I should explain 'the picture' to you. I don't want you thinking I am bonkers. Now you have a perfectly rational explanation.

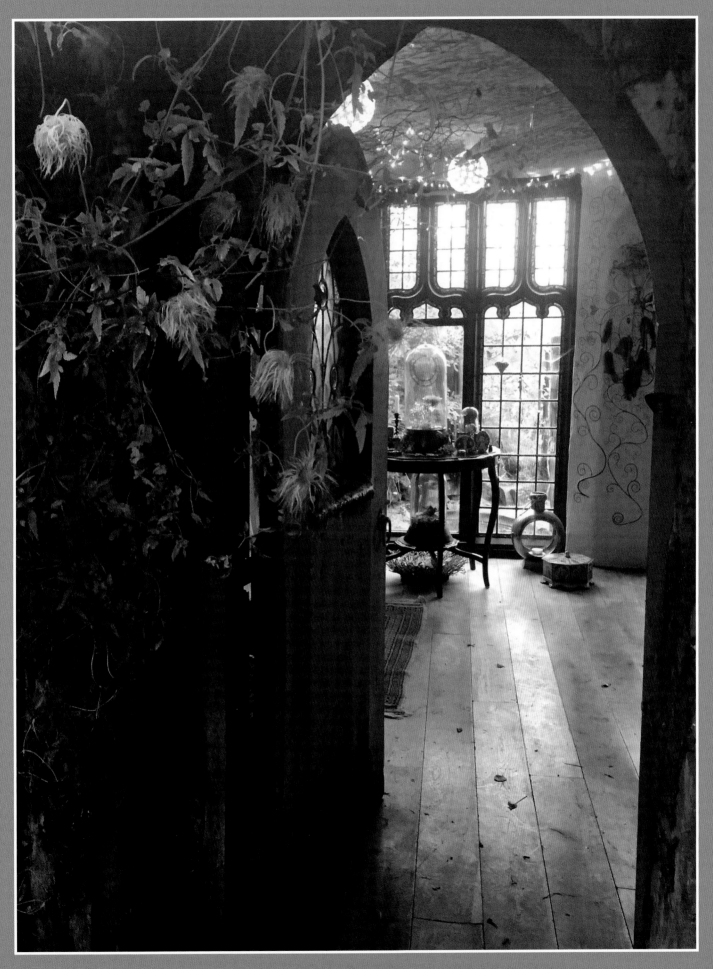

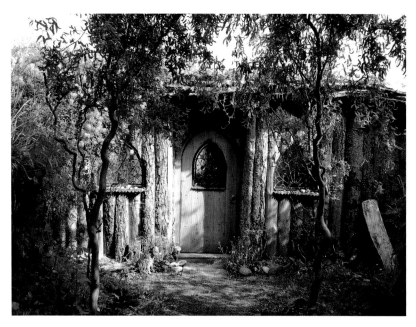

◀ *The heavy oak door at which the fairies accept callers, although no hawkers or goblins.*

◣ *Honesty seed-pod wallpaper creates a feature wall in the Fairy House.*

▶ *Another wall of the Fairy House is papered with birch bark and fragments of vintage wallpaper peeled from the walls of an old cob cottage.*

▶▶ *An arrangement of glass bottles, jars and vials filled with seeds, glitter and sparkles becomes an imagineer's apothecary.*

Honesty, delightfully also known as fairy money, flowers profusely beside my studio steps. When it goes to seed I often gather the pods into my studio, gently opening each papery purse to reveal the seed money within. This is therapeutic in itself, but useful too, since the pods make wallpaper that is granted the fairy seal of approval. The beautiful purple flowers by my steps grow from my studio floor sweepings as if by magic. I guess housework pays in the end.

If all this is not sufficiently enchanting in itself, the flowers are also a valuable source of nectar and are favoured by bees and butterflies, including one of my favourites, the orange-tip (*Anthocharis cardamines*). Orange-tips are also known to entrust their young to the plant, laying their eggs close to its flower buds, so that the caterpillars on emerging can feast and grow.

Hungry orange-tip caterpillars do, however, prefer Jack-by-the-hedge (*Alliaria petiolata*) or lady's smock (*Cardamine pratensis*). I assume they find them altogether more tasty and sustaining. A little bird once told me, having spat one of these caterpillars out, that it tasted ghastly! This is no doubt the alchemy of caterpillar machinations and mustard oils, ingested from the food plants, all of which are members of the mustard family. A clue: orange-tips flash 'warning', silly bird! From what I read and understand, orange-tips are rarely if ever snacked on by our avian friends.

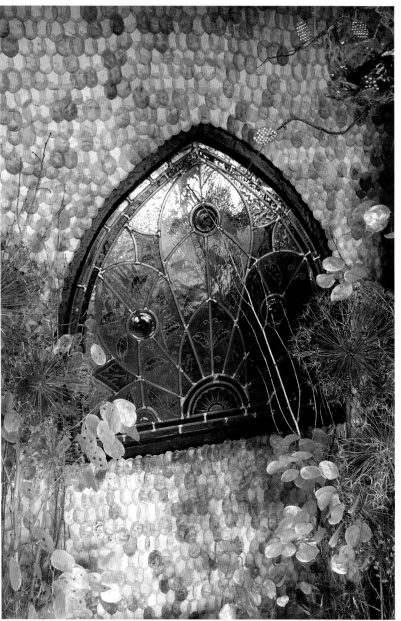

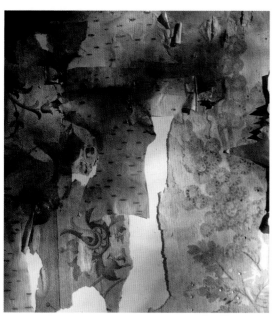

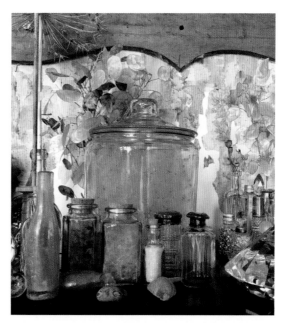

▼ The fairy fireplace. On the mantelpiece rests all manner of ephemera: crystals, jewelled spiders, glass fungi and reels of thread ... Above the mantelpiece, the wall is decorated in shades of dawn, soft pink and mauve, dancing with silk butterflies. Below, surrounding the stove, is a mosaic of pine-cone tiles, and behind the stove trees stand in silhouette against a pink and amber sunset sky.

'Veil for Spring', a lacy shawl inspired by ivy, hangs against the wall to the right of the fireplace. To the left, an antique oil lamp covered in moon-glow honesty seed pods rests on the drop-down shelf of an old kitchen cabinet. Fairy lights, chandelier crystals and 'tinkle bobs' hang from the ceiling.

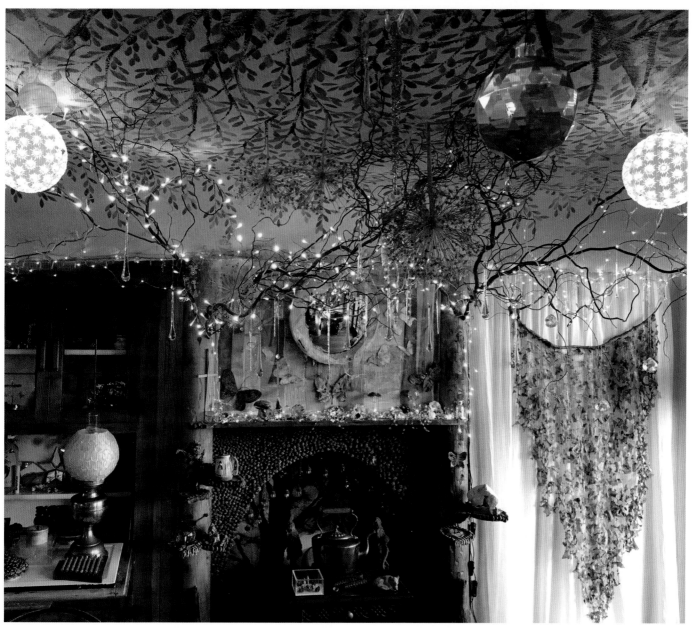

Creative Contemplations

This is a book exploring the creative process and its meditative qualities, inspired by the natural world.

In the following pages we will be exploring a mindful approach to artistic practice inspired by nature through ten 'creative pursuits': observations, thoughts and illuminations to inspire your own creative practice and contemplation.

These pursuits are illustrated both by simple creative ideas and practices and through more complex artistic interpretations realized in my studio using a combination of art and embroidery techniques.

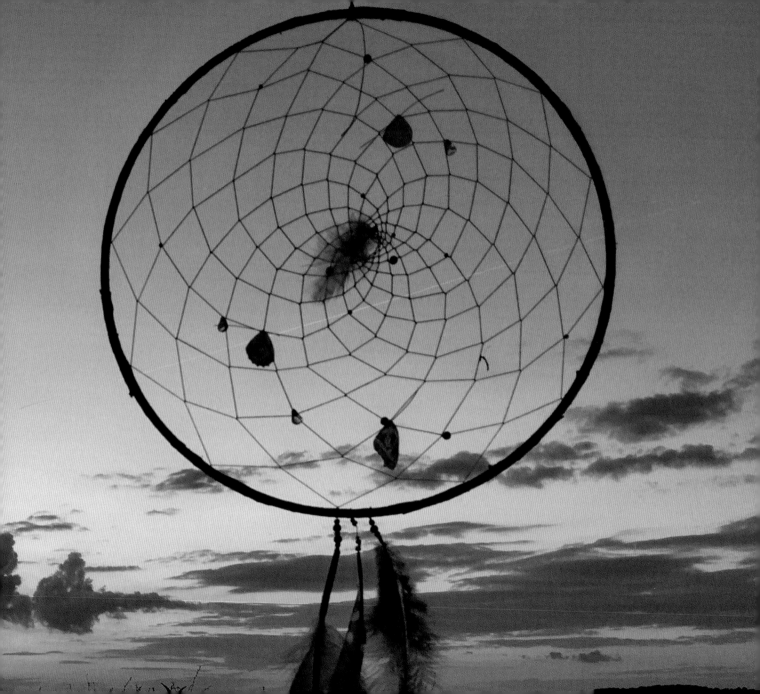

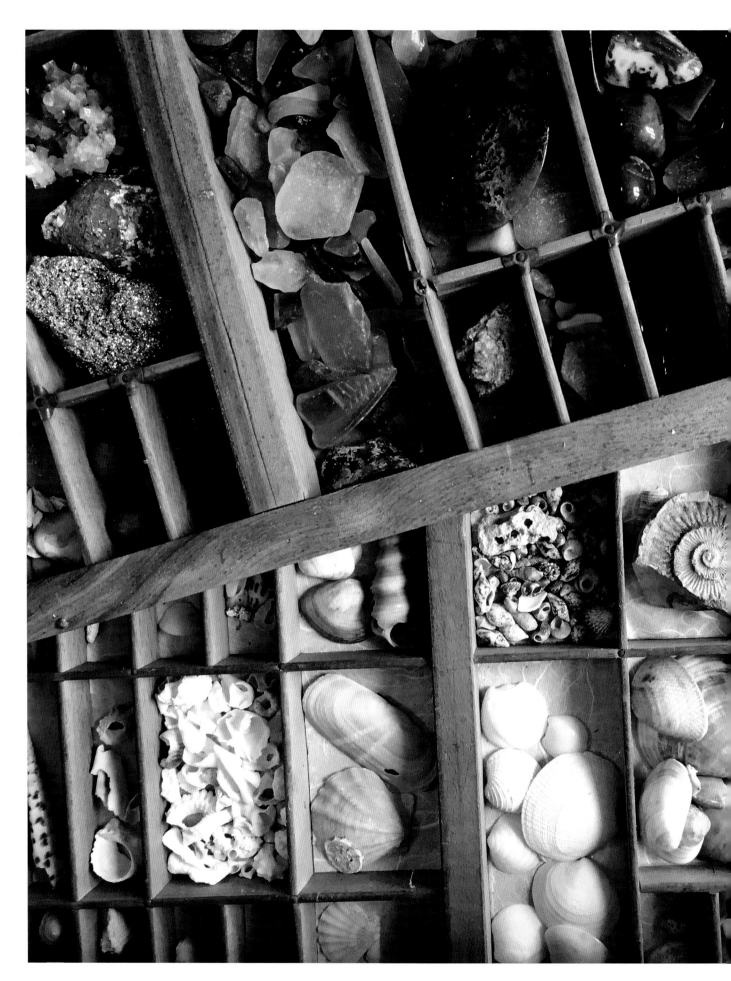

Treasure collection

In my studio stands a double plan chest that I call my 'treasure chest'. Hoarded away within it are all manner of things that I find valuable or precious. It has twelve drawers, just four of which contain things that are of practical use to me as an artist. Paper, card, threads and modelling clay all fit this criterion, as do inks, dyes, pencils, crayons and works in progress, both arty and literary.

The other eight drawers are stashed full of 'treasures' that have no monetary value, yet are priceless to me. Favourite among them are seashells, snail shells, buttons, seeds and beads, vials of sand and crushed rock … I could go on and on. The drawers travel back and forth on their runners a long way, so far that sometimes I fancifully imagine that I could pull them out endlessly. Who knows what might lie at the very back of the drawers, mysteriously long hidden, forgotten even by me.

Time spent perusing my treasures is creatively contemplative and therapeutic in itself. Paying close attention to the qualities of a chosen element, perhaps a lucky stone or a pine cone, is a form of meditation in itself. Mindfully, I ponder the qualities that drew me to treasure it away in the first instance. Perhaps the minute serrations of dormouse nibblings around a hazelnut shell, or the silky lustre of a beach pebble, polished by the tides.

So, too, each precious element holds precious memories. If I pick out the otter's tooth, found on the shores of Iona, I find myself psychologically transported back to the blue-sky, windswept day that I visited this sacred isle, and reconnected to the joy of its discovery. It occurs to me now that it is

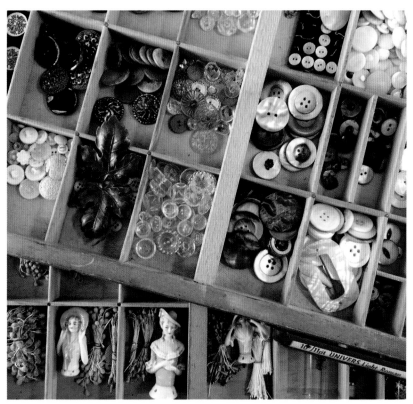

Many of my treasures are collected in old printer's trays. Placing one precious element carefully beside another, I create perpetually changing mosaics. My creatively curated collection is an inspirational resource for contemplation and my artistic pursuits.

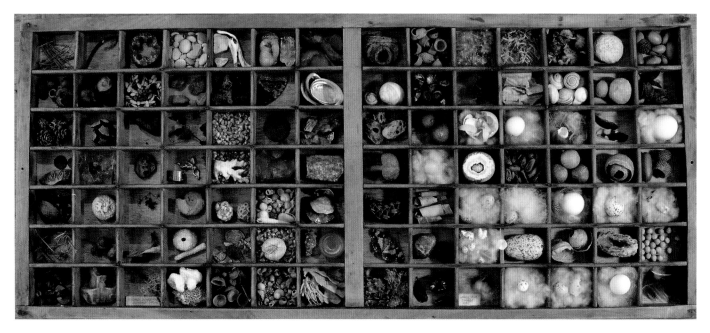

This tray holds a wealth of natural elements, from ancient fossils to delicate eggshells. There is even a handful of 'magic' peas, pocketed while crossing a fallow field and still to be planted.

not only a treasure chest, but also a means of time travel.

I often seek out treasures pertinent to a project or artistic study that I am working on. Particularly valuable to me are the butterflies and other insects, discovered in the wild outdoors or in quiet indoor corners, their spirits long departed. Curiously, I am also often given 'treasures' by folks who know me well, fondly saying something along the lines of: 'I know you like this sort of thing.' I was once given a perfect fluffy queen bumblebee, dusted with pollen and wrapped in a tissue, labelled 'Bee'. Now there's a beautiful thing.

In terms of artistic practice, I find that there is no real equivalent to 'the real thing' when I am trying to capture essence and beauty. Albeit sadly deceased and ghosts of their living counterparts, these inanimate specimens are still hauntingly beautiful, their colour and pattern still vibrant, their exquisite detail fixed.

Another creative joy of what I see as curating a treasure collection is its limitless potential for rainy-day play. Every element displays some pattern and form and, in turn, every element may be arranged into larger patterns or forms: soothing concentric mandalas.

I have not always enjoyed the privilege of owning a double plan chest, but I have always collected things. My curiosities and collectibles were previously contained and curated in boxes, pots, bottles, cutlery trays and printer's trays. Since childhood I have playfully explored and considered 'my world' – whether internal, imagined or real – in this way. Many of my treasures, including some that originated in my childhood, are still in these receptacles, albeit now tidied away into drawers.

I urge you to find space in life for 'treasures'. Gently begin collecting, if you haven't done so already. Respect is the watchword. Our natural world is vulnerable to many harms, so please choose cautiously, being careful not to remove anything to nature's detriment or cost. However, neglect is also a form of harm. Do spend time in nature; pay attention to what is beautiful, admire its qualities and, in so doing, gently meditate upon them.

There are any amount of reusable, recyclable containers in the world – woefully too many, from matchboxes to shoeboxes to juice-shot bottles and bead vials. Even single-use plastics can be more than singularly useful.

A cutlery tray makes an excellent treasury. This one neatly houses recycled plastic bottles, bead vials and sweetie containers, revealing their decorative contents.

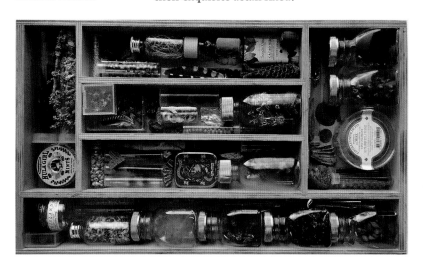

▶ *Countless treasures are curated and stored in my plan chest. This is just a single drawer.*

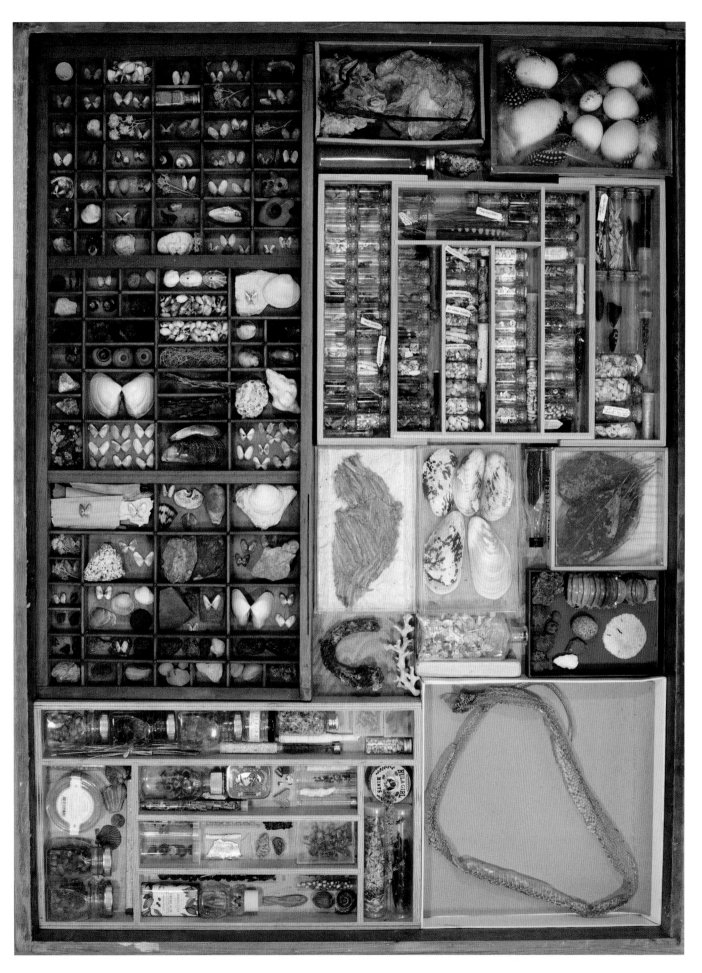

Trinkets and trinket boxes

'Trinket' – the word itself has a magical, sparkly ring. Surely, then, a box full of trinkets must be a magical thing indeed. Treasuring away 'precious' things, from snail shells and seashells to buttons and beads, is, as the adage goes, to invest a little something for rainy days. It gives us a treasury of bright elements to draw on, lightening the spirits on overcast days. Smooth beach pebbles and seashells psychologically carry me to calm shores where the tide rolls in with a gentle, lulling sea-snore. A handful of spiral snail shells transports me into the garden on a warm summer's day; I can all but hear crickets strumming love songs on their instrumentally adept pegged legs, distracting me from the rain pattering against the window pane.

Reflecting on how I treasured away my earliest finds, when gathering them was genuine child's play, I remember the fun of first collecting 'treasure boxes'. Jam jars were splendid, tiny sandwich-paste jars even better. Matchboxes were marvellous, as were date boxes, cheese boxes … all kinds of every box! Inexplicably, I recall a phase of collecting crisp packets; perhaps, ahead of my time, I had begun to question the notion of single-use plastics.

Early in life I became convinced of the notion that if something was considered precious, it should be stored appropriately, in a suitably precious box. A trinket box. Homemade was best – no waiting around for birthdays or Christmas for elaborate musical boxes and the like – and so my creative endeavours began. In adulthood I struggle to throw away 'useful' or pretty boxes, invariably prettifying them more. I urge you to do the same. Take a second look at that beautiful French cheese box, matchbox or chocolate box before consigning it to the bin or recycling. After all, surely recycling should begin at home, the most charitable way of sparing our precious planet, and landfill should always be the very last resort. Filling shapely jars, containers and boxes with trinkets is a wonderful thing.

Turning the following pages, explore with me how I have turned a Camembert box into a pine-cone trinket box; a sweetie box into a clove-covered miniature treasury; an old gift box into a pine-nut memento box (now a time-travel box, a miniature Tardis that transports me back in time to relax beneath the special pine tree in Tuscany where I collected the stripy terracotta nuts with my beloved Neil).

Small, plain boxes make a simple plea to me, asking that I get out my paintbox, pencils and pens and simply enjoy a spot of drawing and colouring-in. A butter-toffee box from Normandy became my magpie's nesting box, holding all those single earrings and strings of broken beads. Perhaps I should make one to hold odd socks, too; now, that could be pretty – and pretty useful too!

The makings of my pine-cone trinket box. All manner of treasures are now tucked away in it, and imaginatively speaking it also contains happy holiday memories.

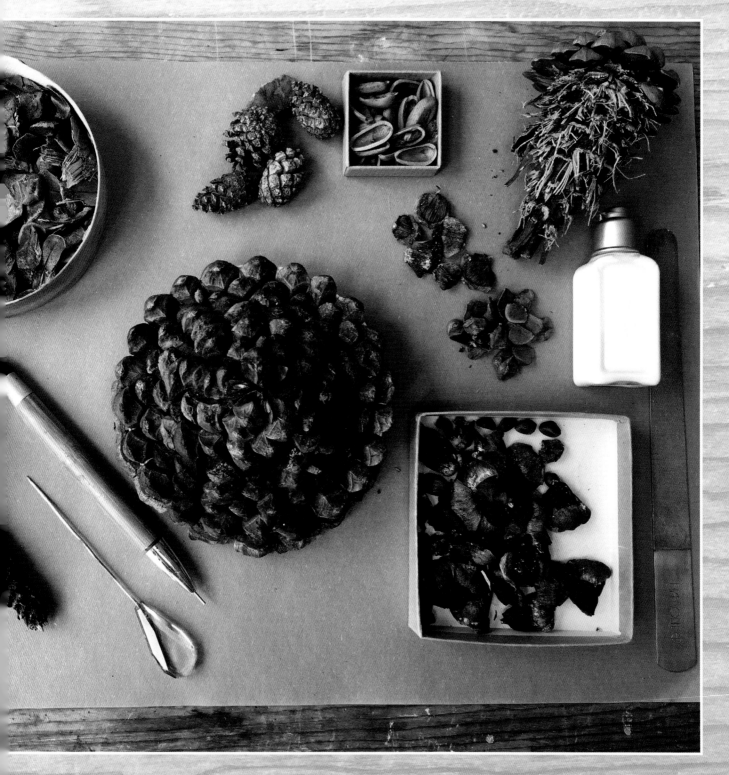

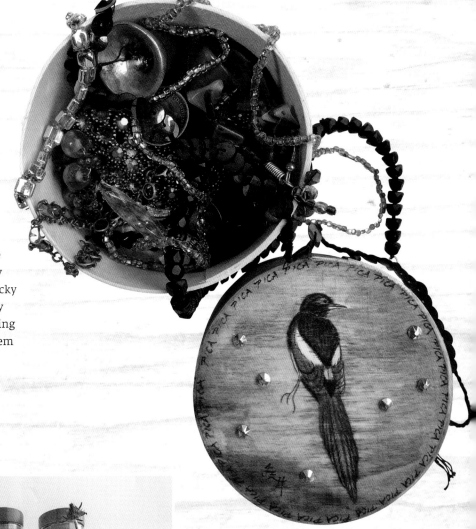

Sometimes it is what is treasured within it that makes a trinket box special; sometimes it is how they are decorated or what they are decorated with. Do you have a handful of seashells, pocketed one happy day, or perhaps some smooth pebbles or lucky stones tucked away in a drawer or jar? Why not consider fixing them to a box lid, making something special of the day you found them and celebrating their intrinsic beauty that caught your eye in the first instance?

▲ *Always losing my earrings, I determined that I needed a safe place to keep all the 'oddly' beautiful ones. Where better than in a magpie's nest, with Pica, the magpie's Latin name, circling the lid. It was once a humble sweetie box – toffees from Normandy – and today the holiday memories remain sweet.*

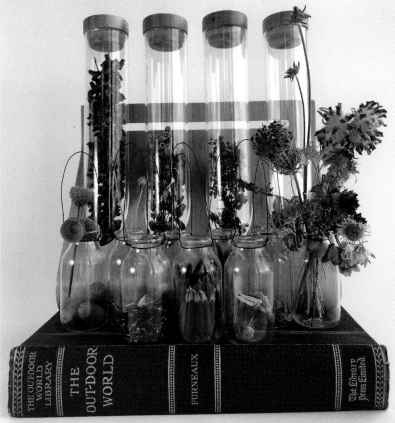

Nature's trinkets, precious elements or natural souvenirs of happy forays into the wild look as pretty as a picture in glass bottles and vials. Always remember, only treasure away elements that nature can spare. Here you see dried flowers, seed pods and acorns gathered in our nature garden.

▶ From left to right:
A handcrafted box, showing
its age, its hammered silver
sheet work gently peeling,
contains tumbled precious
stones gathered for me by a
friend on her travels in South
Africa; three reimagined
cheese and gift boxes,
decorated with pine cones,
cloves and pine-nut shells; and
a little box, just perfect as it is,
its flexible lid like a miniature
roller blind, holds two hidden,
hand-modelled peacock
butterfly chrysalises.

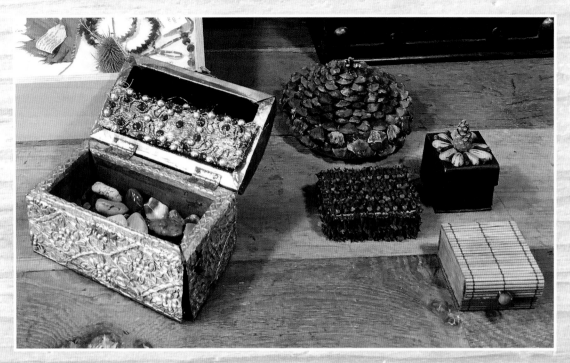

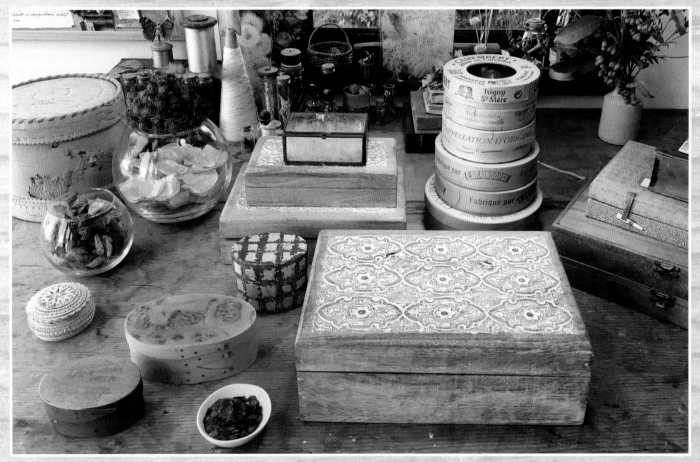

Cheese boxes from happy
holidays in France stack
beautifully, as do the
rectangular boxes, naturally
gradating in size. There is an
art to remembering what is
treasured away inside each
trinket box when you have
an array such as this.

Pine-cone and clove boxes

Exploring nature playfully and curiously, it is remarkable what inspiration and materials it gently suggests. Many a time I have watched squirrels enjoying a tasty 'pine-on-the-cob', spiralling around the cone, chewing off scales close to the stem to reveal the tasty seeds beneath. Although I have never found the discarded scales, I often come across the husks, some of which are prized among my treasures as 'squirrel sculptures', febrile works of art.

Having watched the master sculptor, Squirrel, at work, I determined to have a go myself, only not at the eating part. My creative appetite was for the acquisition of core and scales. The scales make excellent tiles, you see: tesserae for trinket boxes, tiles for imaginative interior décor. I've yet to master nibbling the cores, or creatively repurposing them for that matter. (I jest, of course, dentist do not despair – I would never recommend using one's teeth!) Wire cutters or tile cutters are very useful for releasing each scale, following the growth spiral around the cone, just as the squirrel does. Tile adhesive is an ideal sticking medium, being thick and heavy, with instant grab. It really is child's play, and simply sticking sections of pine cone around a circular box lid is very satisfying indeed. The pine-cone-tiled box pictured opposite has sentimental value, too, the giant pine cone having been picked up for me by Neil while we were walking through a deep forest on our travels. The repurposed Camembert box underneath is all that remains of the picnic we enjoyed that day.

As I was sprinkling cloves on to the kitchen worktop one day, doubtless intent on some higher culinary purpose, several – miraculously, it seemed to me – fell in a row, head to toe. 'What a wonderful pattern,' I heard my imagination whisper ... quite loudly! In no time at all, my energy was creatively diverted. During the course of an afternoon, a small cardboard cheese box became a clove trinket box, which smells heavenly, with no whiff of cheese! In this instance, I used rapid-drying jeweller's glue to hold the cloves in place.

▼ *Work in progress, sticking cloves on to the lid of an old cheese box, lining them up carefully one at a time. An artist's palette makes a useful receptacle for the cloves.*

▲ *Frayed silk ribbons are stored temporarily in my pine-cone trinket box while I build nests (see pages 94–103).*

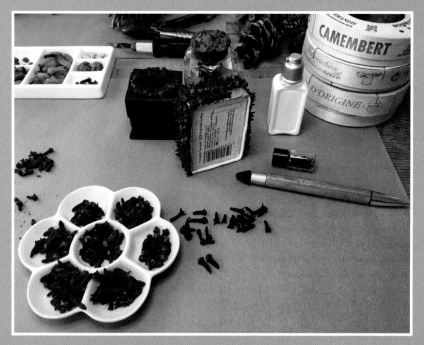

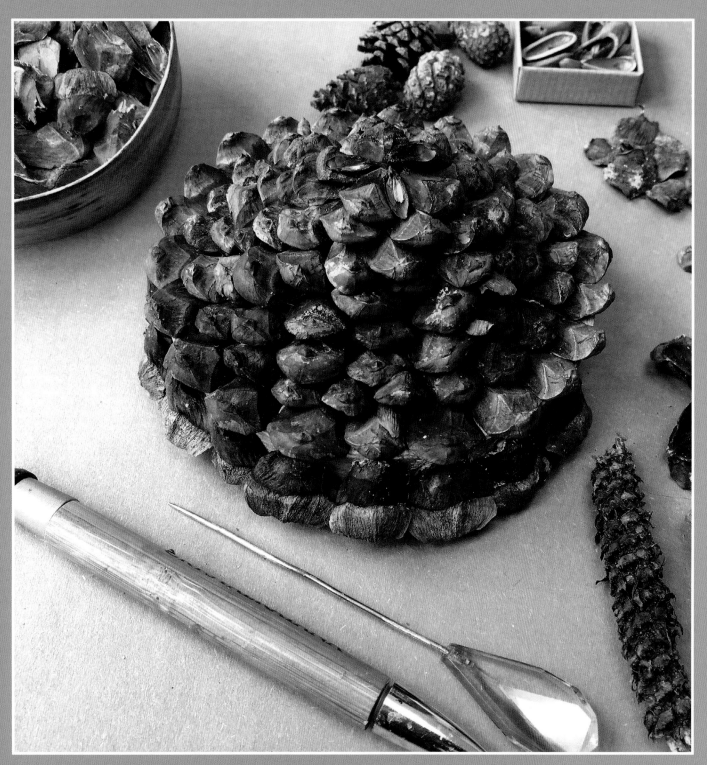

Pine-nut shells also make excellent box tiles. When the nuts inside are ripe, the shells break apart easily and evenly. It took me a whole afternoon relaxing in the shade of an Italian stone pine tree in Tuscany to establish that fact; one must suffer for one's art (she asserts, smilingly). Approximately twenty species of pine tree produce seeds that are large enough to eat; that's a whole lot of species to consider resting mindfully and creatively beneath! Perhaps there is one growing near you.

The finished pine-cone (above) and clove boxes: humble cheese containers reincarnated.

Nature mandalas

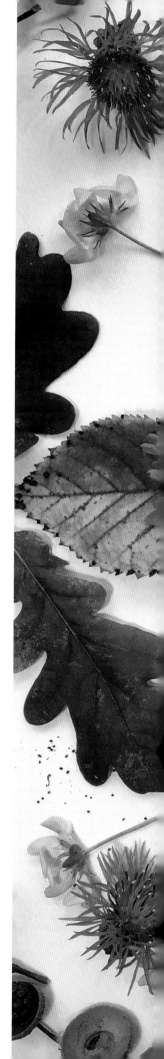

A mandala is a circular pattern representing the universe in Hindu, Buddhist and Jainist symbolism. The word itself is Sanskrit for 'circle' or 'disc'. In religious practice, the creation and contemplation of mandalas hold deep spiritual significance and are practised to attain focus and aid meditation, deepening awareness and appreciation of the self and the universality of spirit.

Although the creation of beautiful, symmetrical circular patterns has been practised devoutly in spiritual and religious traditions for centuries, I believe that nature, with its intrinsic symmetry and geometry, has inspired the creation of more secular decorative motifs and geometric patterns since time immemorial. It is this connection with nature that inspires my creative pursuit and contemplation, directing my arrangement of patterns from natural elements, patterns commonly referred to as 'nature mandalas'.

Discovering patterns in nature is a joyful, creative, mindful pursuit in itself: recognizing the symmetry and geometry that radiate from the centres of flowers, the spirals in seashells or the unfurling fronds of ferns. Simply cutting familiar fruit, such as oranges or apples, in half reveals natural mandalas, beautiful patterns defined by segments or seeds. Spiders' webs, too, are natural mandalas. Spiders are surely nature's finest artisans when it comes to spinning patterns, with their silken webs that spiral delicately outwards, catching dew, raindrops and prey, embellishing their patterns as though with jewels.

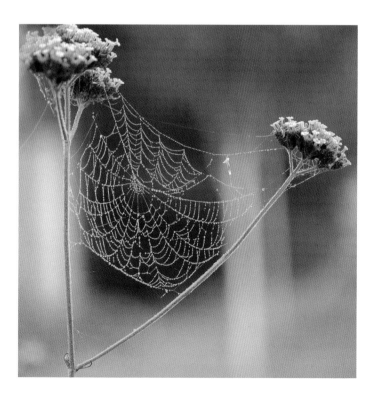

◀ *Espied just beyond my studio, a delicate, dew-covered spider's web hangs between two stems of* Verbena bonariensis. *This plant is a wonderful source of nectar for butterflies and other insects, and, it appears, spectacular scaffolding for orb-weaver spiders' webs. Spiders are innately gifted when it comes to creating mandalas.*

▶ *Celebrating autumn in creative contemplation by making a mandala. Misty heads of wild carrot surround a pretty pink mallow flower, encircled by the fruit of the spindleberry tree, crab apples and mushrooms. Azure chicory flowers rest on golden Himalayan birch leaves and the outer layer is oak leaves, knapweed and bird's-foot trefoil flowers, and acorns, complete with their cups.*

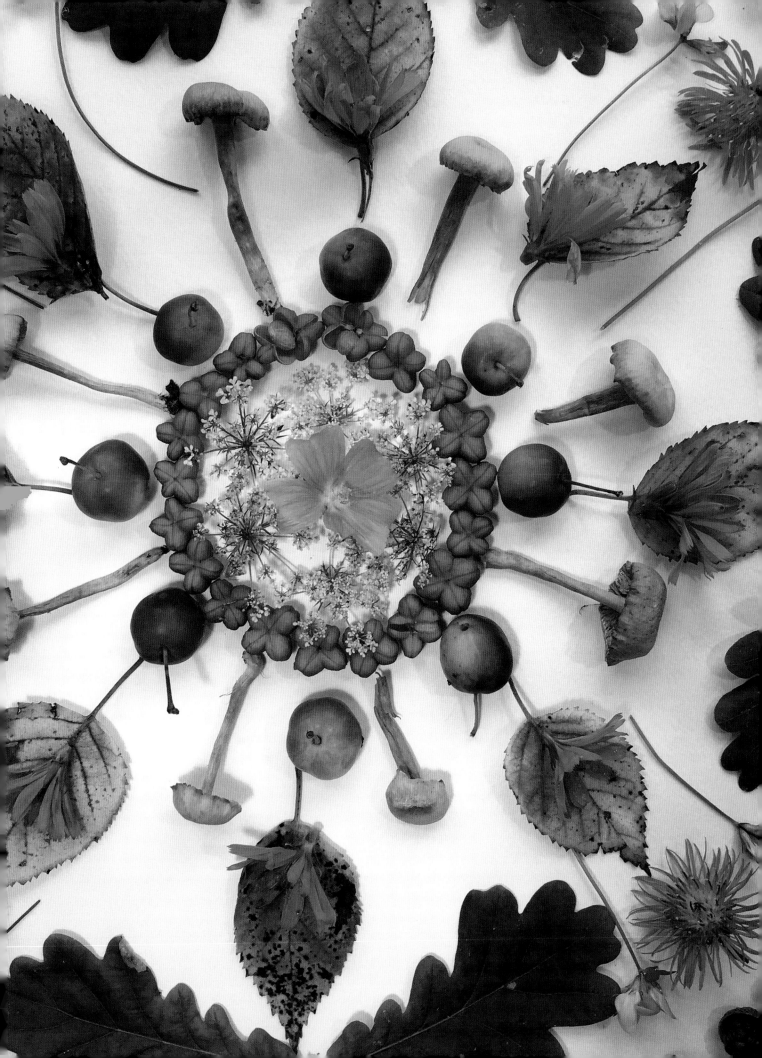

Making mandalas
from natural elements

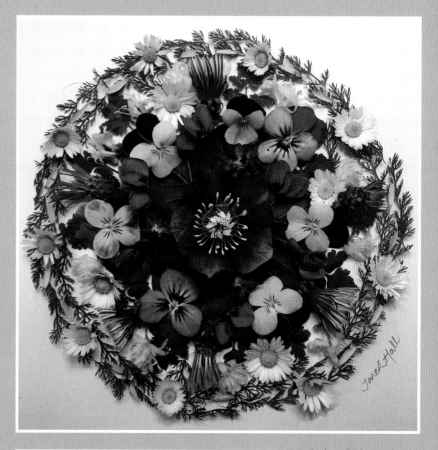

Collecting natural elements to arrange is a creative, mindful process in itself. Wandering through nature, gently garnering natural elements – treasure seeking, as I prefer to think of it – is perhaps the greatest joy in the whole process of making a mandala.

Nature generously provides a limitless palette: flowers, leaves, pine cones and needles, pebbles, stones and shells – all for free! However, as with any kind-natured offer, please refrain from meeting generosity with greed. Pick flowers only where they bloom abundantly, and never if the plant is rare. Have a care for the pleasure of others admiring them; picking just one in twenty blooms is a good measure.

More important than our joy and aesthetic pleasure, wildlife depends on flowers for pollen, nectar, seed and shelter. It is wise to remember that you may well be picking someone's meal, or indeed someone's home, however inadvertently. Earwigs, for example, contrary to folklore, do not live in ears! They far prefer flowers. Certain wild flowers are also butterfly nurseries. Fritillaries of various kinds lay their eggs on violets, and the large blue on wild thyme. Peacocks and small tortoiseshells lay their eggs on nettles. (Clearly, those two species are on to us and our penchant for picking things, choosing to lay their eggs on something stingy by way of protecting the next generation.) If you are gathering supplies at the coast, it is equally important to be careful. A seashell could easily be a hermit crab's home, or a pebble a barnacle estate.

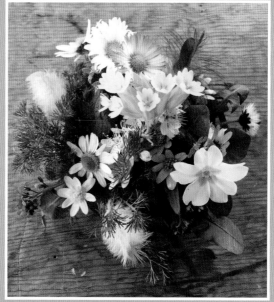

Gathering wild flowers from our nature garden, to make a mandala. It is wise to have some water ready to dip their delicate stems in as soon as they are picked. Be it a vase, jar or teacup, there is something creatively joyful in this simple process alone. I often pause to take a photograph of these posies, pretty as a picture. Flower mandalas are easier to assemble if the flowers you are working with have enjoyed a good drink straight after picking. With the posy resting beside you, you can pick and choose the most beautiful blooms, unwilted by the time you are taking in mindful consideration.

So, sensitively, open-minded and open-hearted as you wander, intuit a feeling of being guided by nature itself, acknowledging and considering what your eyes alight on. Then, as if by magic, a pattern will begin to form.

Some mandala patterns are informed by what you choose to place at their centre, the *bindu* in Sanskrit. The design of others is determined by what you choose to radiate from this point. For me, the whole process of creating a pattern from natural elements is literally and metaphorically organic, born of gentle persuasion rather than creative control. I change where I place things throughout the process, according to the shape, size and quantity of the elements that I have chosen, or, more spiritually speaking, that nature has chosen for me.

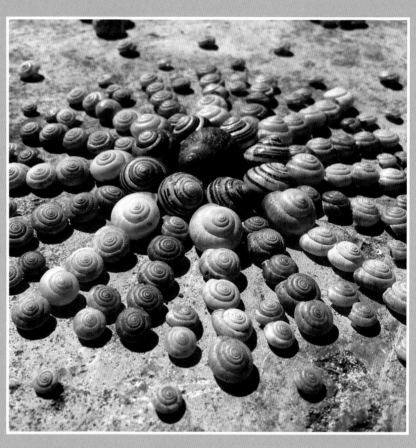

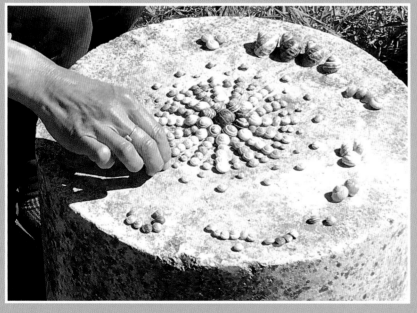

There is perhaps no finer pursuit than making mandalas in the sunshine. Here I am settled at a smooth, circular stone that I refer to as my mandala stone, making a mandala with snail shells. The pattern was determined by the size of the shells, from the largest garden snail (Cornu aspersum) – the song thrush's favourite – at the centre. Encircling this is my favourite, garden banded snail shells (Cepaea hortensis), favoured as a nest by the mason bee (Osmia bicolor; more on this natural wonder later). Ever decreasing in size, the shells circle out towards the edges of my mandala stone.

Having for years bemoaned snails for their voracious appetites – mostly, it seemed, for our tender young vegetable plants – I have now come full circle. It's apt, given the intrinsic shape of the mandala. Now I see snails as a thing of beauty, and comb the garden for their empty shells, as one might comb the shore for seashells.

Why not consider garden shell-seeking, combing your nearby wilds? You may be surprised both by the fun you have and by the creativity it encourages.

Cranesbill mandala

While making wild-flower mandalas, I discovered that members of the cranesbill family have explosive personalities. I truly became aware of it only when I noticed some tiny crowns among the grasses: seed pods of the hedgerow cranesbill.

Beyond joy in the making, there is hidden joy in the wider context of creating nature mandalas. This joy is to be discovered in the secret life of the natural world, uncovered while collecting natural elements: insects hidden in vegetation, spiders' webs suspended between the plumes of tall grasses, butterflies sunning themselves, sipping nectar from the flowers you are creatively scanning. Such encounters are limitless. I often alight on something that surprises me afresh with its beauty, often a previously overlooked detail. Most of the time, our visual focus is set at 'glance'. Life would arguably be overwhelming if our preset were to look curiously and carefully at everything in the world. However, when gathering elements for nature mandalas, one's mindset should be just that: curious, carefully exploring everything wonderful in the world of nature.

One summer's day, meandering through our meadow, I noticed a detail so exquisite that I was truly dismayed not to have noticed it before: the dainty crown-like seed pods of a plant called cut-leaved cranesbill. The cranesbills (*Geranium*) are a genus of wild flowers made up of many species (there are also storksbills, *Erodium*, but that's another story!). Significantly, they all have 'bills' – beak-like seed pods. Although they are delightful in my eyes, many gardeners disdain them. They grow freely and are considered weeds more often than not. But, oh, those seeds! The wild plant has pretty lipstick-pink flowers, too.

The plant holds up several calyces per flowering stem, with five ruby-red, pointed sepals. Atop these are held five olive-green seeds, set like little Crown Jewels. At their centre stands the bill, like a miniature spire. This is delightful enough, but there is yet more detail. As the seed heads ripen, they explode like fairy fireworks, casting the seeds up to 10 feet (3 m) from the plant on miniature springs. Since I first witnessed it, I have watched this phenomenon

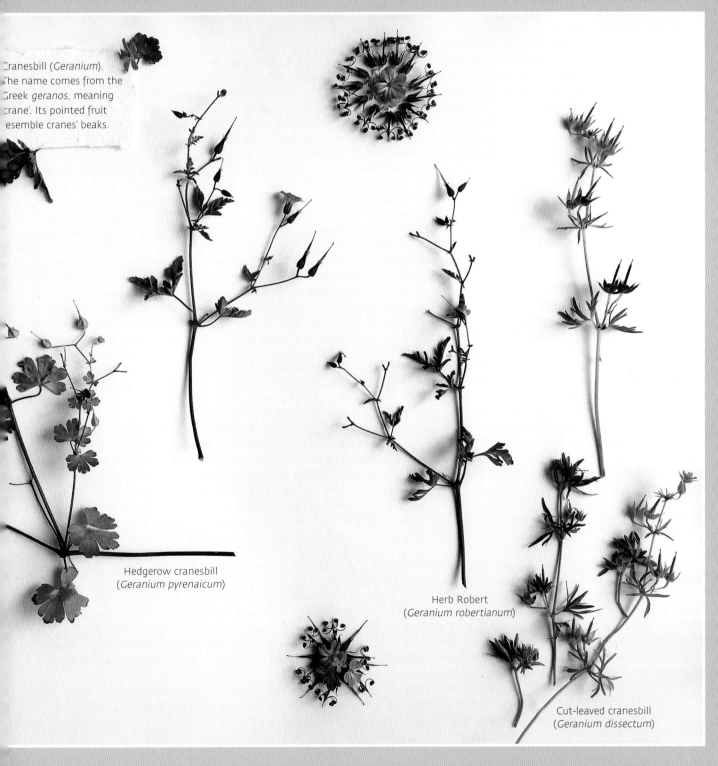

Cranesbill (*Geranium*).
The name comes from the
Greek *geranos*, meaning
crane'. Its pointed fruit
resemble cranes' beaks.

Hedgerow cranesbill
(*Geranium pyrenaicum*)

Herb Robert
(*Geranium robertianum*)

Cut-leaved cranesbill
(*Geranium dissectum*)

gleefully over and over again. Once sprung, the seed heads resemble even daintier crowns, befitting fairy kings and queens.

In honour of this much overlooked wildflower family, I determined to dedicate this mandala to their familial perfection. I gathered twenty or thirty of each element of the cut-leaved cranesbill in the palm of my hand, and so my mandala began.

Next I chose the pointed seed heads of herb Robert, which was growing close by. Herb Robert is perhaps the most familiar member of the family, tenacious enough to grow through brick and pavement. Its seeds are so pointed that they earned it the folk name 'Granny's needles': perfect green, red-tipped needles tucked into tight, tulip-like calyces. Finally, I chose just enough pretty pink flower heads to form a circle, and a handful of small-flowered cranesbill leaves, beautifully variegated in green and red, to ring the imagined circumference of the pattern that was forming in my mind.

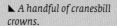

◣ *A handful of cranesbill crowns.*

▼ *A dainty bowl of cranesbill flowers.*

▼▼ *A mini cranesbill mandala.*

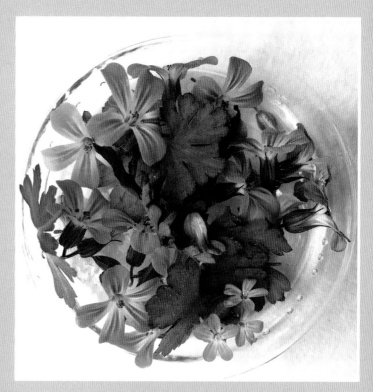

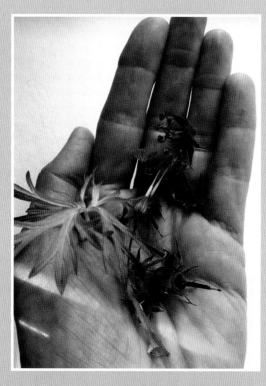

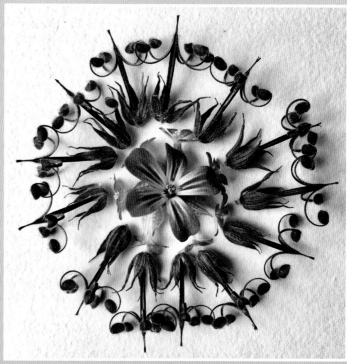

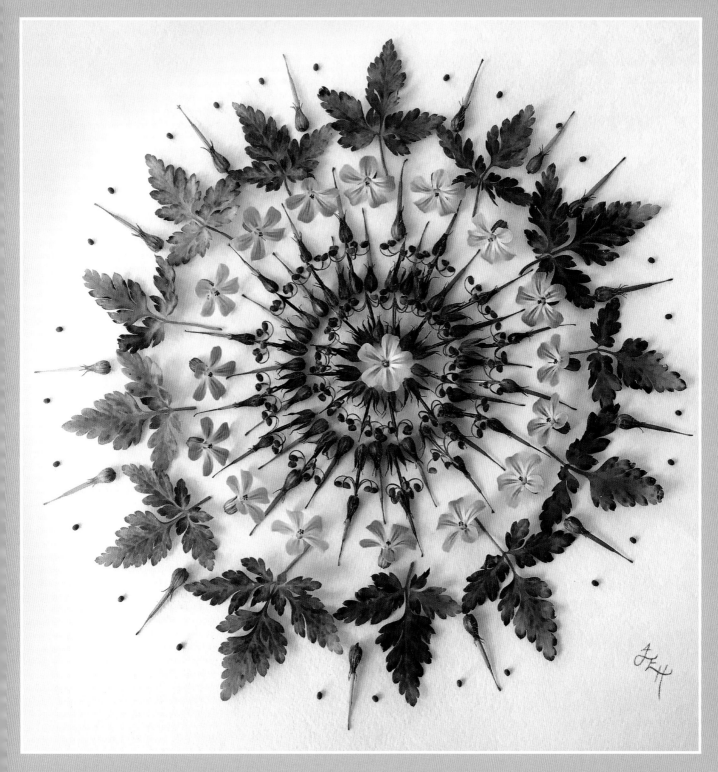

Dandelion mandala

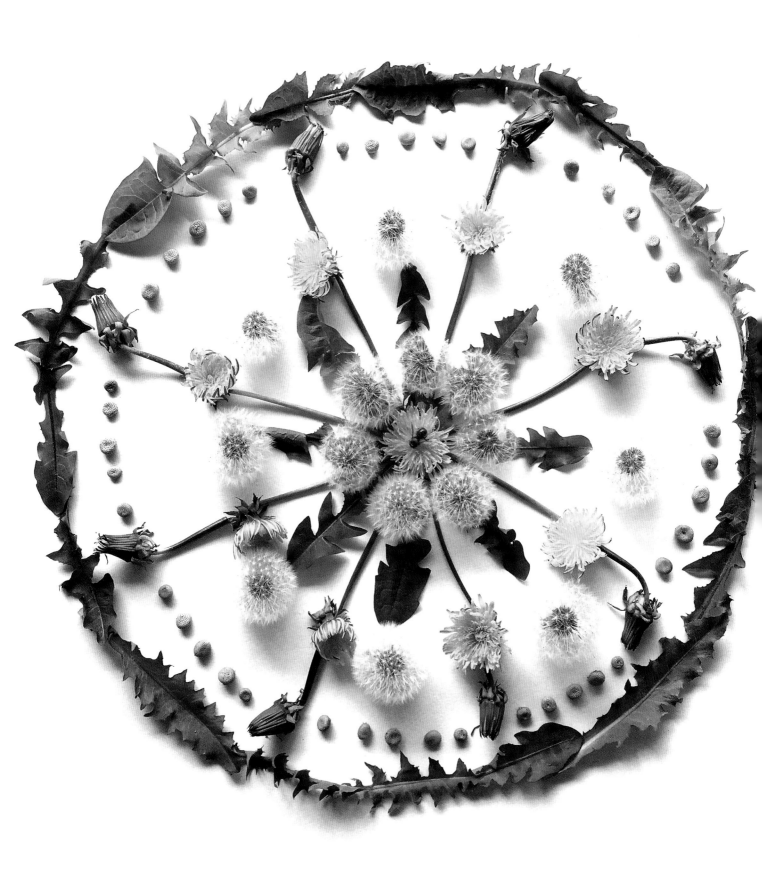

Dandelions (*Taraxacum officinale*) are a great source of both pollen and nectar for pollinating insects. Each yellow flower head is in fact made up of a hundred individual flowers, a veritable banquet of nectaries for bees, butterflies and hoverflies to sup from, all of them hungry after hibernation. Dandelions are important because, being so big-hearted, they flower commonly. Where prospects for pollinators are gloomy, where all else fails to thrive, dandelions shine like miniature suns. What better inducement could there be to dedicate an afternoon of creativity to the mindful appreciation of a woefully under-appreciated flower?

Being at the heart of things, the *bindu* here is a dandelion flower, and atop it, a bee, its time in the sun, alas, flown. I found him beside the door of the Fairy House; it figures, since a honeybee hive rests just next door. Sadly, not all bees make it through the long winter sleep.

Radiating from here are the plant's jagged leaves, widely understood to have prompted its familiar name, from the French *dent de lion*, lion's tooth. The name is also associated with its toothy, hard-to-extract taproot. Gardeners take heed: it is better for all not to pull!

Breath held, softly as a whisper, I then arranged seed clocks on top, to cover the base of each leaf. Delightfully, in country folklore these clocks determined several of the plant's alternative names (see below).

▲ *Like miniature suns, dandelion flowers shine up at the sun and follow it across the sky. It is said that you can tell both time and fortune by blowing on the seed head.*

◄ *In praise of the fine and dandy dandelion! They are full of nectar and pollen for butterflies, bees and other insects, of seedy sustenance for birds, and of vitamins and minerals for humans, and beautiful as well. Several prides of dandy-lions roam our wildlife garden, and I could not be prouder.*

REGIONAL FOLK NAMES FOR THE DANDELION
Clock flower, clocks and watches (Ireland)
Fairy clocks, farmers' clocks, four o'clock, golden suns (Shetland)
Lions' teeth (Yorkshire)
Old man's clock (Devon)
Schoolboy's clock, shepherd's clock (Lincolnshire)
Time teller, time flower, tell-time, twelve o'clock (Clackmannanshire)
Wishes (Somerset)
What o'clock (Wiltshire)

Spent flower stems form the spokes of the design. 'Golden suns', another folkloric name for the flower, rise towards the top of each stem. Further dandelion clocks rest between these flowers, encircled above by what is botanically known as seed receptacles. In the Middle Ages these bald, pitted seed heads were considered to look like monks' heads, leading to further folk names for the plant, such as 'caput monachi' and 'prestis croune'. I simply know them as dandelion buttons – as do the fairies, as you will learn from the pages of this book, referencing nature's haberdashery.

Finally, those crimped, toothy leaves provide the perfect nibbled edge to the mandala.

A very rare, previously unseen species of the family Asteraceae, genus Taraxacum: the Dandelion Dragon.

Dandelion dragon

Needing a break from my creative endeavours, I stepped away from my drawing board, out of my studio door, over the garden hedge and into the adjoining fields. With Neil away for the day working, I had no hand to hold. With no conversation to touch the air, everything seemed still and magnified. I felt small again, like a child playing truant. I found myself recalling walking the wrong way home from school, just to see how it felt. I was 'a good girl', playful and endlessly imaginative but never wilfully naughty, so that was tantamount to truancy for me.

As I walked my crooked mile, making only one set of footprints, it felt twice as far. I startled everything, as much as everything startled me! The wild mallards dabbling in a stream didn't see me coming, and hastened away so fearfully that I ducked myself, my heart skipping several beats. A mob of pheasants announced their panicked departure clamorously by way of their onboard klaxons before I had so much as clapped eyes on them. Then there were the secret, scuffling, scampering things that live in hedges and ditches, departing noisily, making themselves out to be hedge monsters.

But there were gentle things, too: the dance of birdsong in the treetops, the soft blue sky, and the warm sun coaxing the tender green shoots and buds of a new spring, and entreating me to take off my jacket. As I approached the coppice at the foot of the hill, I noticed the 'strapping green' growth of the bluebells emerging in waves of green, soon to become a deep blue sea. There were primroses, celandines, fresh lichens and liverworts, too, all lovely. Then, at the toe of my boot, most ordinary and yet perhaps most magnificent of all, the dandelion – and he didn't roar!

Autumn mandala

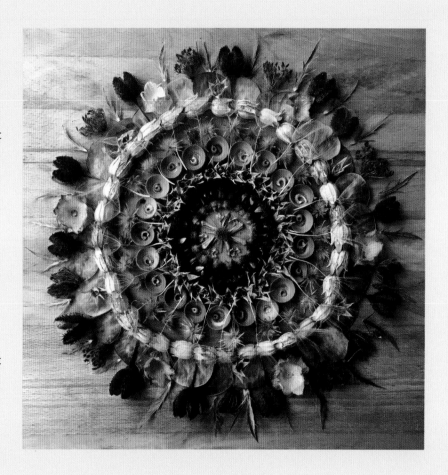

Following the example set by our wild kin, autumn is a time to squirrel things away as nourishment for the long wintry days ahead. Of course, our dietary needs and fancies are more sophisticated than the squirrels', and today we provision our households from grocers and fancy food retailers. But what about emotional sustenance, beauty to feast our eyes on when there is less sunshine to warm and brighten our days?

Particularly towards the end of summer, I begin gleaning treasures from the wild, harvesting wild-flower seeds to sow in little pockets of soil, nurturing the 'micro-habitats' that we are establishing in our wildlife garden, or to broadcast across our meadow, in time making it richer in different species. Now that's what I call investment. However, nature has seeds to spare and beautiful seed cases – to nature no more than wrap and containers – that our creativity can recycle.

This autumn mandala is just that: nature's waste recycled. A sea holly seed head sits at the centre, encircled by other seeds and seed capsules.

THE AUTUMN MANDALA

This simple, soothing mandala is made up of threaded seed heads, dainty wild-flower necklets and bracelets of drilled seeds and seed heads threaded variously on to copper wire, fine raffia and silk thread. From the centre:

✦ Sea holly (*Eryngium maritimum*) seed head. This coastal favourite reminds me of carefree summer days spent by the sea.

✦ Spindleberry (*Euonymus europaeus*) seed cases. Bleached by a season in the sun, these rested on my studio desk as they ripened.

✦ Agrimony (*Agrimonia*) seeds. In flower, these produce tall spires of radiantly beautiful sunshine-yellow flowers.

✦ Sunflower (*Helianthus annuus*) seeds. 'Sun flower' – that says it all!

✦ Rosy garlic (*Allium roseum*) seed heads. A gently faded memory, gathered many summers past and treasured away.

✦ Acorn cups (*Quercus robur*), holding wild marigold (*Calendula arvensis*) seeds.

✦ Fleabane (*Pulicaria dysenterica*) seed heads. Beloved of butterflies and bees, and, as gardeners would say, grows like a weed!

✦ Corncockle (*Agrostemma githago*) seed cases. These are some of my favourite 'wild-flower beads' (see pages 88–9).

✦ Honesty (*Lunaria annua*) seed pods. The stuff of fairy tales (see page 90).

✦ Beech-nut (*Fagus sylvatica*) cases. These came from the tree beside my studio.

✦ Wild carrot (*Daucus carota*) seed heads.

✦ Sea holly's tiny spiny bracts, which whorl around the flower head.

Winter mandala

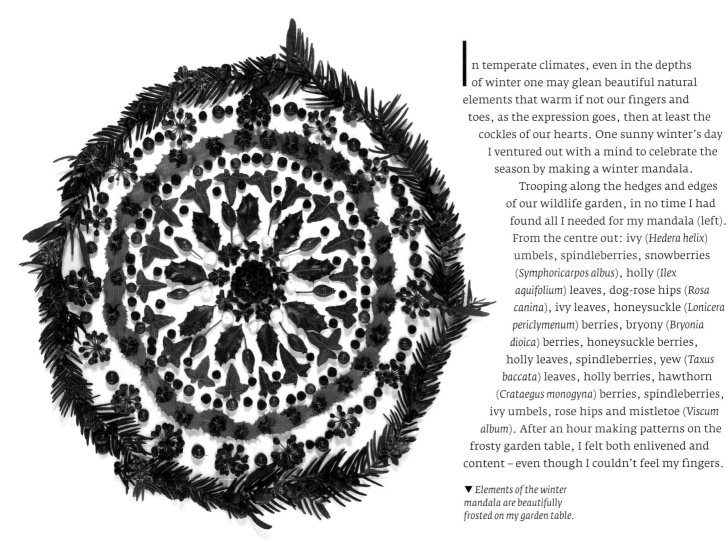

In temperate climates, even in the depths of winter one may glean beautiful natural elements that warm if not our fingers and toes, as the expression goes, then at least the cockles of our hearts. One sunny winter's day I ventured out with a mind to celebrate the season by making a winter mandala.

Trooping along the hedges and edges of our wildlife garden, in no time I had found all I needed for my mandala (left). From the centre out: ivy (*Hedera helix*) umbels, spindleberries, snowberries (*Symphoricarpos albus*), holly (*Ilex aquifolium*) leaves, dog-rose hips (*Rosa canina*), ivy leaves, honeysuckle (*Lonicera periclymenum*) berries, bryony (*Bryonia dioica*) berries, honeysuckle berries, holly leaves, spindleberries, yew (*Taxus baccata*) leaves, holly berries, hawthorn (*Crataegus monogyna*) berries, spindleberries, ivy umbels, rose hips and mistletoe (*Viscum album*). After an hour making patterns on the frosty garden table, I felt both enlivened and content – even though I couldn't feel my fingers.

▼ *Elements of the winter mandala are beautifully frosted on my garden table.*

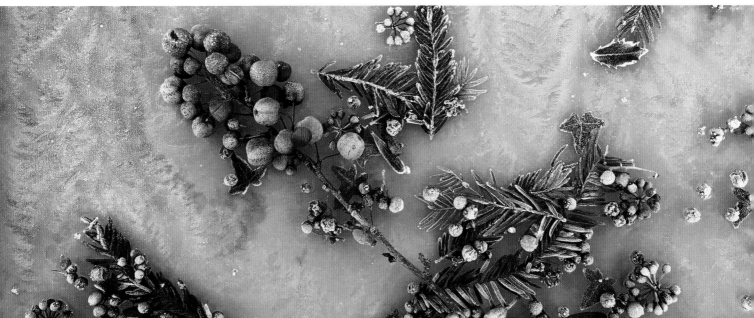

Metamorphosis mandala

Every year I am awed to witness the metamorphosis of butterflies, namely the nettle-feeding species, the peacock butterfly (*Inachis io*), whose precious eggs and caterpillars I gather from the wild, nurturing and shielding them from harm in my bespoke caterpillar enclosure: Nettles Nursery. Predation by parasitic flies and wasps and the destruction of their sole food plant, the common stinging nettle (*Urtica dioica*), result in very few surviving from egg to adult butterfly in the wild. Left to nature's mercy, perhaps one in a hundred take to the summer sky.

Witnessing the infinitesimally small caterpillars that I have gathered mature and, over time, metamorphose into exquisite chrysalises is one of my greatest joys. I am awed by their beauty as they hang from the ceiling of my enclosure, luminously gold, like fairy chandeliers. Then there is the sheer wonder of watching the birth of perfectly new, vibrant-winged butterflies. My heart never fails to lift as I watch them take flight from my fingertips and dance off into the wild.

This butterfly mandala celebrates that joy.

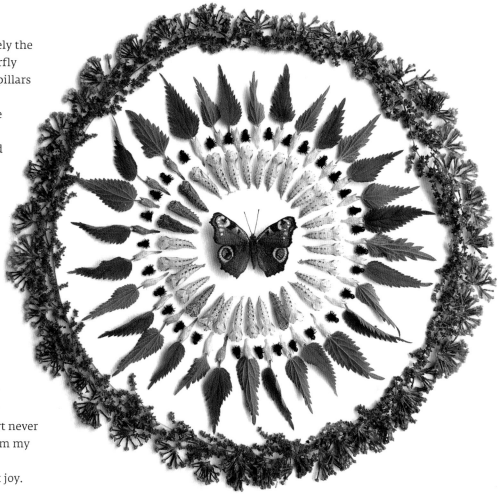

THE METAMORPHOSIS MANDALA

✦ A hand-embroidered peacock butterfly, the artistic rendering of which is considered later (see page 132), rests at the heart of the mandala.

✦ Surrounding the butterfly, the empty chrysalis cases of thirty-one peacock butterflies represent a month of summer's days, a summer over which I actually released 1,001 beautiful adult butterflies.

✦ Circling about them, the spiny black heads of peacock caterpillars, discarded like bikers' helmets as they pupated into chrysalises. Beside each spiny black jewel are the tissue-fine sections of the chrysalis case, covering the butterfly's antennae and face before it ecloses, rather like a Venetian mask.

✦ Then a crown of young nettle leaves. I have never measured out a caterpillar's diet, but these thirty-one should cover breakfast, lunch and dinner for at least one very hungry caterpillar!

✦ Finally, an outer array of nettle seeds and the dainty blooms of buddleia (*Buddleia davidii*) panicles, one of the butterfly's favourite forms of nectar. Many will be familiar with this beautiful shrub, which grows like fun, even in poor conditions. I urge everyone with sufficient outdoor space to grow one. Even more importantly, I urge everyone to find space in their hearts for the common stinging nettle, which gives life to the uncommonly beautiful butterflies that depend on it. Peacocks, small tortoiseshells (*Aglais urticae*), red admirals (*Vanessa atalanta*) and commas (*Polygonia c-album*) are all nettle feeders.

Snail-shell mandala

Although I am no professional in the field of ecology or botany, it is true to say that I have spent countless hours 'studying in the field'. Over the years I have learned the names of creatures, plants and trees more off by heart than academically. Curious to understand them better, I have sought insight and understanding from books and online resources. Head following heart, my knowledge of the natural world keeps growing organically, perhaps as nature intended. Beyond my wild discoveries in the field and through research, whether bookish or online, I find the greatest proponents and advocates of nature are my friends. I have whiled away countless happy hours in their company in search of particular wild flowers, butterflies, mammals, birds and bees – or, as I prefer to think of it, playing out of doors.

One such friend, Brigit, loves bees. Since I have known her, I too have become besotted. One summer's day as we wandered through the meadow, she told me the fantastic yet true story of bees who nest in banded snail shells, thatching their bijou nursery homes with plant stems. Gleefully, she described how they carry thatching material to their homes like miniature witches on broomsticks. Who would have thought it?

The female mason bee discerningly seeks out her shell, favouring the banded variety, the colourful, stripy ones (although I fancy it's not aesthetic whimsy that directs her choice). She fusses it into position, sheltering its entrance from the elements as best she can, before provisioning it with pollen and nectar rolled into a tiny nutritious 'power ball', on which she lays a single egg. She then sets about making a sort of pesto, meticulously chewing leaves to the right consistency before daubing it on the walls of the shell. Finally, she collects grains of soil, sand, tiny pebbles and natural fragments to seal the entrance of her nest before taking to her broomstick. Over the course of half an hour or

so she will collect thirty or more pieces of plant stem and grass, flying them back to her bespoke 'snail shell nursery', cunningly tucked out of sight and out of harm's way.

Waving goodbye to Brigit that day, I had every intention of returning to my studio to work, but I had a bee in my bonnet! In the end I spent the rest of the day moseying about the meadow in search of empty snail shells. You see, Brigit had suggested that I might lure these bee witches to set up home where I might chance to see them,

Sitting at my 'mandala stone' in the sunshine, making my snail-shell mandala. The finished mandala (opposite) will last until it is disturbed by a curious creature, perhaps a thrush or a fox.

a warm and sunny spot where the grass grows low and their favourite plant for 'pesto', burnet (*Sanguisorba minor*), thrives. There I would rest some banded snail shells, and wait and see.

In no time at all I had two pockets full of empty snail shells. Choosing my favourites, hoping that they would be the mason bees' favourites too, I rested them in a favourite sunny spot in our nature garden, known by all who love it as Cuddle Cove. It just so happens that my mandala stone rests in Cuddle Cove, too, so what better way to begin my 'wait and see' than to empty my pockets and, gently contemplating the wonder of mason bees, make a snail-shell mandala in their honour?

In the grand tradition of patience, two years later I'm still waiting to witness a bee on a broomstick fly by.

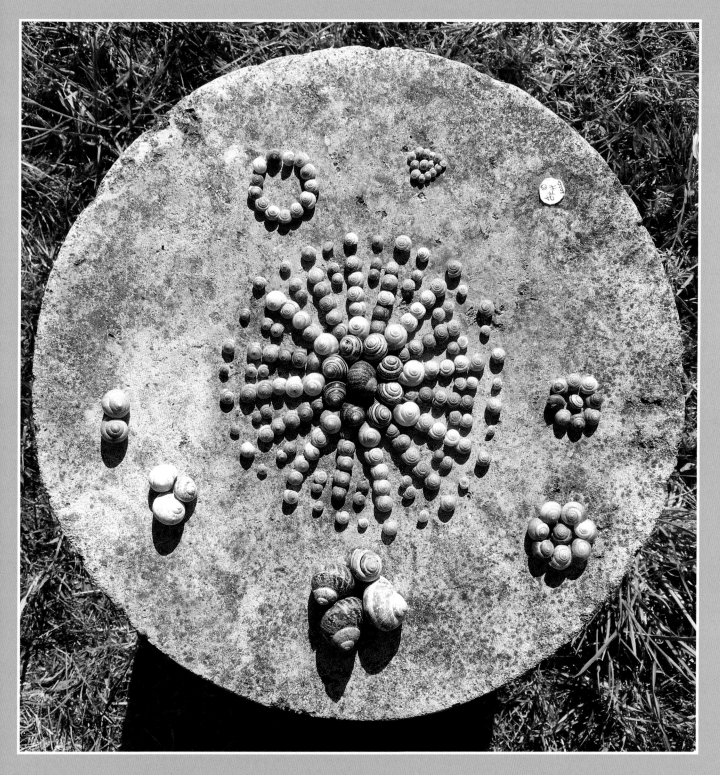

Snowdrop mandala

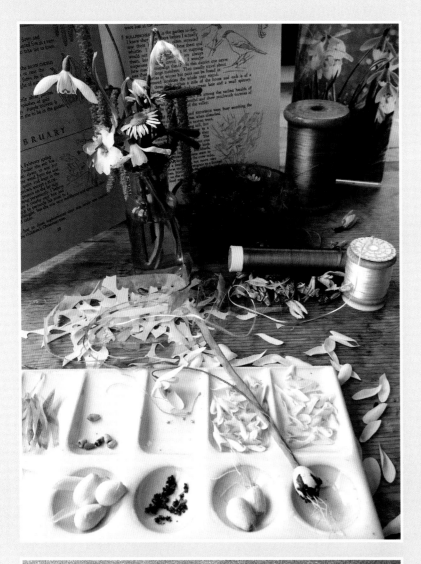

The gentle, mindful process of creating mandalas from natural elements allows the mind to relax and wander freely into the limitless realms of creative possibility. Such wanderings and imaginings may originate in more considered artwork, or muse mandalas, as I like to call them. I happened upon this mandala in just such a meandering way.

Studying snowdrops (*Galanthus nivalis*), mindfully considering their petals, stamens, calyces and leaves so intently that I could see them when I closed my eyes, I determined to relax my gaze. It is important to do this regularly when concentrating intently on artwork, to avoid the physical aches and pains such focus can cause.

Gazing across my desk, I noticed that the dainty silk-satin petals (tepals), stamens, organza spathes and leaves that I had cut and painted by hand throughout the day were seemingly dancing little reels. Many were gathered naturally into circles or whorls, just as I observed them to be in the flowers themselves. Hand-knotted silk stamens counted into groups of six, just as they appear in each flower, rested nearby. The snowdrops I was studying stood in a special snowdrop vase, a gift from a dear friend, and a sprig of willow catkins, heavy with pollen, rested among them. Having nudged the flower vase earlier, I had inadvertently caused the catkin pollen to dust the whole scene, 'like powdered sunshine', as I reflected.

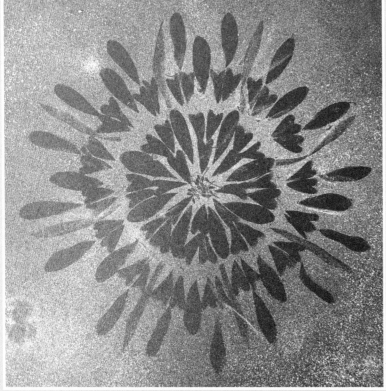

Picking up a paintbrush, I began to coax the elements gently into new patterns. In doing so, I noticed that some had left beautiful shadows beneath them, so I resorted to picking them up carefully with tweezers. Serendipitously, art was born.

I went on to fix these petal patterns carefully to night-black silk, using fine handmade needles and silk thread. Rather than following a creative process, I achieved an entirely unexpected

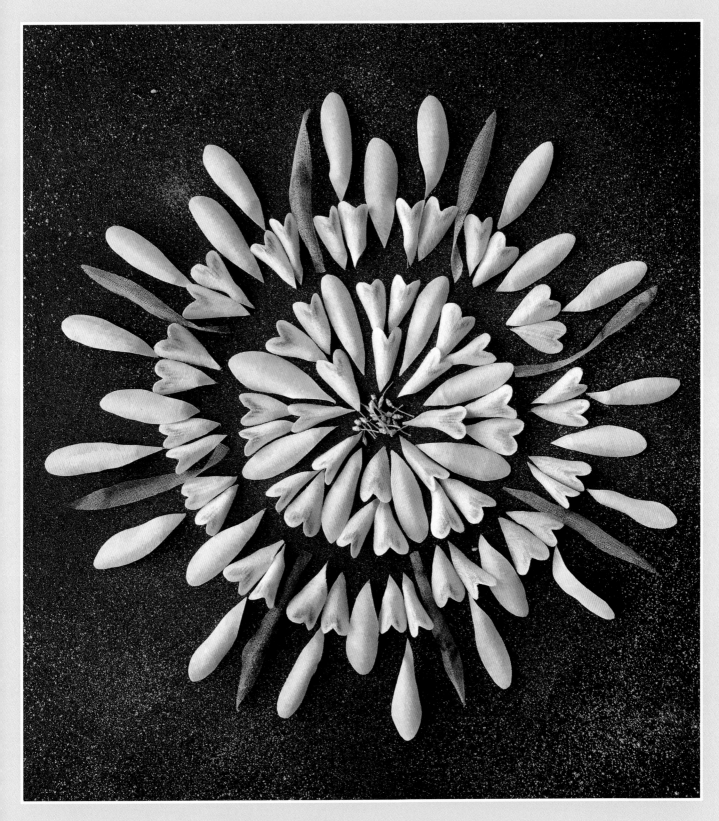

outcome – art by way of surprise, not design, an expression of deeper consciousness, of the meditative mind.

Since they were by nature impermanent, I reinterpreted my pollen paintings by reproducing the patterns I observed on my desk. Cutting corresponding paper elements, I set them on a dark ground and misted them with speckles of pollen-yellow dye before lifting them to reveal the shadow pattern beneath.

It is not always possible to venture out in search of natural elements with which to make a mandala, but rain need not stop play. Distance from nature need not deter, either. If life or the weather dictates playing indoors, look to those 'treasure stores'; these are rainy-day mandala days!

▼ As I make my snowdrops, the various elements rest daintily in a dimpled china artist's palette.

◄ A catkin pollen painting.

▲ My snowdrop mandala is made entirely from handcrafted pieces.

Button mandala

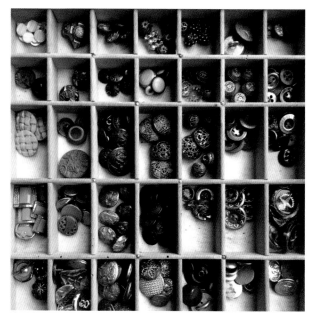

Over the years I have treasured away all manner of things that I find precious. Notable among these is my button collection. To begin with, it was 'Grandma's button box' (more accurately, an old cake tin). It contained a vast array of buttons, hooks and eyes, the occasional marble and a few old nuts and bolts. It served as useful currency when my brother David and I played shops. Of course, the buttons deemed special, and the extra-big ones, held higher value. You could buy a biscuit for one of the really big mother-of-pearl ones! When not in shop circulation, strewn across the kitchen table, they became building blocks for precarious button towers or button flowers, a favourite chosen for each centre, surrounded, of course, by button petals. Indeed, all manner of patterns were possible, and we were limited only by our attention span. Looking back, Grandma must have spent a wearying amount of time simply gathering up all the buttons and putting them back into the tin. I can almost hear the rattly button sweep and tinkle of them falling back in now.

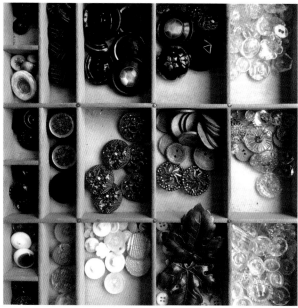

Although my buttons are no longer housed in that original tin, I do still have some that once belonged there. The collection, which I've refined and added to over the years, is now stored in an old printer's tray in my 'treasure chest'. It's true to say that button playtime has become a little more refined, too, helped by a much longer attention span.

To make a button mandala, one simply needs buttons. I have had the advantage of collecting them since childhood, helped by past generations for whom saving buttons was simply a practical, sensible thing to do – early proponents of the now very on-trend recycling movement. Old clothes were rarely discarded before their buttons had been salvaged.

If you haven't already acquired a collection, there's no time like the present. Old clothes that you may have tucked away, destined for the cloth

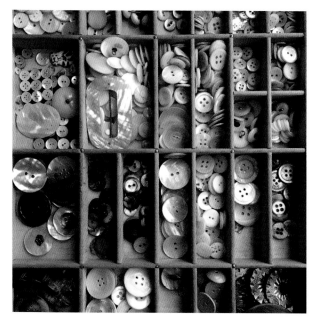

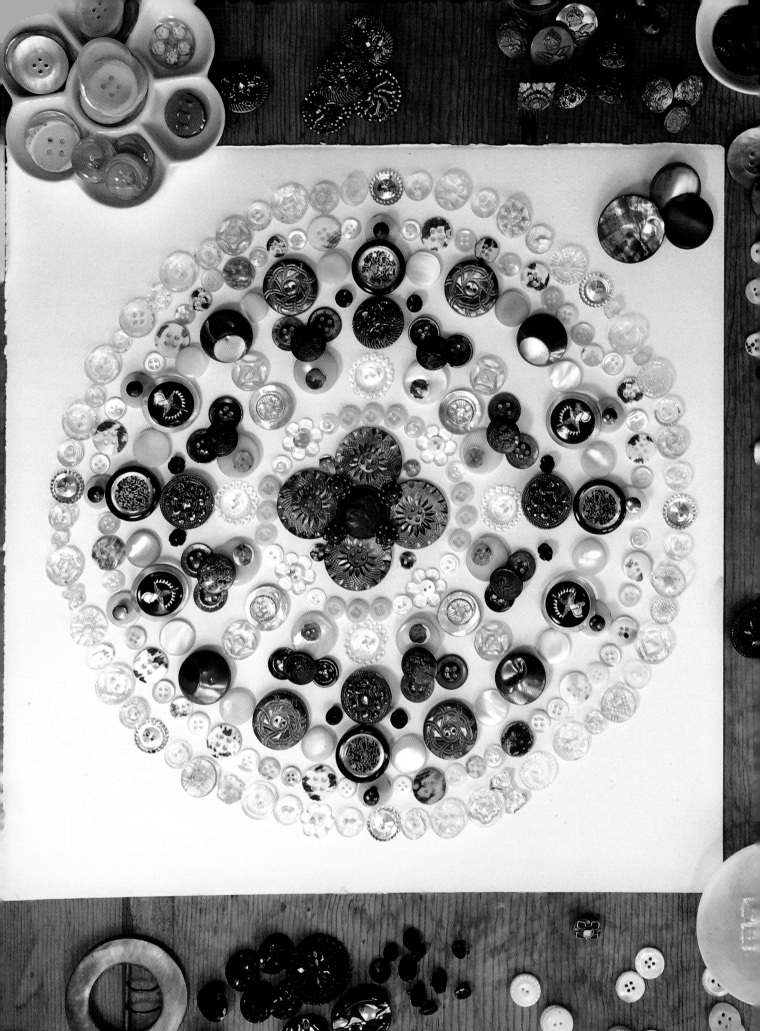

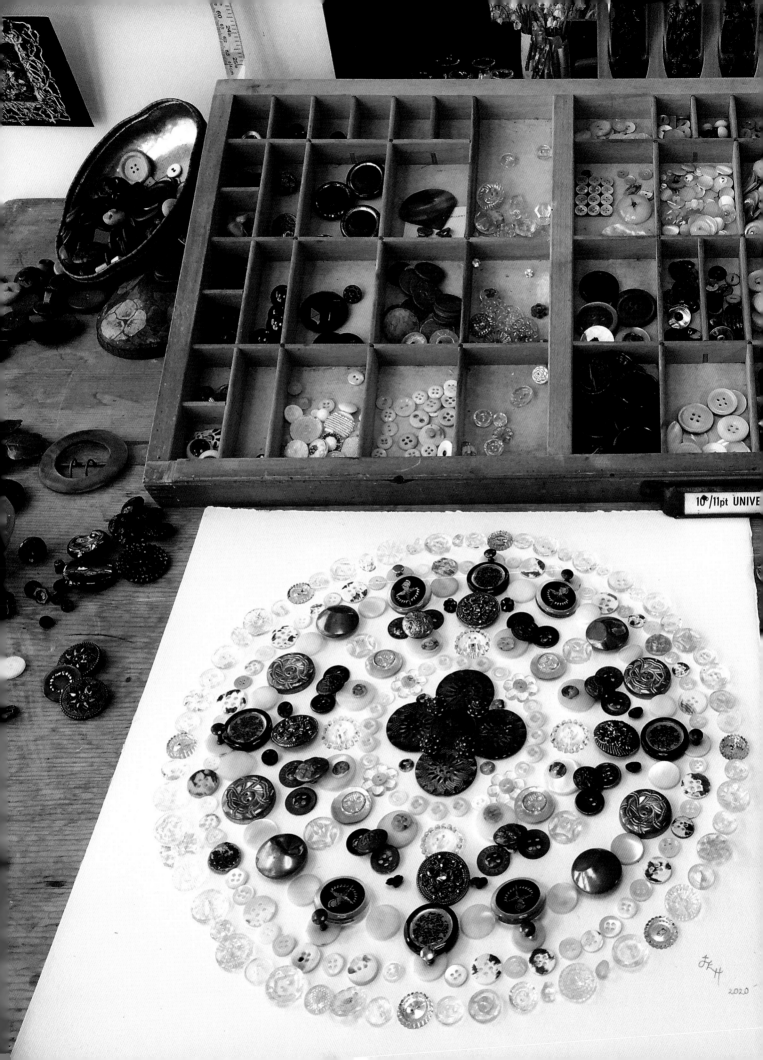

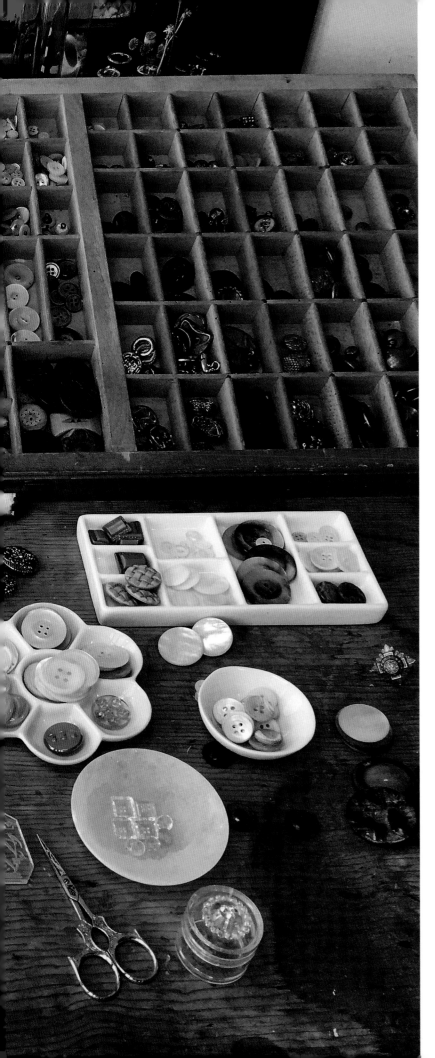

recycling bin, are an excellent place to begin, and charity shops and jumble sales are rich territory for button treasure-hunting.

The joy of buttons in the making of mandalas is that they often come in sets of four, six, eight, sixteen ... ideal for symmetrical pattern-making. I always begin with the *bindu* button, as I affectionately call it: a favourite button, of which there is often just one. Simply and playfully, I build my radiating pattern from there, pondering size, shape, colour and lustre, and always gently mindful of uniformity, of which buttons look right, and where. In no time at all, you'll notice a beautiful pattern emerging.

Of course, all manner of treasures may be used for mandalas. I've gleaned a beautiful shell collection over the years, and one of pebbles. Then there are the feathers, the lucky stones, the sea glass and the broken china. Soon you will begin to notice that you have a veritable treasure trove of elements with which to play creatively on rainy days. Often the joy of considering what you value surpasses the joy of making mandala patterns. It puts me in mind of that favourite instruction of William Morris: 'Have nothing in your houses that you do not know to be useful or believe to be beautiful.'

A gentle note of caution, however: there is a code by which all natural treasure collectors should abide. With growing pressure on habitat and many precious wild species threatened, do pick and choose carefully. However tempting it may be to plunder nature, always ponder: could this be important to a living thing, or possibly even someone's home? A seashell, for example, may have precious algae or seagrass growing on it. A hermit crab may live within. Even if nobody is home, it may provide a neat escape pod for fish. So, too, driftwood is precious territory for mites, springtails and other all-but-invisible seaside tinies. Conversely, sea glass, romantically named mermaids' tears, is referred to environmentally as debris, so collect away! That leads me on neatly to suggest that for every pebble or shell you consider choosing, do also consider picking up washed-up debris, the scourge of our beautiful seaside.

◀ *(and pages 56–7) My button treasury rests on my drawing desk. The mandala beside it made me feel as bright as a button despite the clouds of a grey day.*

Dreamcatchers

I first discovered dreamcatchers while on honeymoon in Nova Scotia, Canada, pinned to the walls of a cosy café. As I peered through the steam rising from my coffee cup, they captured my gaze, as though I were an unsuspecting creature in a web. The idea was not altogether unfamiliar to me; I had seen them pictured on T-shirts and posters, often tagged with clichéd quotations such as 'follow your dreams' and 'dare to dream'. I had noticed small decorative versions of them hanging from key rings and car rear-view mirrors, but I had not discovered authentic dreamcatchers until that particular moment, sitting in a pool of early autumn sunshine in that café in Mahone Bay.

There was nothing clichéd, manufactured or mass-produced about these. They were complex, skilfully created 'works of wonder', works of art. Their captivating beauty drew me to take a closer look. Some were woven from sinew, some from sheeny thread, others from fine, fibrous twine. Bright beads were threaded in, punctuating their radiating patterns like a spider's prey. Some had flint arrowheads or decoratively carved pieces of bone fastened to their centres. From their bases drifted feathers, knotted to fine strips of bead-threaded leather or twine. Visually powerful, they commanded reverence for their creation and, beyond this, for the act of creation itself.

These dreamcatchers caught both my eye and my imagination. Animatedly, I asked the surly, bearded barista about them. With a weary tone the opposite of mine, he explained that they were made by descendants of the earliest inhabitants of Nova Scotia, the Mi'kmaq people, and briefly introduced me to their origin story: 'Traditionally, they're hung above the heads of sleepers, kids in particular. They're left to drift in the night air, reckoned to be cast with dreams. They allow good ones to pass through, travelling down the feathers and into sleepy heads. The bad ones get caught up in the web and evaporate at first light. They're expensive, mind!', he added.

I didn't buy one, but creatively, I remain captured by them and have reverentially gone on to weave many of my own. It's a soothing, healing process. I have explored their story further, too, both in its traditional context and in the context of my own personal narrative.

Through reading, and visiting museums and reserves, I have discovered a vast web of wonder and significance pertaining to dreamcatchers, relating to various indigenous groups among the First Nations. From the Atlantic to the Pacific coast, Navajo, Lakota, Huron, Cree (Nehiyawak), Mohawk, Cherokee, Iroquois and Ojibwe lay claim to the origin of the dreamcatcher. However, consensus seems to identify the Ojibwe as the real originators. I find it fascinating to discover that the dreamcatcher is revered by such diverse and widespread groups of people. It's clearly a tradition that unites a nation. In our modern world, the dreamcatcher's significance resonates far beyond the First Nations, like the vibrations of a giant web spun across the world, touching the people of far-off lands.

I created my first dreamcatcher literally in my dreams. While we were on honeymoon, I fell ill. Sleeping restlessly, I dreamed that I was wandering through deeply wooded glades, the leaf mould soft and earthily fragrant beneath my feet. Then I found myself beachcombing along sparkling seashores, dancing in and out

My garden dreamcatcher, hung in my studio window, catches the setting sunlight.

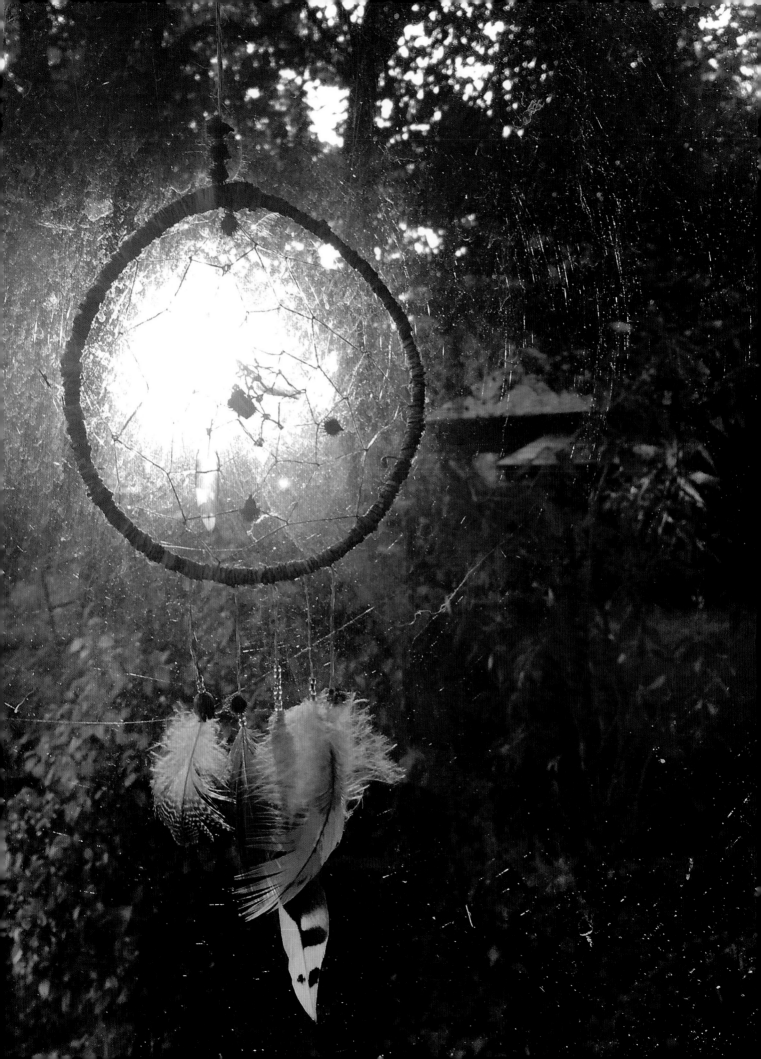

▼ *My honeymoon dreamcatcher was inspired by our trip to Nova Scotia, exploring the beautiful mineral-rich coastline and wandering inland along woodland paths, among tall pines and sacred birch. What will inspire your first dreamcatcher? Perhaps an adventure abroad, or a saunter closer to home. Whatever the inspiration, wherever the place, may it be close to your heart, for that is where the best dreamcatcher threads are drawn from, and all good stories are born.*

▶ *In my dreamcatcher workspace, I weave my thoughts together and realize my dreamcatcher webs. Consider surrounding yourself with precious natural elements and threads and seeing what comes to mind, delighting in the creativity that such thoughts manifest. The simple weaving process, explained on pages 64–5, will carry you through; simply trust your innate creativity.*

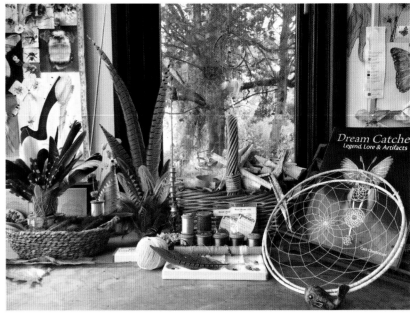

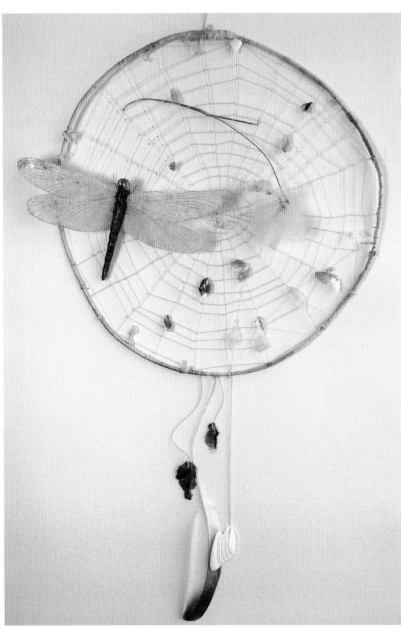

of the gentle surf of a giant sea. By and by I rested, plaiting grasses, drawing patterns in the earth and sand, feeling the warmth of the sun on my face, the cool of the shade about my shoulders. Along the way, I picked up precious things with which to make a dreamcatcher: a soft golden feather the shape of a ginkgo leaf; an acorn cup brimful of golden light; lichen in every shade of green; handfuls of sparkle from the sea. Then, within my dream, I fell into a deep, peaceful sleep guarded by my dreamcatcher. When I woke up properly, I felt much better.

I made my first 'material' dreamcatcher when I returned home. It hangs in my studio to this day, protecting me from dark daydreams, letting light and inspiration flow through and into my creative space.

I made it without reference to traditional methods, fashioning a hoop from wire, binding it first with silk and then with birch bark, reminiscent of walks through the magnificent woodlands of Nova Scotia. I then wove a silk web across it, anchoring the thread through the sides of the hoop before crossing it to form spokes, through which I then wove and knotted, slowly making my way towards the centre. As I wove, I caught up tiny fragments of seashell and mica, familiar treasure from the mineral-rich coast of Nova Scotia. I also incorporated a fine stem of cottongrass. I attached a seabird's feather to the bottom of the hoop, together with more fragments of seashell and iridescent mica. Finally, I made a dragonfly to rest against my web, a creature that carries deeper meaning for me, adding my own personal whisper of narrative to this dreamcatcher's origin story.

Fairies' dreamcatcher

By way of enchantment, the fairies charged a garden orb-weaving spider with spinning them a dreamcatcher to hang beside their front door. The spider, not knowing front from back, felt obliged to spin two. They remain there to this day. Spun from the finest, strongest spider silk and spellbound to last an eternity, they catch bad dreams and negative energy, not allowing it to cross the threshold into the fairies' house.

I would not have noticed these spidery silk dreamcatchers if it had not been for the ragged robin caught up in one. Now I am perplexed as to why such a beautiful wild flower should be caught up in this way, although I imagine that 'goblins' will have had something to do with it. Goblins are wilful and wily, and foe to fairies. I can picture them now, arriving at the heavy oak door, tapping gently and hiding behind their princess-pink posy, hoping to catch the fairies unawares. Delighted and distracted by such a pretty doorstep delivery, the fairies might not notice the goblins creeping in. Their purpose? To cause mischief and make off with the fairies' wild-flower nectar and syrup!

Fairies are bright little creatures and goblins rather dim, so I have no doubt that they did not enter. I sat inside the Fairy House for some time today (by open invitation), and did not notice a thing out of place, although I did see an extra four-leaf clover in a gilded frame beside the fireplace. Four-leaf clover is to goblins as garlic is to vampires. Personally, I have never understood the efficacy of either, since neither seems fearful to me, but then I am only human. I suppose fairies know differently, hence the doubling up of the deterrent. Furthermore, while rearranging the flower pots outside the front door, I disturbed a rather princely toad, obviously on guard duty. There has definitely been trouble!

Now, I wonder, should I get back to my embroidery or should I seek out that toad and give him a kiss?

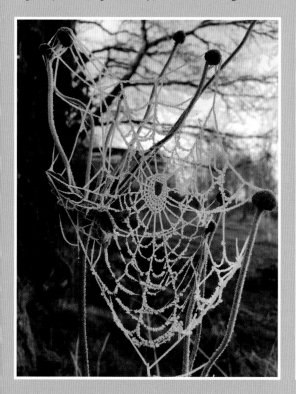

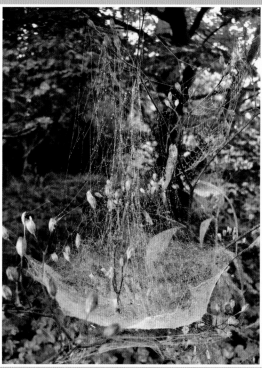

◀◀ *An orb-weaver spider's web is exquisitely touched by hoar frost.*

◀ *A sheet web spun by one of the many members of family Linyphiidae catches the early-morning dew – and perhaps a spidery snack or two.*

MAKING
Weaving a dreamcatcher

Dreamcatchers are a joy to make. They are relatively simple in their basic construction; all that is needed initially is a hoop, something to bind it with, some suitable thread for weaving the web and some elements that resonate with you personally.

The Newborough Warren dreamcatcher was inspired by the gentle shores of Newborough, on the island of Anglesey, north Wales.

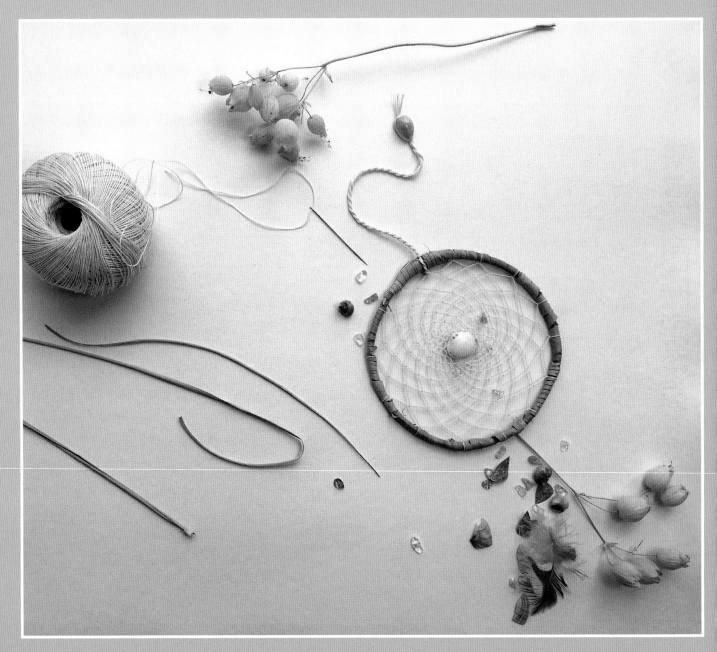

STEP 1

Firstly, find elements that resonate with you: feathers, shells, beads, seeds, gemstones, lucky stones. I've even used odd earrings, broken necklaces and gems from old brooches, from a trinket-box stash that I refer to as my 'magpie's nesting box'. Foraged or found, it is your choice, but it is important that they feel meaningful to you.

STEP 2

Now find or fashion a hoop. Metal and wooden hoops are available in a variety of sizes, specifically manufactured for making dreamcatchers. However, I often choose to make mine, using wire or, more often, willow, of which I have a bountiful supply in our wildlife garden. Willow is very flexible, and it is child's play to bend a length into a circle, slightly overlapping the ends and fastening them with raffia or twine. Willow hoops become stronger as they dry. On a whim, I often choose to make a few at a time, hanging them to dry in a warm place, perhaps over a light fitting in the warmth of my studio.

STEP 3

The hoop, whether it be willow, wire or manufactured, will need binding. My preferred binding materials are birch bark or grass, but any twine, thread, ribbon or other suitable alternative will suffice. In the Native American tradition, leather is often used. Whatever material you choose, secure it to the hoop with a knot and be sure to wrap closely and tightly; the intention is to obscure the hoop. When you have wound all the way around your hoop, the binding will need fastening, and for this I suggest a stitch, a tiny spot of glue or a simple knot. If you choose a knot, you could hang your dreamcatcher from this point by forming a loop.

STEP 4

Now the weaving begins! Any thread will do. I often use cotton or silk, although I have also used plant fibres, or 'cordage'. In Native American tradition, sinew was often used. You might consider adding a little sparkle to your web by threading on some crystal chips or beads as you weave, so that they decoratively punctuate the radiating pattern. To begin, secure the thread to the hoop using a double knot. Working clockwise, stretch the thread over the hoop, approximately 2 inches (5 cm) along, then loop it around and back over itself, hitching it in place. Move around the hoop in this fashion, maintaining an even distance between hitches, until you reach your starting point. Now loop the string around the hoop next to the starting knot. There should be an uneven number of loops.

STEP 5

Next, create a second layer of web. Loop the thread around the centre of the first line of thread, again creating a hitch, and simply continue the mesmeric process of making your way towards the centre, noticing it getting smaller and smaller as you weave. Be careful not to tug too hard, tensioning the thread too much, or it may snap.

STEP 6

When the circle in the centre of your web is small, tie the thread off, instead of hitching it. A double knot should ensure that it doesn't come loose. I often choose to tie in something special at this point, perhaps a seashell or a precious stone.

STEP 7

The hanging loop is simple to fashion. Take a piece of thread approximately 6 inches (15 cm) long and tie the ends together to form a loop, then push the knotted end through the hoop and pass it back through the thread loop.

STEP 8

To hang decorative elements to the base of your dreamcatcher, start by forming a loop of thread, then place the loop underneath the base of the dreamcatcher and thread the ends back through the loop. You can then thread drilled natural elements such as seeds, shells and beads. Feathers may be attached in a similar fashion, by binding the thread around the quill before fastening it with a tiny dot of fast-drying glue or threading it back through the quill with a fine needle and knotting it off. Sweet dreams!

▶ *Horsehair – perfect for weaving webs – is caught on a fence, naturally looped in the fashion of a dreamcatcher.*

Garden dreamcatcher *Changing seasons*

Meteorologically, summer ends on 31 August. Astronomically, it ends on 22 September, a date referred to as the autumn equinox. The 'genius' green woodpecker that I have been watching through my studio window does not need to check this online, as I have just done. The squirrel is 'in on it', too. Although it all but defies belief, I have just seen that squirrel shimmy down a tree and bury an acorn in the very same peck that the woodpecker made earlier. I am certain of this, because when he had finished his surreptitious pecking, I ventured out to see what he had been sticking his beak into. Surely he had hidden something very special indeed in there. But no. The laughing 'yaffle' of the woodpecker echoing back at me from the woods was, I felt, entirely at my expense. I discovered a hole – just a hole. I had of course hoped for buried treasure. Not finding any, I wondered what he might have uncovered or, indeed, recovered, perhaps taking back the treasure for himself! Perhaps the true treasure rests in my imagining that I might have found something magical. Imagination is, after all, a veritable treasure chest, capable of manifesting all kinds of wild and wonderful things. There is magic, too, in witnessing nature's largely unseen behaviour, in being 'in on the secret'. By rule of head or heart, treasuring encounters with nature amounts to immeasurable wealth.

That day I determined to embark on a foraging exercise of my own, in search of something I deemed precious. I was intent on making something born of nature that I could treasure: a garden dreamcatcher.

Autumn is a glorious time of year in our wildlife garden. The meadow is like the tangled tresses of autumn herself, adorned with a fashionable scattering of wild flowers – perhaps a little 'last season', but defiantly and beautifully still in bloom. As I brush through these meadow tresses in my wellies, I find that they are tangled up with seed heads and strewn with glistening spiders' webs, like little hairnets.

Having recently read about making cordage (thread made from plant fibres), I gathered some woody nettle stems and shimmery rosebay willowherb stalks from the meadow's fringes. 'These will be my binding and weaving threads,' I thought confidently, resting them in my foraging basket.

I then took big strides deeper into the meadow, anxious not to crush anything underfoot, picking and choosing seeds for beads. The delicate goblet-shaped seed heads of campion (*Silene dioica*) particularly pleased my eye. Gently, I picked a bunch, waving the stems in the air to sprinkle their tiny ebony seeds over the meadow. I fancied myself every bit the flower fairy, casting spells with my improvised wild-flower wand. They would come true next spring and summer with a flourish!

A beautiful tall, yellow flowering plant called agrimony thrives along the banks bordering the meadow. It is commonly known as 'sticky bud', since that is exactly what it does – stick! Just brushing past it on the way back to my studio, I gathered more than enough seeds on my sleeves to make something from them. The dainty seed heads of wild cranesbill growing beside my studio steps also caught my eye. Remembering a pinch of feathers that I had gathered over the year, still resting in a bobbin on my desk, I decided I had everything I needed. So to begin.

Having bruised and stripped the nettle leaves, I garnered enough long, sinewy fibres from the stems to bind my hoop. Willowherb thread is altogether more delicate to twist, but with patience I made enough to weave my web.

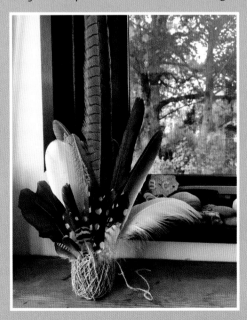

▼ *My nettle-string bird is a curious species born simply of using a ball of string to hold found feathers. Why not invite a similar bird to settle in your workspace? All it takes is a little imagination, a ball of string and some feathers.*

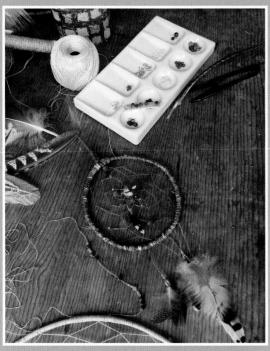

◀ Weaving 'dreamcatcher magic': natural elements strewn across my desk and resting on a china paint palette.

▼ Great spotted woodpecker feathers, caught as if drifting across my garden dreamcatcher. Mallard, pheasant, woodpecker and chaffinch feathers hang from the base of the hoop.

I couldn't resist incorporating just one sparkly element that I hadn't foraged from the garden: vintage glass seed beads, shimmery like the dew on the spiders' webs in the meadow. It was finicky work to thread them on to the willowherb thread before I began to weave. Having completed my web, I knotted more seed beads in place across it. The agrimony seeds were relatively easy to drill with my hobby drill, and fun, too. Next time, I thought, I will make a necklace and matching bracelet! I also chose two small feathers from a great spotted woodpecker to cast across it, knotting them in place, again, with willowherb thread. I threaded the cranesbill and campion seeds on to willowherb threads and knotted them securely to the base of the dreamcatcher, with feathers chosen from my nettle-string bird (see opposite). Finally, I threaded the hanging loop, also made from willowherb, with agrimony-seed beads.

I found deep satisfaction in making something from the earth that didn't cost the Earth; in fact, it didn't cost a penny. Making it afforded me the opportunity to daydream, too. As I worked, I pondered what creative expressions ancient humans might have made, born simply of imagination, ingenuity and the call of the wild.

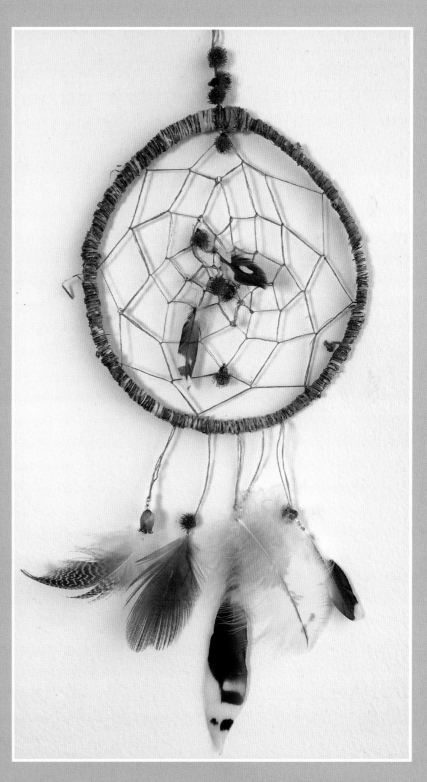

Newborough Warren dreamcatcher

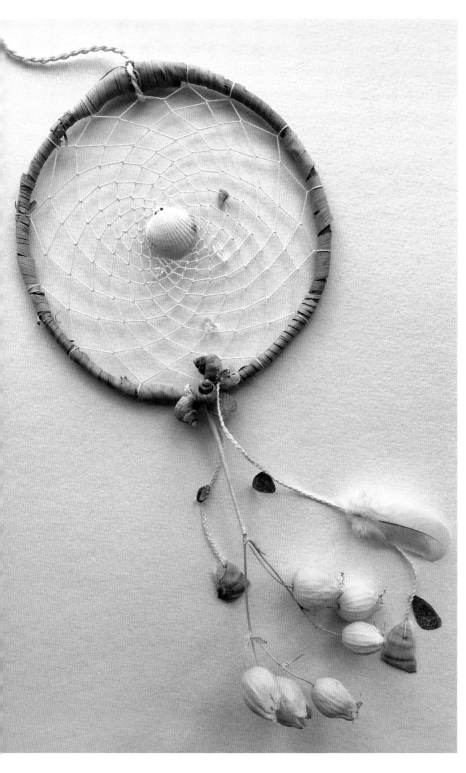

Life can be challenging. At times it can seem like a bad dream, leaving one feeling lost and exhausted. I always seek solace in nature. Even just a gentle stroll affords me time to think, freeing me from the physical constraints of the situation I am facing and the emotions that perplex me. The simple rhythm of my steps and the physical distance that I cover allow me to step through things mentally and gain perspective.

Sadly, my dear mother-in-law, Beryl, suffered from dementia and Alzheimer's disease during her last years, becoming increasingly dependent on those she loved. She lived many miles from us, and the journey there was debilitating in itself, every mile spent musing over the difficulty of the situation or anticipating the unexpected predicament that we would inevitably find her in when we arrived. Yet, as we journeyed, we would also reflect on the beautiful world that she had introduced us to before her decline: the fair island of Anglesey or Ynys Môn. We anticipated where we would revisit and explore when she was settled, the physical mountains that we would skirt, if not climb, in times of respite from climbing the emotional mountain of her situation.

Beryl knew many magical places, some of nature's most wonderful beauty spots. They were her playground as a child, and her solace as she grew older. There is a word in Welsh (that doesn't truly translate) to describe this special sense: *cynefin*, a place where a person or animal feels it ought to live and belong; where nature around you feels right and welcoming. These are the places that Beryl introduced us to. From time to time we would find our own way, too, discovering places that afforded us welcome, along coastal paths, in the valleys and up in the mountains.

To me, the greatest sense of respite and warmest of welcomes was always to be found along the gentle shores of Newborough, collectively known as Newborough Warren. Here, the marram grass grows tall and rare orchids flower in the spring, followed by fragrant dog

roses, heartsease, sea holly, bladder campion, kidney vetch … a 'tussie-mussie' of wild-flower loveliness. Moon-white wild horses that, I fancifully believe, look more like unicorns, graze among the dunes. Merlins, hen harriers and other birds of prey soar high above the sands and salt marshes, and rare waders find winter sanctuary there. Oh, and then there are the dragonflies, damselflies, hoverflies and solitary bees. More delightful still to me, reflecting like love itself in my eyes, are the butterflies that consider it their place, their *cynefin*.

There is a very particular spot, a sandy mile or so along the shore, where the nature around me does indeed feel just right. It does, too, to a long-established colony of uncommonly beautiful common blue butterflies. Like a cross on a treasure map, an emotional X marks this spot in my memory, just there, where golden flowers bloom radiantly even on grey summer days. Kidney vetch smothers the soft, slumping dune, guarded by ancient anthills, the home of ants with whom blue butterflies (of the family Lycaenidae) foster a symbiotic relationship. Horseshoe vetch and bird's-foot trefoil also thrive there, their equally vibrant yellow blooms adding to the lustre of the land. On sunny days, sapphire-blue butterfly wings sparkle above the dune like a heavenly constellation, their iridescence refracting the light like stardust. As summer and its blooms fade, the spirit of the adult butterflies returns to the blue beyond. Their offspring, entrusted to the dune,

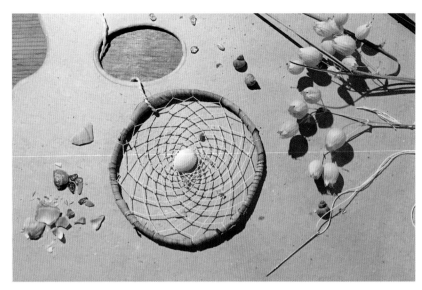

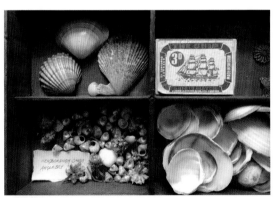

overwinter there as caterpillars, nestled beneath the sweet hay of broken-down plant stems and soft, downy seed, deep in hibernation among the ants, to emerge the following spring. Even in the depths of winter, the blue butterfly's beauty is tangible here, benignly haunting this special place of belonging, both theirs and mine.

I have woven something of this 'enchantment of place' into a dreamcatcher that now hangs above my studio desk. Perhaps it protects me from bad dreams and recollections of difficult times, and captures something of the light and love that sustained us, particularly nature's blessed sense of place.

The hoop is fashioned from willow, cut from a tree in Beryl's paddock, now re-rooted in our garden. Its origin is of particular significance to me and, therefore, to this dreamcatcher. I joined the overlapping ends of willow with smooth raffia, before binding the whole hoop with marram grass. The web is woven from vintage glove yarn, discovered by Beryl in her squirrel stash while we were tidying up together one day. This good daydream drifts through the dreamcatcher's weave as I work. Tiny chips of crystal attached to the web recollect the shimmering sea and sparkling sunlight, and a seashell picked up in the dunes rests at its heart. A stem of bladder-campion seed heads, its dainty cups once brimful of Anglesey sunlight, hangs from the base of the hoop, with a silver-grey feather and more seashells. Miracles such as the sparkle and light of butterflies in flight elude description, but tiny blue wings cut from hand-dyed silk paper remind me of their place, on the fair Ynys Môn.

▲ My dreamcatcher evolves, a needle threaded with the vintage glove yarn for the web resting among empty bladder-campion seed heads, fragments of seashell and chips of semi-precious stone. The blue butterfly wings are cut from handmade, hand-painted silk paper.

◄ Precious finds from Newborough Warren are treasured away in the sections of an old printer's tray.

◣ A confetti of elements used in the making of the Newborough Warren dreamcatcher.

Owl eulogy dreamcatcher

The process of making this dreamcatcher was a soulful experience. The piece was inspired by a beautiful owl who stole my heart one evening and broke it before the following dawn.

Walking our familiar route along country lanes close to home, Neil and I noticed an unfamiliar form ahead of us. It was stumbling, lifting a few inches off the ground, then faltering and falling. My pulse quickened with our pace as we hurried along, concerned and perplexed. What could it possibly be? My heart skipped a beat when we realized that it was a barn owl, so extraordinarily beautiful as to be almost not of this Earth.

Clearly, all was not well. Disorientated and afraid, the owl continued her desperate dance back and forth across the road. She seemed to be carried on angel wings that spanned at least 35 inches (90 cm). I was utterly awed by her presence and anxious to preserve her life. My greatest fear was the road, since occasionally cars pass at great speed along this particular stretch, with no thought for human or owl. As walkers, we often fear for our safety; our fears increased tenfold for this vulnerable creature.

As calmly as possible, we shadowed the owl's movements before gathering her up in my fleece. With her wings bent gently to her sides and her long, feathered legs dangling loosely, we could now gaze into her eyes: oblique, feather-lidded, long and narrow, black as night, deep as eternity, set in the softest, moon-white, heart-shaped face. Having sought advice, we proceeded to carry her the short distance home. I remember thinking that she was as light as my breath, which was anxiously held as I cradled her. We settled her in a protected place, praying that she would be safe until morning, hoping beyond hope that we might find her recovered on our return.

Much to my sadness, that was not the case. Still as the moon itself, her face no longer radiated life. Her perfectly plumed body lay immobile. Her night-black eyes had closed tight long before dawn. I laid her to rest beneath the silver-birch trees in our garden, and retreated to my studio to mourn.

Seeking comfort in creativity, I began to weave a dreamcatcher as a form of eulogy. I bound the hoop with silver-birch bark, peeled carefully from the trees beneath which I had laid the owl to rest. As I worked, I marvelled at how similar the soft, silvery-tawny tones of the birch are to the feather tones of the barn owl. I chose a soft cream linen thread, and threaded on to it moonstone teardrop beads and drilled amber and tiger's-eye chips before anchoring it to the top of the hoop. As I wove, the thread carried my thoughts, and the emerging pattern soothed my distress. I reflected on the beauty of the owl, the privilege of encountering her and the opportunity I had had to help. Little by little, I came to accept the fact that truly rescuing her had not been within my gift.

When I reached the centre, I remembered an agate cabochon that had been tucked away in my 'treasure chest' for years. It held the warm tones of the owl's plumage, with streaks of black and luminous moon white. And so there it rests, at the heart of my dreamcatcher. I carefully stitched speckled-wood butterfly wings of hand-painted and embroidered silk to the web at intervals. The speckled wood is a species of the woodland margins where owls hunt for prey, so its wings are meaningful in this context. They are also symbolic, for butterflies have been synonymous with the soul since ancient times, and are believed to carry it from this world to the next.

To finish, I threaded on to the base of the dreamcatcher a sparrowhawk feather and two precious barn-owl feathers, which I had discovered in a local tithe barn. I decorated them with chips of semi-precious stone and fragments of bark coloured teal blue by fungi.

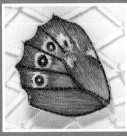

▲ The agate cabochon (top) at the centre of the web, and one of the hand-painted, embroidered speckled-wood butterfly wings caught across it, secured with a single stitch.

▶ My eulogy to the barn owl: rescued at dusk, lost before dawn. The poignant memory of happening upon this angelically beautiful bird is forever woven into my dreamcatcher.

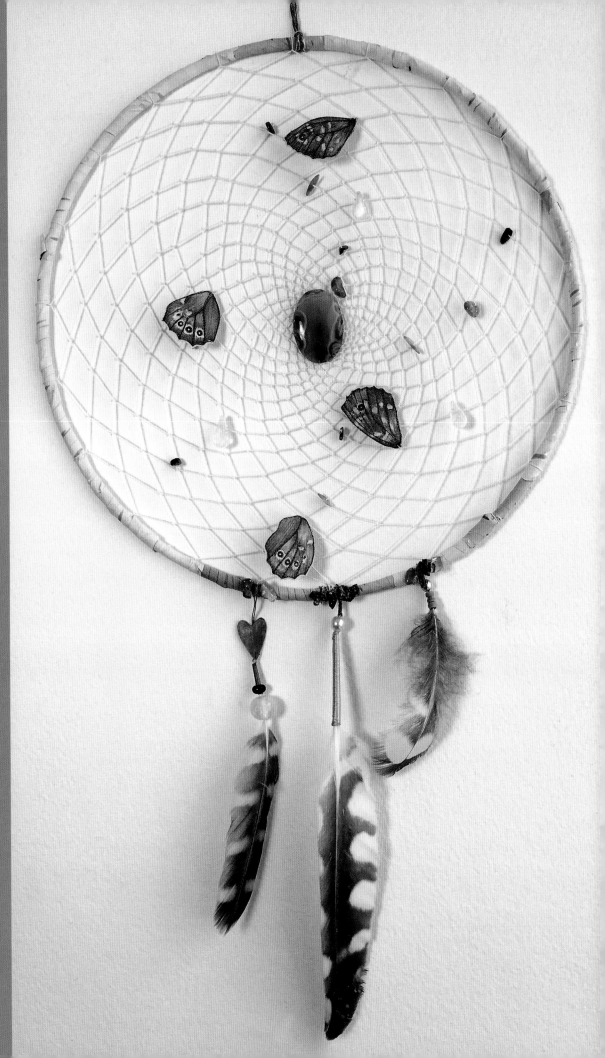

Notes to nature

Since childhood I have felt tangibly close to nature. While I was pondering how to translate this feeling into words, the phrase 'in communication' came to mind. It may be a little stilted, but it is literally true, and its dictionary definition – the imparting or exchanging of information by speaking, writing or using some other medium – pertains to nature and me. I have talked to nature, and written to it, regularly for as long as I can remember.

I have very early memories of playing out imaginary scenarios in the garden, chatting away to the birds and the trees. I believed they were chatting back in melodies of song or the whisper and rustle of leaves.

I would lay picnics for fairies and songbirds, inviting them to tea. From time to time I would even invite them formally, posting little notes into garden hedges on the way to school, generally accompanied by a crumbled biscuit. Often, too, I would write just to say 'I hope you are OK.' No wonder grown-ups used to call me 'a funny little ossity'. Many of my friends and family still know me as that.

Although my nature writing now generally takes the more sophisticated form of diary entries and sketchbook doodles, and my conversations and observations of nature are these days more artistic and literary, I still see myself as a child of nature at play, in communication with the wonderful natural world about me, and writing, conversing and finding creatively mindful ways of connecting both to nature and to myself.

With practice, one can also learn to read nature's always prompt, often eloquent, responses. When my eyes light upon a feather resting on a leaf, say, or a summer wild flower blooming in winter, they read to me as nature's poetry, as love letters from Mother Nature. I see the feather and imagine the bird from which it drifted, feeling the breeze that carried it. I see the wild flower and sense the vibrancy and warmth of summer in the hue of its petals,

My drawing desk is strewn with love letters and notes to nature. Natural finds make three-dimensional 'postcards' that I read as if they were posted to me by Mother Nature herself. They recall happy times exploring the wonderful wild.

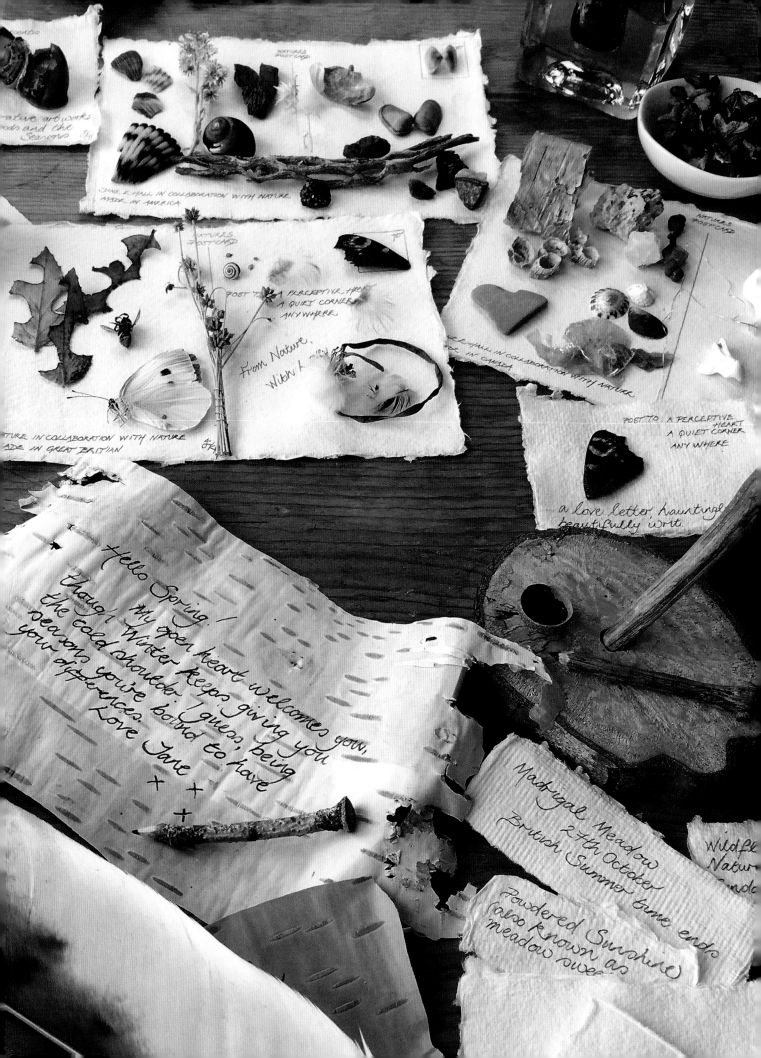

Nature artworks
...ods and the
Seasons 5/4

NATURES
POST CARD

SANDE HALL IN COLLABORATION WITH NATURE
MADE IN AMERICA

NATURES
POST CARD

POST TO A PERCEPTIVE HEART
A QUIET CORNER
ANY WHERE

From Nature,
With Love

...TURE IN COLLABORATION WITH NATURE
...DE IN GREAT BRITIAN

NATURES
POST CARD

...E HALL IN COLLABORATION WITH NATURE
... IN CANADA

POST TO A PERCEPTIVE
HEART
A QUIET CORNER
ANY WHERE

a love letter, hauntingly
beautifully writ

Hello Spring!
My open heart welcomes you,
though Winter keeps giving you
the cold shoulder. I guess, being
seasons you're bound to have
your differences.
Love Jane
x x
x

Madrigal Meadow
27th October
British Summer time ends

Powdered Sunshine
(also known as
meadow sweet

Wildfl...
Natu...
...nda...

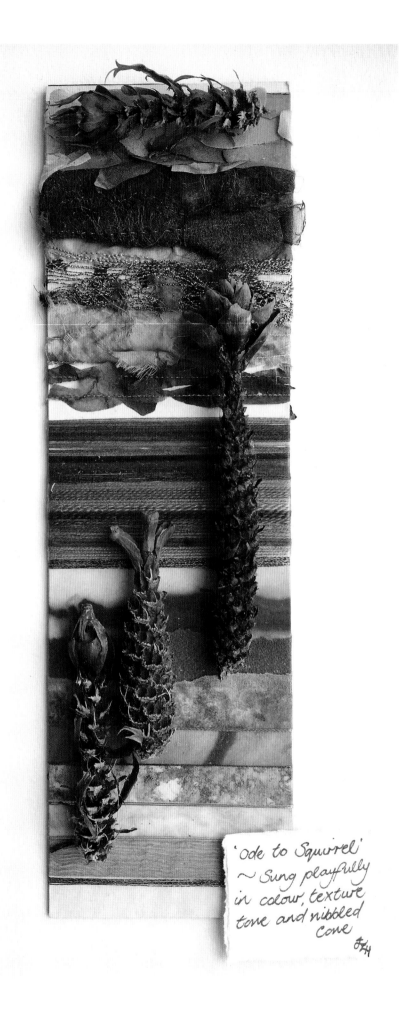

'Ode to Squirrel'
~ Sung playfully
in colour, texture
tone and nibbled
cone
JH

rainbow-bright, arcing across the seasons, promising that warm, sun-kissed days will return. These messages are like blessings to me. Relaxing into a sense of nature's beautiful, benign energy is perhaps one of the most precious human experiences. It is as simple as paying attention, looking at nature through bright eyes, lovingly and playfully.

Alongside receiving or, should I say, 'perceiving' postcards from nature and responding in kind, I fashion my responses creatively using the language of colour, texture and tone, through the simple device of wrapping a card or creating a swatch. For instance, my 'Ode to Squirrel' explores the light, colour and textures of the woodland wherein I discovered several unmistakably squirrel-nibbled pine cones. 'Stanza to Spring', wrapping a card with silks in the shades of an orange-tip butterfly, creatively celebrates my first butterfly sighting of spring.

Perhaps it is not too grandiose to boast that having studied fine-art embroidery and practised art for more than thirty years, I speak more than one language fluently: English and art! Perhaps all any artist aspires to do is to become more fluent at communicating their inspiration.

Here I share a handful of nature notes, letters and responses, and urge you to consider being in communication too.

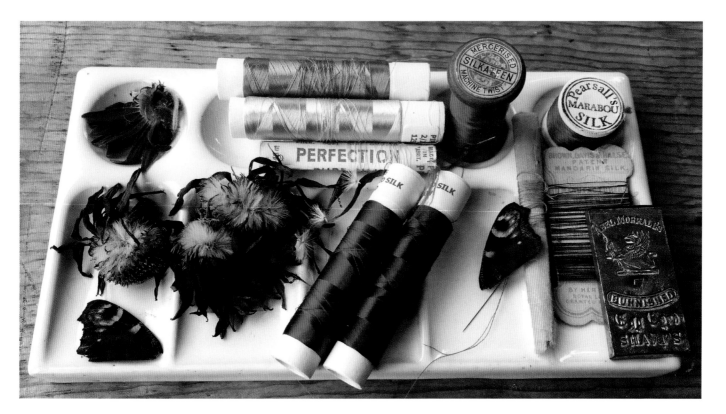

▲ A china palette holds natural elements and silk threads that describe the beauty of the peacock butterfly as eloquently as words.

◄ 'Stanza to Spring' is a simple piece of card, wrapped with silk threads, describing the exquisite colouring of an orange-tip butterfly's wings. Male orange-tips are among the first butterflies to emerge from their chrysalises each spring. One of nature's many small miracles, they overwinter as pupae, their metamorphosis from caterpillar to butterfly having begun the previous June or July.

Nature's writing set

Like a giddy adolescent, taking a juicy, ripe blackberry between my finger and thumb one day, I wrote 'Jane loves Neil' on a smooth, warm pebble beside the pond. Blackberry ink is a wonderful thing! Writing with it is as simple as crushing a berry and dipping your nib, be it pen nib, quill or sharpened stick. (Although, if you want your love for someone or something to be indelibly writ, your blackberry ink will require the addition of a fixative or mordant.)

There are a good many 'natural' pigments out there in the wonderful wild, from blackberries to avocado stones. Experimenting is the epitome of creativity, and foraging mindfully for juicy, ripe berries, shaggy ink-cap mushrooms or all manner of other wildly wonderful things is the very ethos of this book. Space does not allow me to explore such alchemy here, but there is a good deal of information online and in print.

I find playfully gathering bright berries and leaves, and picking up a smooth pebble in lieu of a pestle – effectively 'squish and scribe' – very efficacious in creative terms and a wonderfully gentle emotional diversion. I encourage you to have a play, even if by simply declaring your devotion in blackberry ink on a stone.

'Lay aside your cloak, O Birch-tree!', as Henry Wadsworth Longfellow put it so picturesquely in The Song of Hiawatha.

YOU WILL NEED

Pen You can use a purchased dipping pen or quill (I have several, including an elegant glass dipping pen that I love writing with), but fashioning pens by sharpening sticks, cutting found feather quills or snipping plant stems not only is immensely rewarding, but also connects one more closely with nature.

Ink 'Ink' can be made from berries foraged while out walking, or even from fungi; certain mushrooms make excellent ink (of course, be careful not to ingest any part of a foraged mushroom). I often use crushed blackberries, although their pigment requires a fixative to remain permanent.

Paper Any smooth 'leaf' of paper will suffice: a sycamore or dock leaf, perhaps, or, better still, a peeling sheet of paper-birch bark (*Betula papyrifera*) yielded by the tree. I have experimented with fresh leaves, but they bruise rather easily, so you will need to press or dry most leaves before you can write on them fluidly. Birch bark is ready to scribe on, although you may have to dust the powdery green mould from its surface. Do please remember not to cause undue disturbance to insects such as ladybirds or earwigs who may be using the very same sheets of silvery bark as bedsheets!

Lay aside your cloak, o Birch-tree!
Lay aside your white-skin wrapper—
For the Summer-time is coming,
And the sun is warm in heaven
And you need no white-skin wrapper—

▼ Ripe, juicy natural finds are gathered on a china palette, and blackberries are crushed with a smooth, round stone into a dimple dish.

▼▼ One bleak winter's day, it seemed to me that every gentle, fragile thing was being given the cold shoulder by Jack Frost. I therefore determined to write a gentle love letter, addressing both Mother Nature and myself. Snowdrops contain antifreeze proteins, which protect their cells from frost damage. How 'cool' is that?

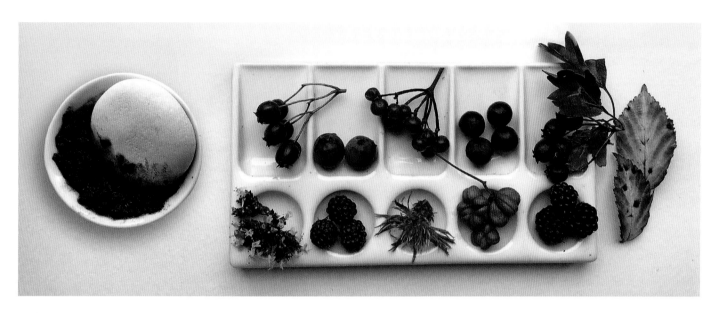

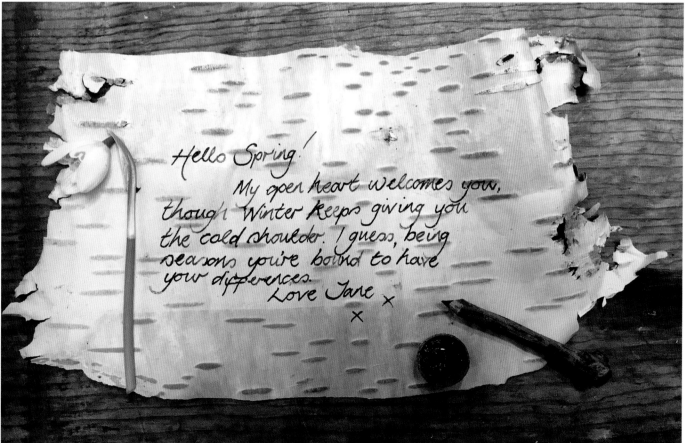

Love letter
to the purple emperor

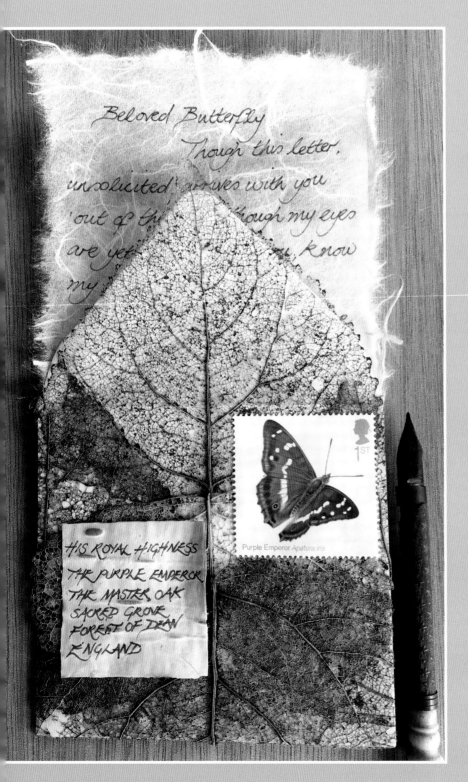

Beloved Butterfly

Though this letter,

unsolicited, arrives with you

'out of the ... though my eyes

are yet ... you, know

my ...

HIS ROYAL HIGHNESS

THE PURPLE EMPEROR

THE MASTER OAK

SACRED GROVE

FOREST OF DEAN

ENGLAND

Purple Emperor Apatura iris

1ST

The beauty of the purple emperor, as elusive as the rainbow's end. Many's the time I've gazed wistfully up into the canopy of ancient oaks, longing to glimpse a flash of rainbow-blue, a flicker of iridescent purple, the flutter of a purple emperor's wings patrolling his elevated kingdom. Alas, thwarted and lovesick I remain! This little letter pinned up in my studio proclaims that love. Maybe it failed to be delivered because I addressed him inappropriately. It occurs to me that it should perhaps be 'His Imperial Majesty' rather than 'His Royal Highness'. But then, he does live much of his life high in the treetops.

The envelope

Imaginatively speaking, enveloping my love letter in a leaf was designed to expedite its delivery to the tops of the oak trees where purple emperor butterflies play out their courtship and feed on honeydew and tree sap. Of course, these skeletal leaves are of the under-canopy, too, ensuring that, should His Royal Highness descend to the ground to indulge his somewhat less seemly tastes (for droppings and other unspeakable detritus), my love letter would still reach him. Simply wrapping skeletal leaves, faintly brushed with glue, around a handmade envelope achieved this effect. It being impossible to address His Royal Highness clearly over delicate, skeletal leaf veins, an address label cut from silver birch presented itself as a perfect solution. What luck that limited-edition stamps, designed by the talented Richard Lewington, were issued by the Royal Mail that very year!

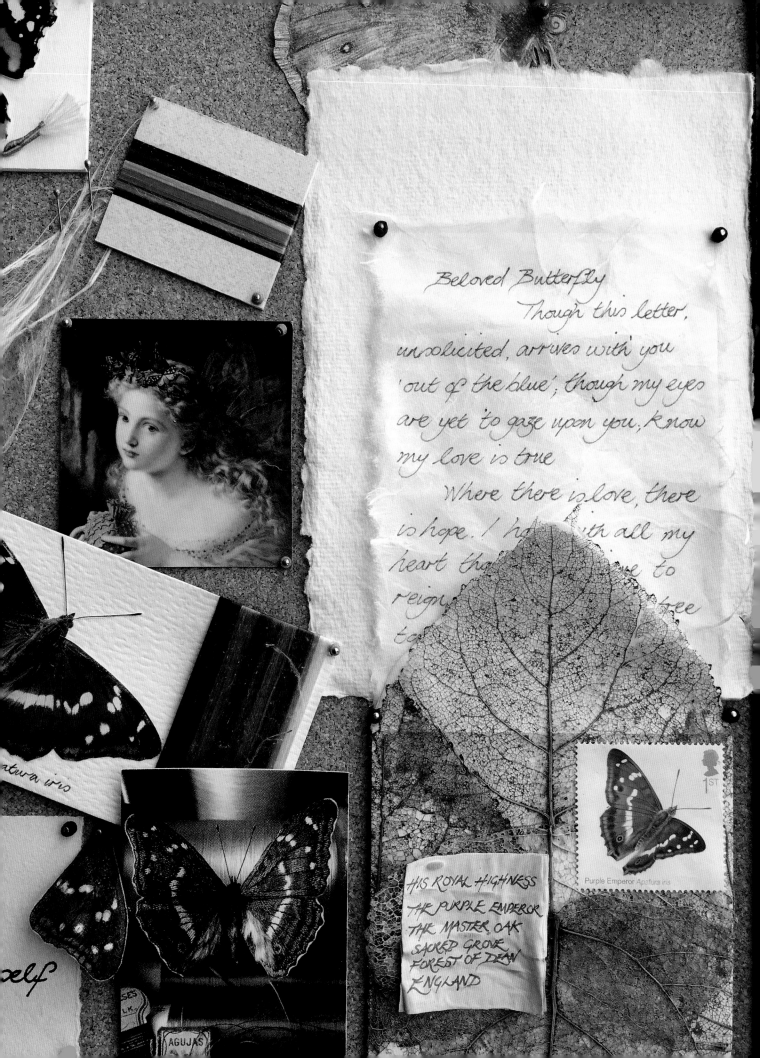

Beloved Butterfly

Though this letter, unsolicited, arrives with you 'out of the blue'; though my eyes are yet to gaze upon you, know my love is true

Where there is love, there is hope. I ho... ...ith all my heart tha... ...ve to reign... ...ee ta...

HIS ROYAL HIGHNESS
THE PURPLE EMPEROR
THE MASTER OAK
SACRED GROVE
FOREST OF DEAN
ENGLAND

Purple Emperor Apatura iris

1ST

Postcards
from nature

The simple process of resting precious natural finds on a piece of card or handmade paper and taking a picture or drawing the composition – a snapshot both of time and place, annotated with a few words – is a gentle joy. Perhaps in the grand old tradition of writing postcards, all that one need say is: 'Having a lovely time, wish you were here.'

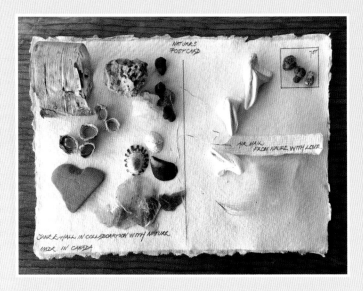

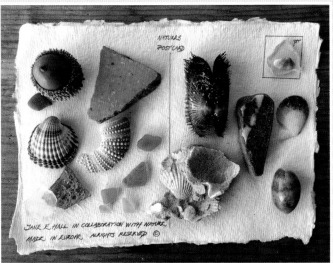

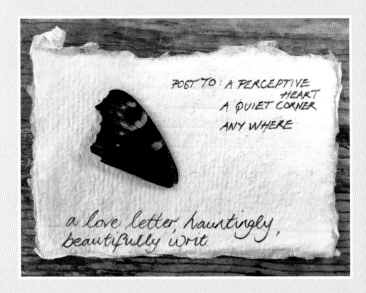

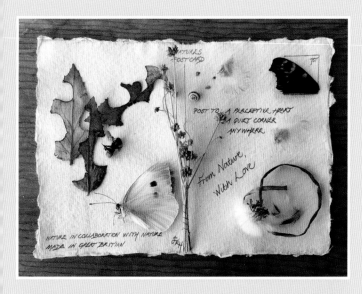

NATURES POST CARD

POST TO... A PERCEPTIVE HEART
IN A QUIET CORNER
ANYWHERE

From Nature,
With Love

NATURE IN COLLABORATION WITH NATURE
MADE IN GREAT BRITIAN

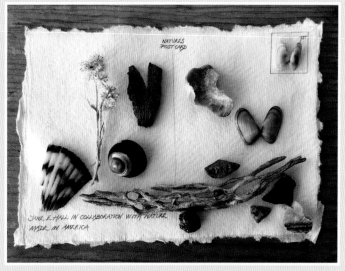

NATURES POST CARD

JANE E HALL IN COLLABORATION WITH NATURE
MADE IN AMERICA

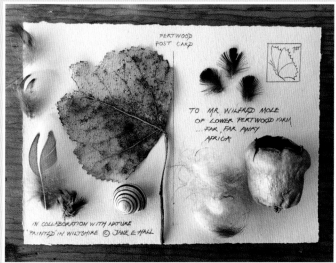

PERTWOOD POST CARD

TO MR WILFRED MOLE
OF LOWER PERTWOOD FARM
...FAR, FAR AWAY
AFRICA

IN COLLABORATION WITH NATURE
"PRINTED" IN WILTSHIRE © JANE E HALL

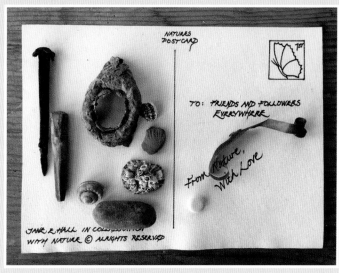

NATURES POST CARD

TO: FRIENDS AND FOLLOWERS
EVERYWHERE

From Nature,
With Love

JANE E HALL IN COLLABORATION
WITH NATURE © ALL RIGHTS RESERVED

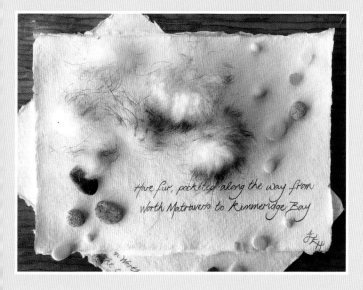

Hare fur, pocketed along the way from
Worth Matravers to Kimmeridge Bay

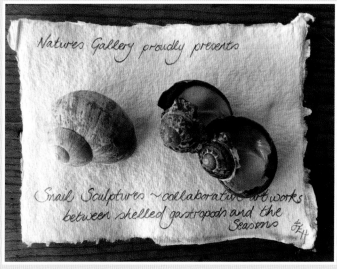

Natures Gallery proudly presents

Snail Sculptures ~ collaborative artworks
between shelled gastropods and the
Seasons

Nature's haberdashery

Once upon a time, when I was about six, my sewing needles were mostly made of pine, gathered from beneath the 'needle tree', a giant Scots pine growing at the bottom of the garden, rooted there for well over a hundred years. Up and up it climbed, higher than Jack's beanstalk, although I was never a climber, content to play beneath it. Since I was tiny, it seems I've not had to reach far to access the playful realms of imagination and creativity. There was a spindly stand of young oak and hazel trees in the far corner of the garden, too, and this was another favourite place to play, providing plenty of leaves for me to stitch and pin together with my special needles.

This formative time in nature's playground undoubtedly influenced how I grew up and who I grew up to be: an artist and writer, inspired by nature. Yet I am still a child at heart. I find playful joy in all manner of creative pursuits, remembering and reliving those days, playing in the garden.

A certain valuable knowledge of the natural world has grown with me, and, like Jack's beanstalk, it just keeps growing and growing. I have learned that nature generously provides all manner of materials to play with, both found and fashioned, from pine needles and leaves of paper to willowherb cordage and thistledown paper. I have also discovered perceptions of nature that play to my imagination. I am fascinated by folklore and fairy tale and their many associations with the natural world.

Through nomenclature, folklore suggests a whole haberdashery of materials discoverable in nature, if not literally then perceptively. There are wild flowers known as 'billy buttons' (*Althaea officinalis*), and 'Robin's pincushions' (also known as rose bedeguar galls) are attributed to a woodland sprite called Robin Goodfellow, but actually made by gall wasps. These beautiful, mossy galls tinted a soft pink are formed on wild roses by the larvae of a tiny wasp, *Diplolepis rosae*, causing no harm to the host plant. The common wild flower herb Robert is also known as 'Granny's needles' or 'Granny's thread'. Country folklore opens up a world of creative, imaginative possibilities.

What better place is there when we are shopping around for inspiration than nature's store of possibilities, the haberdashery department in particular? It is great restorative fun! Having piqued one's curiosity, a 'shopping expedition' in search of needles in nature, particularly for an embroiderer such as myself, is as much if not more fun than searching for an old-fashioned haberdashery on the high street. Indeed, in today's world one is likely to be disappointed in pursuit of the latter. Finding a pine tree is by far the easier goal. A handful of

The booty of a shopping trip at nature's haberdashery.

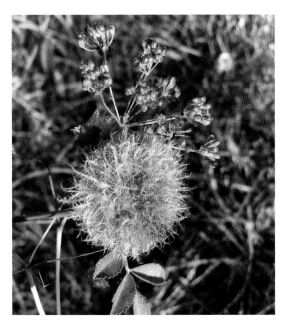

pine needles and several handfuls of leaves later, I have the makings of a natural shawl – as could you. Just imagine what finery you could fashion, and what fun you might have!

If shopping for pins and needles does not satisfy, venturing out in search of lacework may. It might prompt you simply to admire nature's finery, or to consider more curiously the wildly talented artisan who fashioned it: the plume moth, perhaps, or the leafcutter bee.

You may consider making something of your finds, a mandala, perhaps, or an interpretive creative study. Once, I made pine needles from silk-covered wire, and 'stitched' together silk oak leaves into a stole. The possibilities are endless, as is the depth of one's imagination; just stand on the shore and look out across your own beautiful sea of creative possibilities.

◀ *Robin's pincushion, or rose bedeguar gall, formed by a tiny wasp laying her eggs in the bud of a dog rose.*

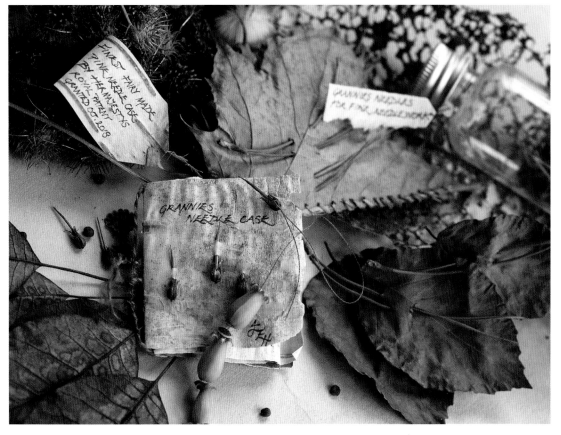

Will you sew imaginative ideas with your natural needles, or simply cherish them just as they are?

Nature's lacemakers

Beetle larvae (I assume), working as deftly as human lacemakers, have created a lacy dock-leaf doily, most suitable for fairies' tea parties!

I have always loved lace. It is one of the first materials that I remember playing with creatively as a child. A rudimentary run of stitches along the top of just a few inches, gathered around a dolly's waist, made a skirt fit for a queen. A yard could dress an entire party of peg dolls. I even learned to make bobbin lace at secondary school, although I did it very badly, since it was far too complicated for a daydreamer like me; for bobbin lace one had to do things properly, rather than playfully. I still treasure the lace bobbins I practised with, though, in particular one that my teacher beaded for me. I also have beautiful lengths of vintage lace, and lacy family heirlooms, treasured away in my plan chest for rainy days.

However fine these particular lacy treasures may be, in my eyes there is no lace finer than that to be found in nature's haberdashery, from Queen Anne's lace (another name for the wild carrot), with its frothy flower heads, to the exquisite tracery of insect-nibbled leaves. One could say that they have great taste, with their miniature mandibles, cutting all kinds of pattern into all kinds of leaf (although each favours particular species). Certain beetles can make even common dock leaves look pretty. There is joy in growing to understand these maker's marks, so to speak; increasingly, I say to myself: 'I wonder which species nibbled these.' I cannot be sure if it was a plume moth caterpillar or the offspring of the convolvulus hawk moth, but once I discovered a bindweed flower, nibbled in the bud, which opened out into an exquisite *broderie anglaise* collar.

The exquisite work of an insect lacemaker.

MAKING
Grandpy Light's beads

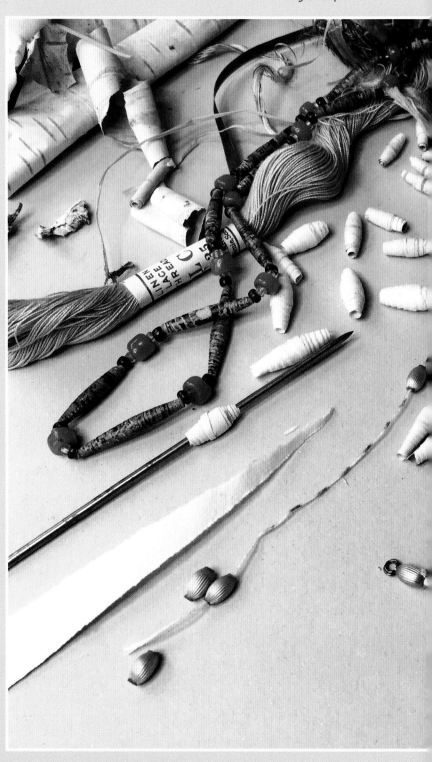

The makings of birch-bark beads, and finished beads strung with turquoise and red glass drops.

Among my most valued treasures is a string of paper beads made from empty cigarette packets. It was made by my great-grandfather, who was affectionately known as 'Grandpy' Light, while he was recovering from being gassed during the First World War. Much like the theme of this book, the pursuit of calm, meditative work, such as embroidery or beadwork, was considered to provide significant therapeutic benefits. The practice of 'lap crafts', as they were known then, helped to rehabilitate fine motor movement and coordination, to abate the painful tics associated with shell shock and, in occupying the mind, to soothe anxiety and melancholy. Whenever I come across Grandpy's beads today and am in a somewhat melancholy mood, I think about how much he, and heroes like him, suffered and sacrificed to ensure peace, and I reflect on the continuing sacrifices made by members of our armed forces and peacekeepers. Settling these special beads around my neck, I instantly feel profoundly grateful for love and for life.

As I was playfully peeling the papery bark from a silver-birch tree one day, I watched as a small piece curled up in my hand to form a bead, just like Grandpy's. Thinking of him, I returned to my studio feeling inspired and blessed. There, I studied his beads more carefully than ever. When I held them under my magnifying lamp, I could plainly make out letters. Unfaded against the sepia-toned card of the cigarette packet, they disjointedly but poignantly read 'Award' and 'harm'. They inspired me to make my own beads, carried on a wave of creative freedom born of love and peace.

Undoubtedly, my first birch-bark-bead necklace will not be my last; why, I may even go on to make a whole curtain. The joy of creativity is its limitless sense of possibility!

YOU WILL NEED

Silver-birch bark (a little goes a long way)

Cutting mat

Ruler (ideally metal)

Small craft knife

Small spatula

PVA glue

Knitting needle or skewer

Length of embroidery thread or string

Embroidery needle (for stringing the beads)

Other beads; metal clasp or wire to make a simple clasp (optional)

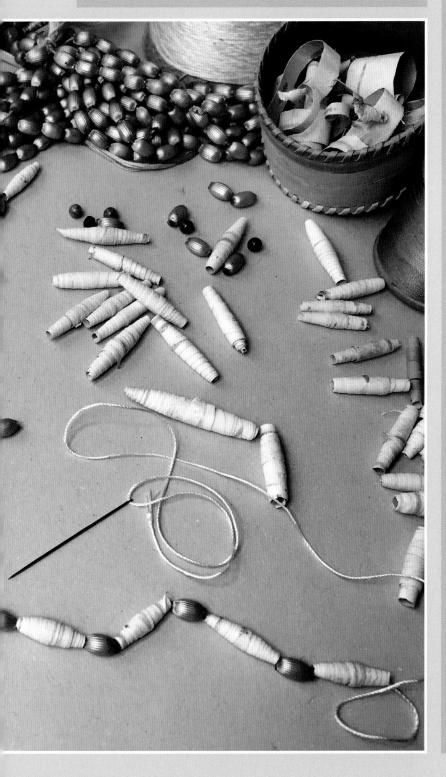

STEP 1

Gently peel a smooth, papery sheet of bark from a silver-birch tree. Be careful not to disturb earwigs and any other creatures that may be sleeping 'between the sheets'. Take a peep, and if an insect is snuggled in, choose a more unmade bed, an area where the bark is hanging more freely from the tree.

STEP 2

To create the tapered ends of each bead, smooth the sheet of bark out on the cutting mat. Holding it there with a ruler, tear off an elongated triangular fragment, like a miniature pennant, about 1 inch (2.5 cm) wide and 6 inches (15 cm) long. A small craft knife will help if tearing proves difficult. As in the case of many crafts, practice makes perfect. The fragment may begin to roll itself up as it breaks free along the ruler's edge, but that's OK; you can re-roll it properly later. Along from the first torn edge, tear or cut another triangular fragment, then another, to make as many triangles as you require beads.

STEP 3

Now to fashion your beads. You will need to apply a little glue to the back of each triangle as you work. I find that a spatula cut from birch bark makes a wonderfully flexible tool; equally, a plastic one will suffice. Starting with the wide end, roll each bark triangle around a knitting needle or skewer to form a little cylinder. Far from finding this a repetitive, dull activity, I find it a delight to, quite literally, 'turn out' each bead; it's a gentle, meditative process, just as my dear Grandpy was advised by the hospital staff. Carefully slide each bead off the needle or skewer as you finish it. In what feels like no time at all, you will have enough to string a necklace.

STEP 4

When it comes to stringing your beads, there is a world of creative possibilities. I chose to string mine alternately with some beautiful vintage coppery-pink glass beads, but you could use drilled natural elements such as seed heads or acorn cups. Then, to finish my necklace, I fashioned a simple wire clasp, just as Grandpy Light did all those years ago.

Billy buttons

Mallow seeds are among my very favourite to collect. They form inside little round fruit known as 'cheeses', collectively referred to as nutlets. That's lovely to begin with! Lovelier still are the exquisite 'buttons' that secure the nutlets inside the cheeses as they ripen, giving rise to the folk name of mallow: 'billy buttons'. Furthermore, I have learned that mallow roots were once enjoyed as a vegetable – a dish that was said to have given the great Cicero indigestion! (Perhaps that brought about its culinary demise.)

Mallow has been used to treat hangovers and protect against aches and pains. It has been decocted into love potions and, conversely, administered to cool ardour and calm conduct. It is also traditionally made into an ointment to draw out stings and soothe irritated skin. Bless its buttons, it is a marvel, not simply a mallow. My new-found whimsical wisdom and herbal know-how have induced me to love it all the more. Hang on, did I get some mallow sap on my fingers? I'm actually feeling rather calm, and I've lost my aches and pains, too!

My collection of billy buttons.

Natural notions for making nature's bead necklaces: willowherb thread and a beautiful assortment of 'beads'.

Seed beads:
Miss Wilmotts ghost (blue bugles)
Allium (flower beads)
Campion
Mallow
Billy button

My collection of natural bead necklaces, buttons, a leaf needle case, Granny's needles, burdock-burr (Arctium tomentosum) pincushion and willowherb thread.

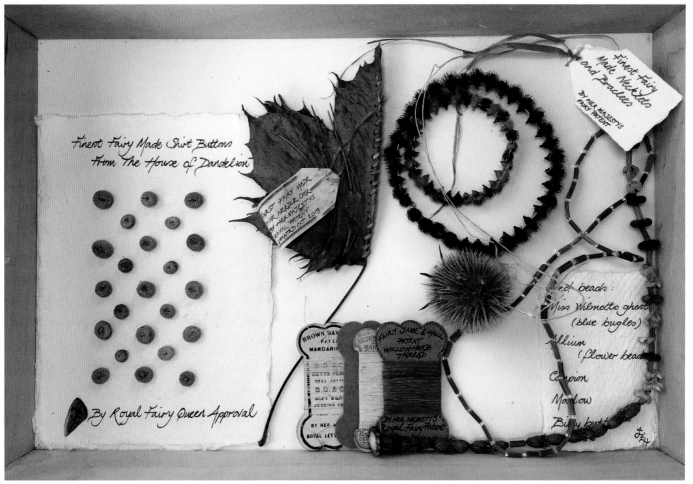

Finest Fairy Made Shirt Buttons from The House of Dandelion

By Royal Fairy Queen Approval

Seed beads:
Miss Wilmotts ghost (blue bugles)
Allium (flower beads)
Campion
Mallow
Billy button

MAKING
Fairy money purse

This purse is esential for storing fairy money to spend in the wild, and useful while shopping at nature's haberdashery. One of my (many) favourite wild flowers is honesty. Not a native of the United Kingdom – originating instead from southeastern Europe – it is truly wild at heart, but over the centuries it has endeared itself to every wild corner of the British Isles.

This tall plant with attractive purple flowers is known best for its silvery, translucent seed pods, recognized by many as silver coins. In South-east Asia it is known as the 'money plant', in the Netherlands as 'coins of Judas' and in France as *monnaie du pape*, 'Pope's money'. In the United States it has gained the name 'silver dollar'. Its English name, honesty, is by contrast derived from the moon-white seed pods, which reveal the seeds within.

Honesty's value as fairy money was unknown to me until relatively recently. It was first shared with me by a dear little girl, who was visiting the Fairy House with her mother and grandma for the very first time. Her little face beamed with delight as, with a fairy-tale creak, the heavy oak door swung open, revealing a 'small fortune' concealed inside. 'Mummy, look,' she exclaimed. 'Look at all the fairy money!' Her eyes danced across the room; it was everywhere! Papering the walls, hanging from the ceiling, standing tall in vases, resting in baskets by the fire …

She could barely contain her excitement. She had, of course, promised that she would be very good and not jump up and down or touch anything. Ah, that age-old parental caution. Needless to say, I melted and would have bestowed the whole fortune on her, but her mother said: 'Just three purses.' I recall the joy of watching her tiny fingers open the purses in the meadow, spending the 'money' to grow into flowers for the butterflies, bees and fairies to delight in during the summers to follow.

An honesty plant has gone to seed. Here, many of the prized silvery moons are still covered by their opaque outer membranes, protecting the 'seed money' within.

So, having discovered that money really does grow on trees (well, plants), I determined to fashion a purse to stash it in. This money is particularly valuable, since it does not only pay dividends imaginatively and creatively speaking. The plant itself is a valuable early source of nectar and a larval food plant of moths and butterflies, orange-tips in particular.

It grows like fun in our wildlife garden, because we've cast a wealth of its seed over the years. I've used the discarded seed pods creatively in various ways, covering trinket boxes and tea-light jars and decorating wrapping paper. I have covered an old oil lamp, which now seems to glow even when it's not lit, and papered an entire wall of the Fairy House. Surely few can boast of having walls papered with money.

One day, while pondering the disappointment of single-use cellophane card bags, it occurred to me that even they could be reimagined, and the idea of a purse for fairy money was conceived.

▶ *I delight in these little purses. Hung against my studio windows, they catch the sunlight beautifully, although, in all honesty, they rarely hold any fairy money. I prefer to invest it in our wildlife garden and watch it grow. These little purses full of sunshine have the added value of discouraging bird strikes.*

The American historian and man of letters Henry Brooks Adams is quoted as saying 'Chaos was the law of nature; Order was the dream of man'. I often find myself proclaiming this out loud when I find myself in a state of creative chaos – but who could mind with natural materials of such beauty as these?

YOU WILL NEED

Handful of honesty seed pods

Flexible spatula (I prefer to fashion one from soft birch bark, but a plastic one will do)

PVA glue

Cellophane greetings-card sleeve

2 button-shaped seed heads (I used mallow, but poppy seed-head tops would do nicely, as would simple discs of heavy paper or card)

Plant fibre, raffia or natural twine

Piece of wire

Birch-bark beads (see page 86) and seeds (optional)

A NOTE ON HONESTY

Honesty, Lunaria annua, is a hardy annual or biennial. I urge you to grow some if you have garden space. Far better to grow your own than to buy it or gather it from the wild. That way you can enjoy the beauty of the plant, with its pretty purple or white flowers and heart-shaped leaves, and delight in the nectar-feeding insects that visit and the orange-tip caterpillars you may find feasting on it.

STEP 1

If you are able to grow it, or fortunate enough to find it in the wild before the seed pods (siliculae) ripen fully, you'll notice that the seed, or 'fairy money', is actually tucked away between three purse sleeves. These consist of two opaque outer membranes, or 'valves', with a translucent membrane in the middle. It is the inner, translucent layer that we require for our magical fairy purses. The outer layers gradually fall away in the wild, although, particularly when the stems are gathered in early, they often need coaxing. Peeling these layers apart adds to the fun – a gentle, creatively meditative process in itself.

STEP 2

Use the spatula to glue the layers on to the cellophane card sleeve; go very gently, because they are very delicate. I often dilute the glue slightly so that it is easier to glide across the surface of the pod. Overlap the discs carefully, enjoying the emerging scaly pattern, reminiscent of a mermaid's scales or a moon dragon's tail. In a daydream or two, you will find you have covered the entire sleeve. Remember to include the flap, which will become the tongue of the purse.

STEP 3

The purse is closed with a seed-button fastening. Stick one seed head to the tongue of the purse, an inch or so above the edge, and another opposite it on the main body of the purse. Trap a short length of plant fibre, raffia or twine under the top button, to create a simple tie fastening. Secure the purse by simply wrapping the tie around both buttons in a figure of eight.

STEP 4

The handle is formed from a length of wire (for a sturdier look) or plant fibre, raffia or twine strung with birch-bark beads and seeds. Thread it through the sides towards the top of the purse and knot it securely.

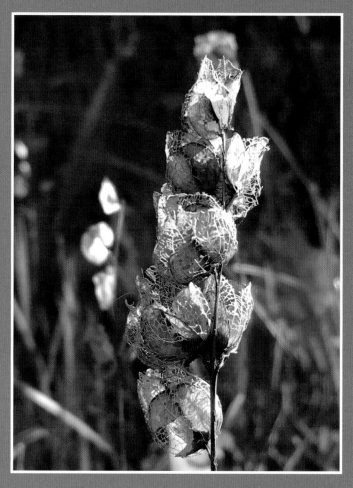

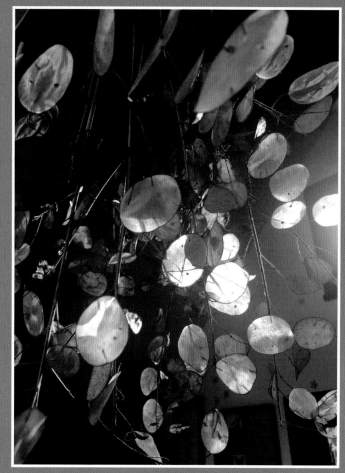

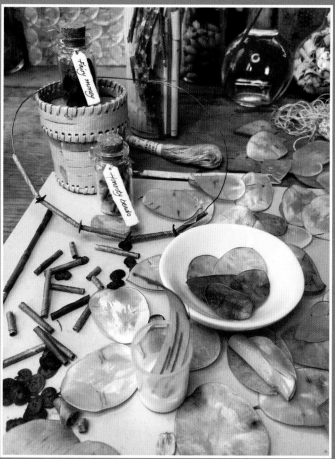

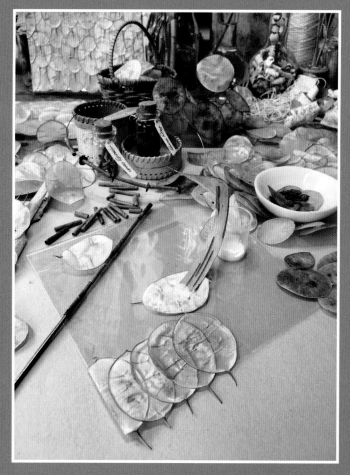

Nests

irds are among nature's finest artisans. They construct their nests so skilfully and secretly as to convince me that there must be fantastical, invisible threads woven into each and every one.

I watch in wonder when birds skip or fly by with their beaks full of moss or grasses, or as they incongruously steer twigs through the air on journeys back to the treetops, thickets and hedges. Of course, it is commonly understood that birds build nests, so one need not wonder what they are up to, but how they construct their homes and where they choose to build them is a constant source of fascination to me, not to mention sheer wonder.

I have searched for nests since my childhood. Their builders are extraordinarily good at hiding them. Of course, this is entirely by design, so that they keep their young safe and their construction skills as secret as magicians' tricks. Thankfully for the welfare of the birds, my childhood searches were predominantly unsuccessful, although I did once find an abandoned blackbird's nest in my grandfather's shed. Who knows what disturbance I might have innocently caused if I had found a brood of eggs or vulnerable fledglings? No doubt my feathered friends would not have chosen to share the biscuit in my pocket or thanked me for the shiny bits and pieces that I intended to give them. I did, however, make use of those bits and pieces myself, making my own nests, which I balanced precariously in low shrubs and hedges in the garden or on the way to school.

And so I continue today, closely observing nature, seeking out its secrets and making nests with my 'bits and pieces'. With maturity comes patience, however. Although I am still given to flights of fancy, I am less of a flibbertigibbet than my younger self. It transpires that being still and watchful is more rewarding when it comes to seeking out nature's secrets and treasures than charging about the garden with a biscuit and some beads in my pocket.

As I write, I am watching a mother blackbird patter across the lawn with a beak full of worms. I know for a fact that she has five fledglings nestled on the second shelf down on the left in the garden shed. The robins abandoned their nest on the top shelf when the blackbirds moved in. I didn't witness the less than neighbourly dispute, but I am guessing that there was one. There are dunnocks nesting in the box hedge beside the garden steps, sparrows in the eves of the house and wrens in the ivy, and all our nesting boxes have residents. I pass by them from time to time, cocking an ear to listen; they have all become magical musical boxes, playing baby birdsong.

The makings of imaginary nests, inspired by their counterparts in nature. Surely birds are some of nature's finest artisans. I often work with reference material, both fact and fantasy, propped up around me.

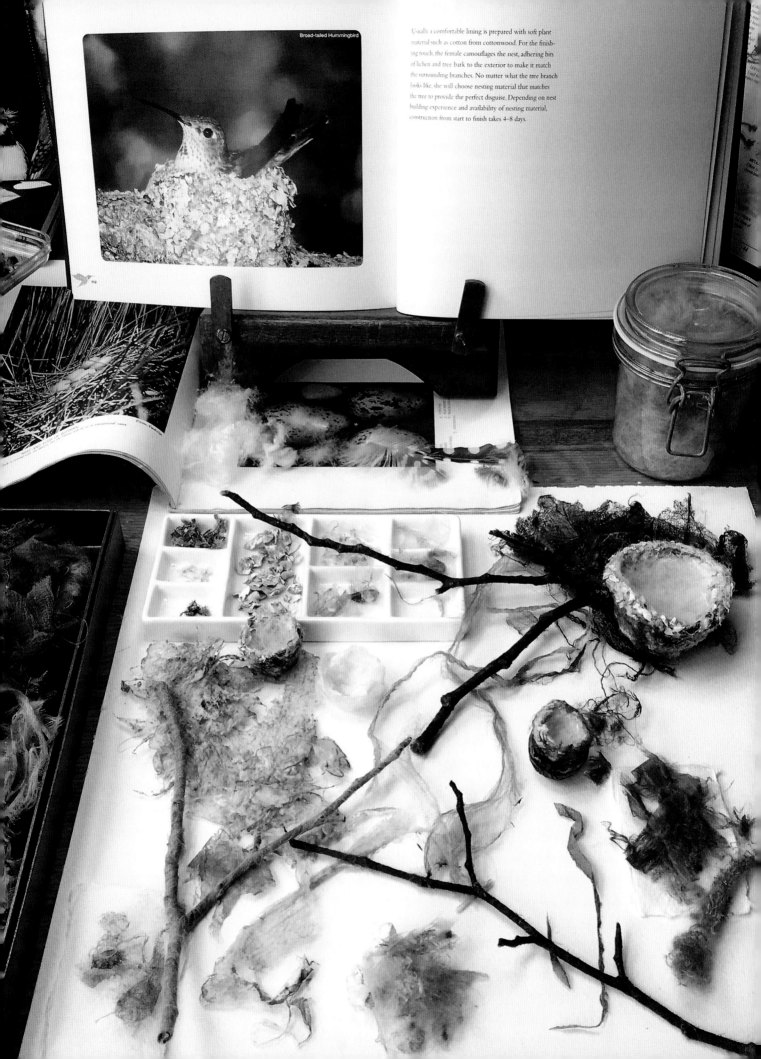

Broad-tailed Hummingbird

Usually a comfortable lining is prepared with soft plant material such as cotton from cottonwood. For the finishing touch, the female camouflages the nest, adhering bits of lichen and tree bark to the exterior to make it match the surrounding branches. No matter what the tree branch looks like, she will choose nesting material that matches the tree to provide the perfect disguise. Depending on nest building experience and availability of nesting material, construction from start to finish takes 4–8 days.

112

▼ The garden-shed fledglings. As far as I am aware, all five young blackbirds survived.

▼▼ An abandoned robin's nest holds a solitary egg. Disapproving of or perhaps intimidated by their new neighbours Mr and Mrs Blackbird, the robins promptly moved out.

▶ A printer's tray holds a selection of broken or abandoned eggs, discovered in our nature garden or along the country lanes. Nestled in tufts of fur and tree seed, it seems for all the world that they might yet hatch. The tray also holds elements with qualities akin to birds' eggs and nests: a pebble, a broken agate 'egg', wasps' nests, seeds and a stone 'nesting' within a stone.

So there is inspiration quite literally on my doorstep. More can be found through online searches and in the pages of the nature books that sit on my studio shelves. There is insight to be gleaned into the building habits and creative processes of every breed of bird, and, as I shuffle through my books, picking out fairy tales, I discover some that live solely in the realms of fantasy.

There are weaver birds and tailorbirds, which – to an artist such as myself with a penchant for stitching – seem particularly apt. Weaver birds, which are natives of Africa and tropical areas of Asia, build intricately woven nests from plant fibres, commonly choosing long, supple blades of grass. Beginning by knotting a single strand firmly to a branch (an art in itself), the master weaver then proceeds to create a nest comprising more than a thousand strands, each one woven in diligently using beak and claw.

Tailorbirds, which are native to tropical Asia, begin their nest-building craft by stitching large leaves together, using plant fibres or spider silk as thread. They pierce tiny holes in the edges of the leaves and thread them together to form a cradle, which they line with soft fibres to create a perfect home for their nestlings. How awesome is that?

Hummingbirds, natives of the Americas, are the daintiest of birds and so use the daintiest, most ephemeral of things to make their thimble-sized nests. Indeed, their materials list reads like a fairy spell: spider silk, thistledown, lichen, moss. I wouldn't be surprised to discover unicorn hair in there!

I hope these brief descriptions of a few of nature's artisan nest-builders have inspired you to gather some 'bits and pieces' and begin nesting too. But first, a shrill songbird note of alarm: nesting birds should never be disturbed, and their eggs must never be taken!

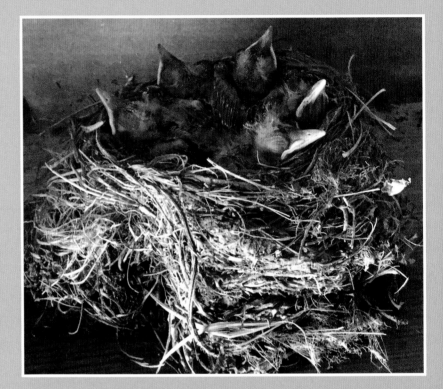

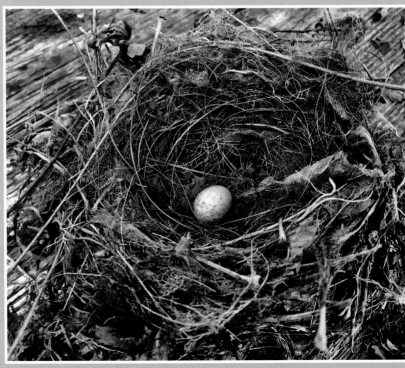

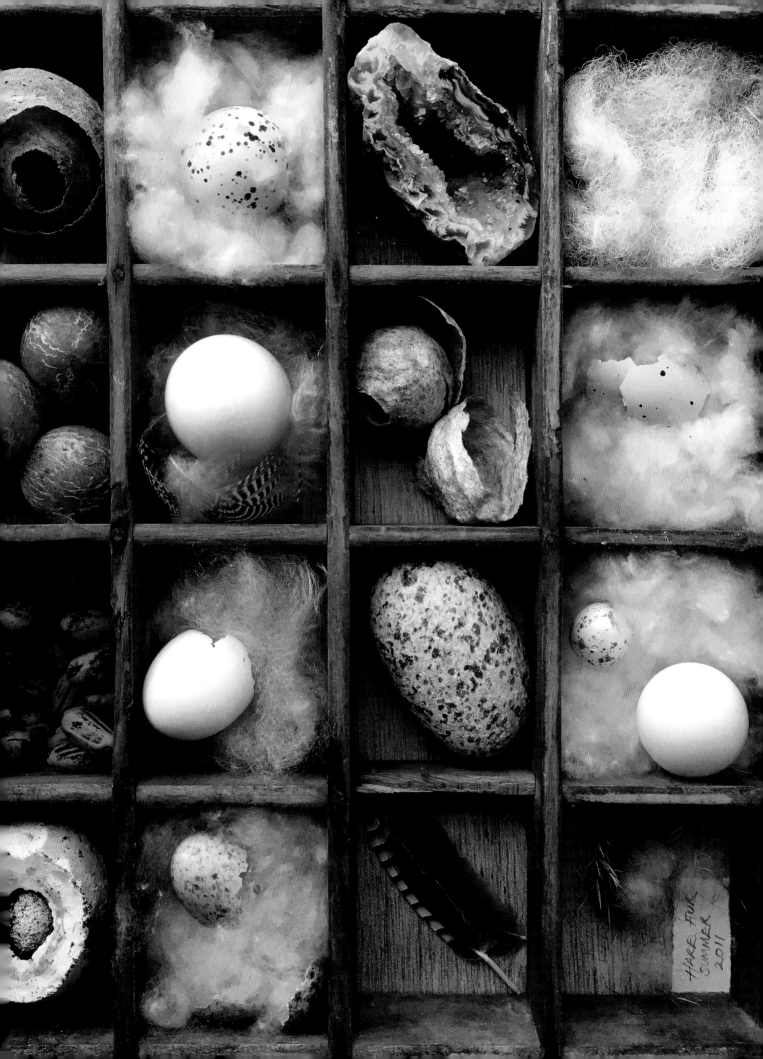

HARE FUR
SUMMER
2011

'Bits and pieces'

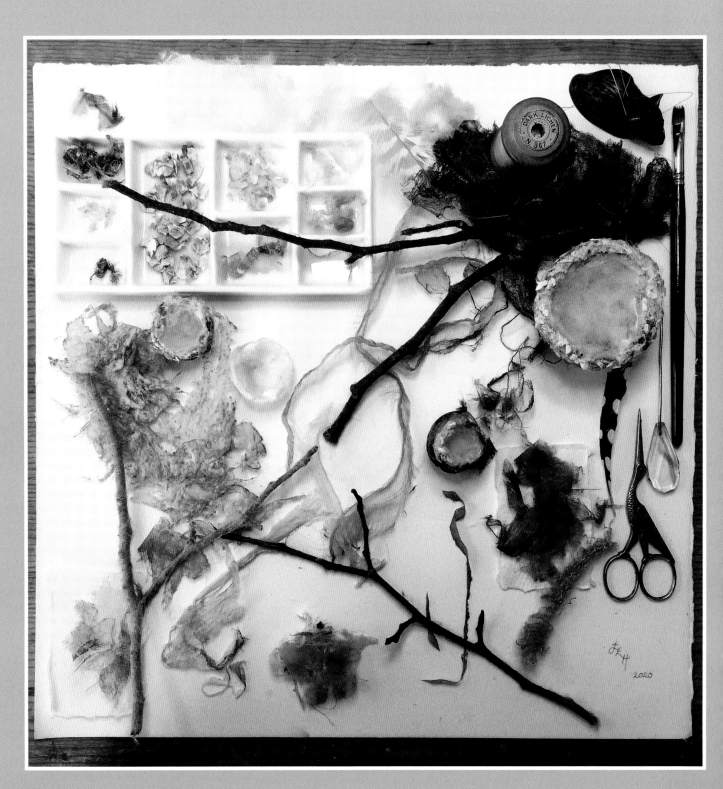

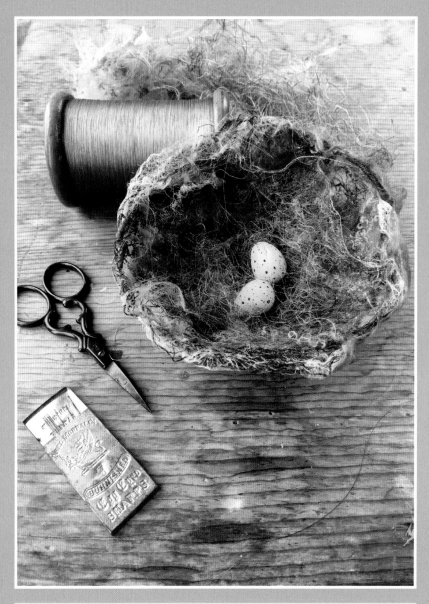

The eggs are modelled from an air-drying modelling medium, painted (aptly) with eggshell emulsion before being detailed with oil paint.

'**B**ird brain' is a derogatory remark that could not be less valid. Birds are in fact bright and beautiful! They are bright enough to design, plan and build bespoke homes in which to raise their young. They tirelessly gather the materials they need, often including ephemeral bits and pieces to make them feel more at home, or perhaps to attract a partner. What is more, most are also accomplished musicians!

The bowerbirds of New Guinea and Australia are renowned for their interior design, arranging all manner of beautiful items in their bowers: stones, feathers, glass, seeds and these days, alas, brightly coloured rubbish, throwaway things such as bottle tops and sweet wrappers. Currency has even been discovered lining the entrance of a bower, perhaps staking a valuable real-estate claim. Scientists have also realized that bowerbirds arrange things to create the illusion of perspective, making them artists in the truest sense. Bird brain? Tosh!

So how, without a bright bird brain, does one set about building a nest, using relatively clumsy human hands in lieu of beak and claw?

Construction

It transpires that making a dainty nest cup around one's own form, weaving in ribbons of grass and strands of hair, and softly pushing hare fur or down into place to cushion the eggs is not really a workable method for a human being. Improvisation again is key; indeed, perhaps it is true to say that improvisation is the most fundamental form of creativity.

There are as many ideas as there are imaginary nests to be made. Essentially, what I playfully realized in childhood remains true today. If you cherish the idea of discovering a secret in the natural world but fail, why not seek that hidden treasure in the supernatural world of fairy tales, in natural-history books or online. Then you can make manifest what you discover there.

Twigs and branches

Wire, bound with silk thread and torn silk ribbon, makes splendid branches. Tearing the ribbon gives them the texture of bark.

Cobweb

Gathering cobweb is a very delicate, digit-challenging process. Even if it were possible to gather enough to make use of, it would deprive our spidery – and feathered – friends of critical building materials. However, silk fibres or 'tops' imitate spider silk exceedingly well. A little diluted glue 'sticky beaks' them into place nicely.

Moss

Holding the lustre and texture of moss in a form that retains its qualities for more than a few days is challenging. Moreover, there are more mindful moments to be enjoyed through harvesting one's own 'moss' from crimpy silk crêpe de Chine or by fraying silk ribbons. It is better not to take the birds' supply from the lawn.

Lichen

I have also found that lichen does not like being appropriated into an artist's palette of nest-building materials, fading and desiccating in no time at all. Instead, moulding it from air-drying modelling medium is a very satisfying, playful process. Believe me, I've spent hours making lichen.

Of lichen, thread and whispers

A dainty cup-shaped nest is formed from silk fibres bonded using diluted PVA glue, shaped over a dainty bowl while wet, and allowed to dry completely before lifting it free. Channelling my inner songbird, I then stitched into this delicate wispy cup, steadying and securing its shape, adding moss-like fragments of fabric and thread, delicate feathers and wind-blown seeds.

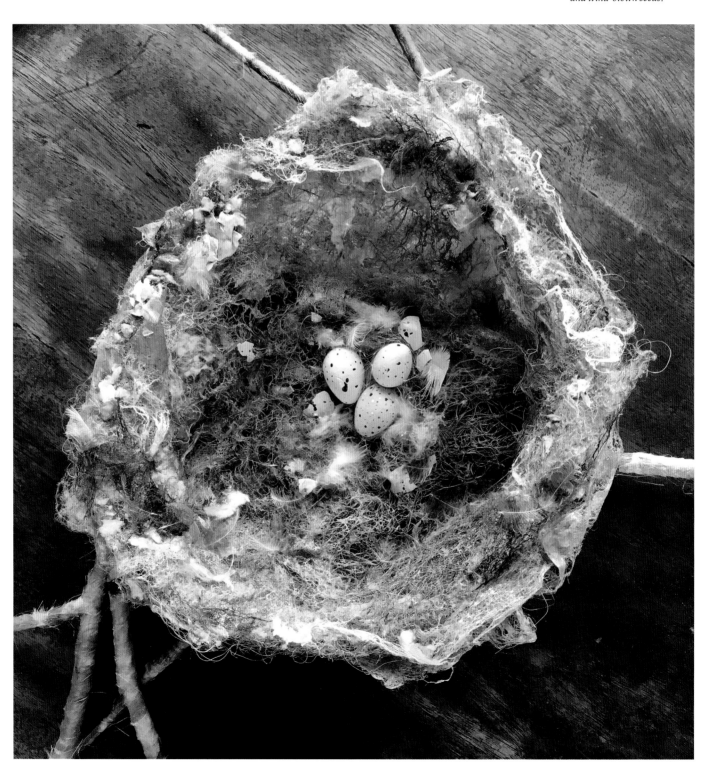

Will-o'-the-wisp

Perchance by the light of will-o'-the-wisp, you may see a nest such as this! I formed this nest using two circles of machine embroidery worked over cold-water-dissolvable fabric, overlapping in an organic lacy pattern. After dissolving the fabric away, I was left with two lacy cups, between which I trapped peacock feathers, fanning them out over the edges of the nests. Perhaps I felt, a little like a bowerbird, that such exotic plumage might attract an imaginary bird on a flight of fancy to settle in my nest. You could say that it worked, since two eggs now rest inside! Hand-modelled according to my creative fancy, they are nestled in with wisps of silk and frayed fabric. Countless stitches – both long and taut, like fairy tightropes, and short and anchoring – all but invisibly hold the nest together, belying its fragile appearance.

The term 'will-o'-the-wisp' is used for something that keeps disappearing or that is impossible to reach, or a certain magical light that enchants one's sight.

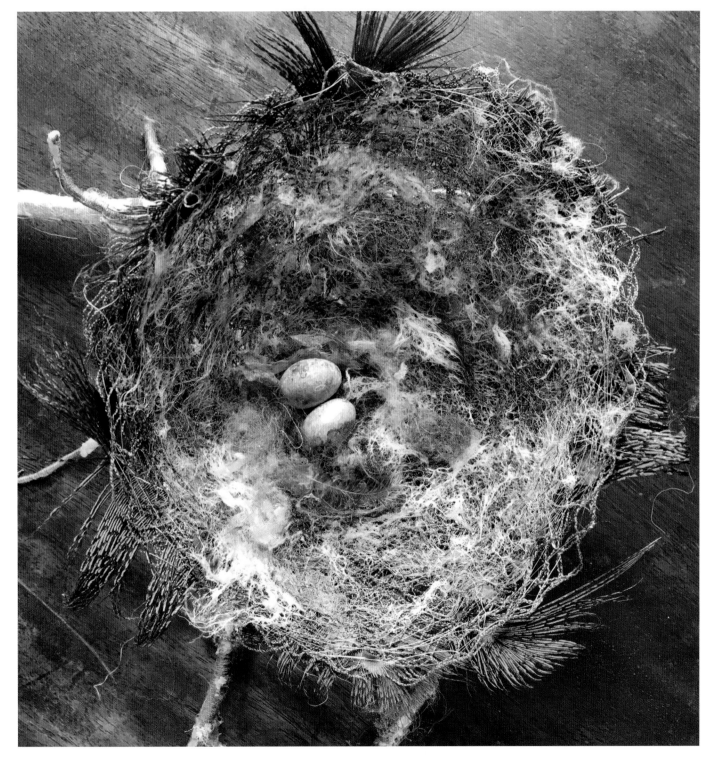

Cloud cuckoo's nest

Cloud cuckoos are delightful birds, living quiet, elusive lives, mostly on the wing, a little like the better-understood swallows and house martins. Some people say that cloud cuckoos have no legs, because they never land, but this is entirely a matter of conjecture.

There are several species of cloud cuckoo, of various sizes. All species are predominantly white, although very rare sightings (uncorroborated) suggest the existence of rainbow-plumed species. They live on unpolluted thin air and love. Pollution is undoubtedly the greatest threat they face, so more love and the reduction of air pollution are imperative to their survival.

Their nests are constructed mostly of cloud, loosely interwoven with sunlight, high-blown seed (mostly of the thistledown variety) and feathers. These feathers and seeds are generally gathered while airborne, since, as we have seen, it is not known if cloud cuckoos ever land or draw close to Earth to collect nesting materials. The strongest evidence of their existence is based on eyewitness reports and very rare discoveries of nests (or parts thereof) that have inexplicably fallen to Earth. Of course, such discoveries can be made only by believers, making such evidence very rare indeed.

Here you see gathered my cloud-cuckoo nesting materials: silk tops, feather down (drawn from the base of feather quills), silk and silvery threads, fragments of iridescent shell, mica and chips of raindrop-bright crystal. To create my nest, I brought all these elements together around and within a cup formed from silk fibres modelled over a dainty bowl, bonded with dilute glue. Having fallen to Earth in Silver Wind Spinney, the wood surrounding the Fairy House, it has been resettled in branches of the Fairy House tree. You may notice that one of the eggs seems to be hatching!

Of course, having been accused of being slightly cuckoo, a frequent flyer in respect of flights of fancy and imagination, I found it second nature to create this nest. I wonder what type of nest you might build, and which nesting materials you will choose. Quietly and confidently, for permission is fantastically granted, simply claim creative freedom and allow your imagination to take flight!

▲▲ The 'nesting materials' used to form my cloud cuckoo's nest.

◢▶ The finished nest sits in the branches of the tree at the centre of the Fairy House.

▲ A cloud cuckoo's egg . . . hatching!

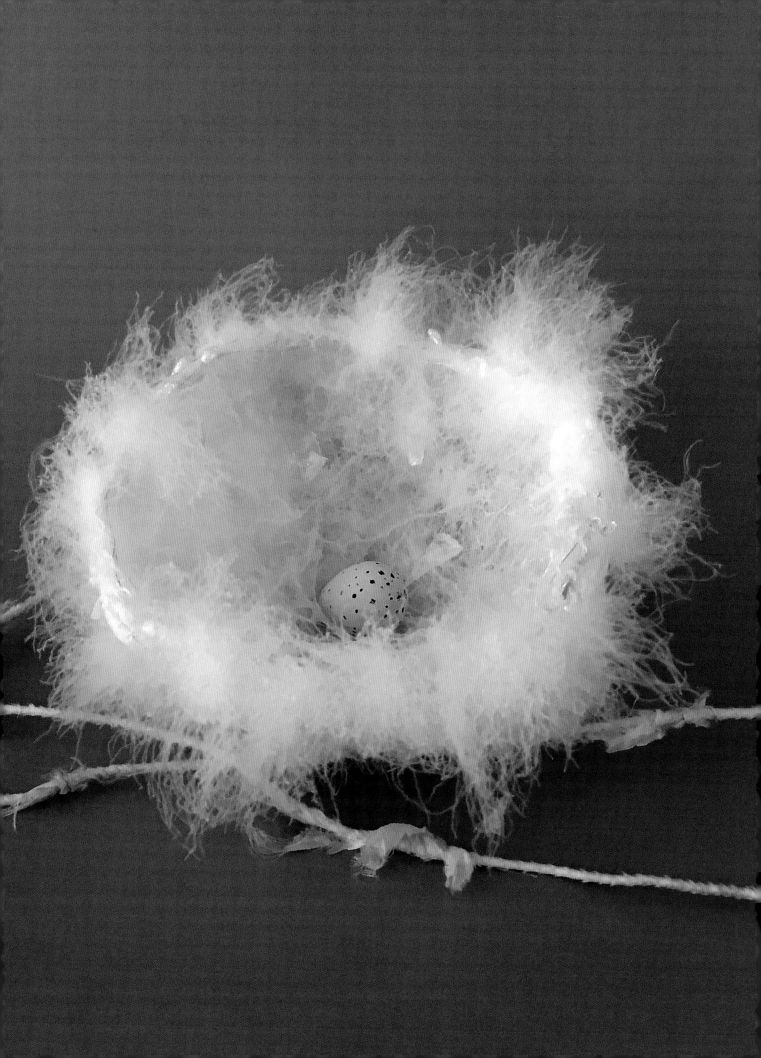

Wild-flower hours

◣ Often I honour nature just as it is, through direct observation. I made this bluebell complete with moon-white bulb and earthy roots.

▶ A wild-flower study of lady's smock. Having first made a watercolour sketch, I replicated each element in silk, modelling medium and fine wire. The finished stem now stands in Psyche's Cabinet (see pages 154–9).

In my artistic practice, I may gaze upon a single flower for hours, possibly even days. Mindfully, I consider its petals, stamens, calyces and leaves. Mentally, and creatively, I notice how the flower head joins the stem, then perhaps how the sepals or tepals form a whorl at the base of the flower. I contemplate the flower's colour, tone, weight and texture. All in all, I delight in what I see and define what I can achieve creatively.

In my work, these flower studies often become an integral part of a larger whole. For example, a stem of lady's smock, one of my (many) favourite wild flowers, creates the context for an orange-tip butterfly study, the flower being the butterfly's larval food plant.

So too, on occasion, a flower or plant may be presented as a work of art in itself. I often choose to honour nature just as I see it in the wild, by way of direct observation; for example a bluebell or snowdrop considered botanically, with their moonshine bulbs and earthy rootlets attached.

Each study represents the practice of contemplation and creativity that somehow looses me from the shackles of time and professional expectation. More often than not, I feel delighted and surprised when, with the twist of a thread or a snip of my scissors, a flower stem is finally accomplished. It feels as if I am more conduit than creator. Meditation in practice? Possibly.

Often, my creative pursuit of floral beauty is more playful. Although in years I am officially grown up (or possibly even growing old), I still make daisy chains. I still make patterns from flowers and leaves, just as I did when I was five or six, although doubtless with a little more dexterity. More recently, I am delighted to have discovered the recognized art form of nature mandalas (see pages 38–55), somehow affording me higher authority to play!

I urge you to venture out to play, too. On a sunny day, seek a flower, whether in the wilds or in tamer spaces such as a garden or park. Consider its intrinsic beauty. Look attentively; be present in the moment, mindfully.

If the plant flowers profusely, you might pick a single bloom to study further. Again, mindfully, recognize its qualities, but now think about how you might translate them to create a flower rooted in artistry. A sketch, painting or careful flower pressing can hold a beautiful moment indefinitely, triggering memory and guiding creative meditation in the future. And of course, whatever the weather and wherever the green, open space may be, there are nearly always enough daisies to be found to thread into a chain.

To meander mindfully through a wild-flower meadow, visit a bluebell wood in spring or picnic among daisies making dainty garlands are a few of my favourite things. To gaze attentively upon a flower can doubtless be considered meditation, which (according to its simplest dictionary definition) is the act of giving your attention to only one thing, as a way of becoming calm and relaxed. For me, this meditative process translates seamlessly into mindful creative practice.

Bluebell
~ Hyacinthoides non-scripta

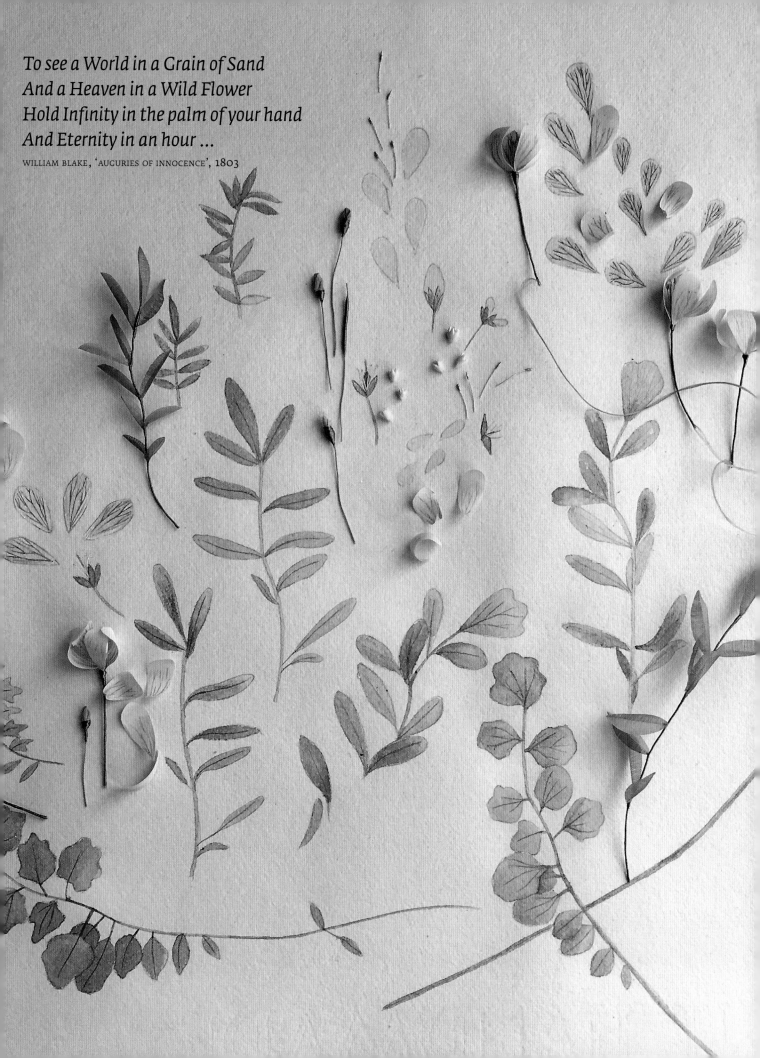

To see a World in a Grain of Sand
And a Heaven in a Wild Flower
Hold Infinity in the palm of your hand
And Eternity in an hour ...

WILLIAM BLAKE, 'AUGURIES OF INNOCENCE', 1803

Wild imaginings

There are perhaps as many playful ways to engage creatively with nature as there are species of wild flower in the world. With a creative, playful mindset, step out into the natural world if you can. You do not have to become an intrepid explorer; such explorations can even begin by tuning into a documentary or turning the pages of a natural-history book.

I long to visit faraway places and study rare orchids or watch bowerbirds at work, but not travelling there physically doesn't mean I can't go there in a creatively curious, imaginative sense. I can travel by 'magical televisual portal!' I can see and sense such wonders in richly illustrated books, and my imagination can bridge any gaps. I feel fortunate to live in the British countryside; believe me, it is a jungle out there. When I do travel, top of my agenda is to take a stroll in the nearest public gardens or nature park or, better still, out into the wide beyond – beyond the city walls, off the major road network, where nature (I hope) still thrives.

Many reading this will have access to green spaces, garden space or at the very least a windowsill or planter. Do look carefully; you may be surprised at the wonders you discover growing and even thriving under your nose. I once followed a tiny banded snail as it cavorted about my desk, leaving silvery trails, before returning to sleep in a posy of wild flowers. I enjoyed its company for several days before releasing it – slightly reluctantly, I must admit – back into the wild.

Thankfully, there are lively and engaging conservation trusts and groups established across the globe. They form a whole world of support to guide and encourage you in exploring the natural world close to you. One such initiative in Britain and Ireland is Wildflower Hour, with the purpose of flooding the internet with wild flowers for an hour every Sunday evening. I love to imagine it seeding the virtual world with flowers. How beautiful that must be, with thousands of wild flowers being broadcast across the ether, via Twitter, Facebook and Instagram, every Sunday since it started in August 2015. I delight all the more in the love of wild flowers and nature that these posts represent. I both joined the tide and surf the wave. It is glorious!

The premise is simple: seek out wild flowers throughout the week and record what you find using camera, notebook, sketchbook or memory. Wherever you are in the world, it is as possible as it is positive to find time for wild flowers in this way. It benefits both the natural world, by way of your acknowledgement and appreciation, and you. 'Wild-flower delight' is a real feeling, I promise. When I discover the flowers of something rare or unusual, I have been known to jump for joy and squeal with delight.

In our wildlife garden last year I counted 125 different wild-flower species thriving on a single summer's day. And when wild flowers thrive, so do I. Turn the pages to discover how this is true for me, then turn to yourself and find how it might become true for you, too.

◀ I find that lovingly writing each wild-flower label before setting out to attach them all to their flowers is a great help to me in learning their names by heart.

▶ A list of the wild flowers in bloom in our nature garden one summer's day, decorated with a few of the brightest and loveliest.

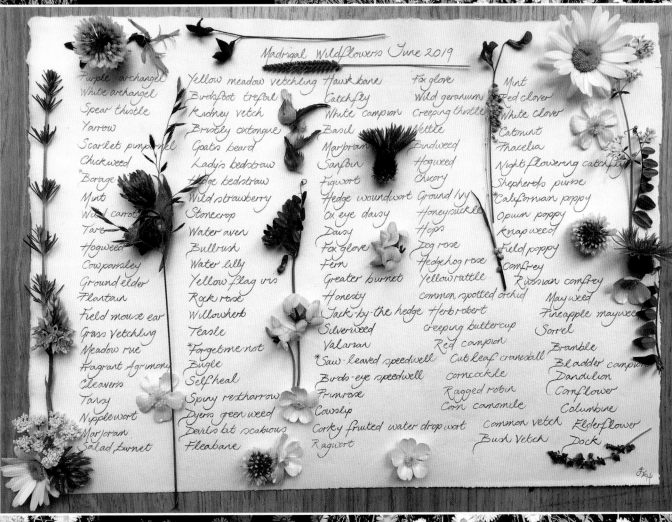

Gloves for foxes

▲◣ A 'finger bowl' of foxglove flowers.

◣◣ Fashioning foxgloves into finger-gloves.

◀ ▼ While gathering wild flowers from our nature garden in a wooden trug, it seems I tempted a garden snail to come along for the ride.

Foxgloves – gloves for foxes, fairies and ladies' fingers. May also be worn by dandies and other men of good taste.

Foxgloves, the perfect fit! Not tried, I hasten to add, before the bumblebees had popped them on. I discovered a pair discarded beneath the plants this morning. Could dapper Mr Fox have dropped them or – more akin to fairy tale – as Cinderella lost her slipper, could fairies have dropped them when on the stroke of midnight they hastily left the Wild-flower Ball?

Great willowherb

Ragwort

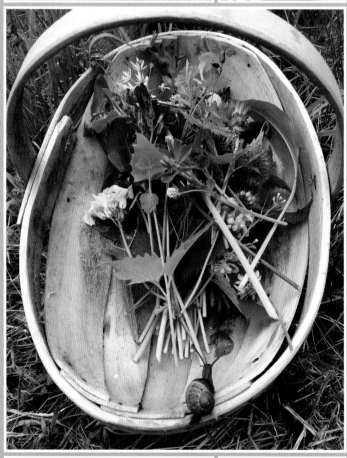

Mallow

Tormentil

Wild-flower arrays and posies

◄ *'May cup': a teacup full of wild flowers gathered in celebration of May Day.*

◣ *A dainty array of meadow flowers in a glass jar.*

▼ *An old glass inkwell holds a cheerful posy of summer blooms, with a single chicory flower, blue as the summer sky, beside it.*

When the plants in our wildlife garden are really flourishing and can spare a bloom or two, I often pick myself a simple posy, and rest it beside me to enjoy as I work. Sometimes I simply cover my desk in blooms, admiring them both individually and collectively. I ponder which I might choose to meditate on for longer. Perhaps I will consider making a nature mandala (see pages 38–55) or a wild-flower fairy (see pages 136–7). Perhaps I will choose to embark on a more complex course of creative study and manifest one in silk, with hand-painted petals, modelled calyces, bound stems and intricately cut serrated leaves. Or perhaps I will simply pop their stems in water and invite their beauty to nurture me.

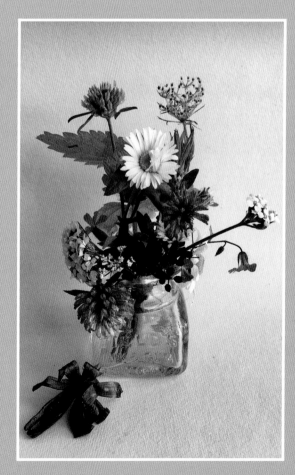

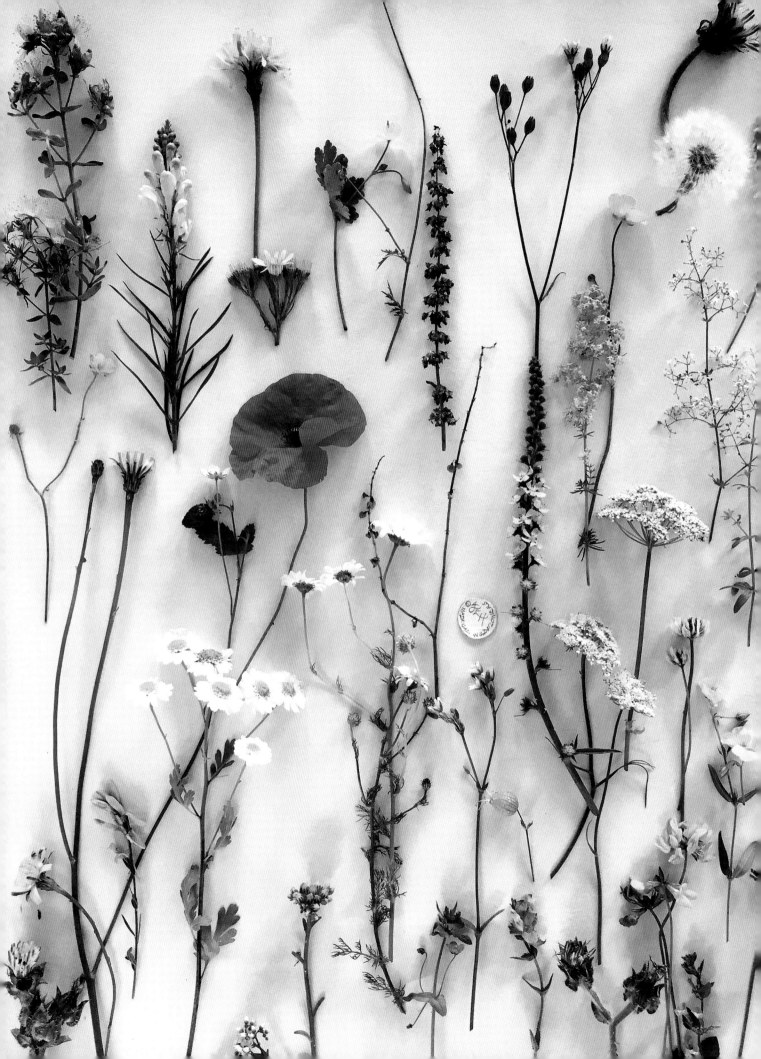

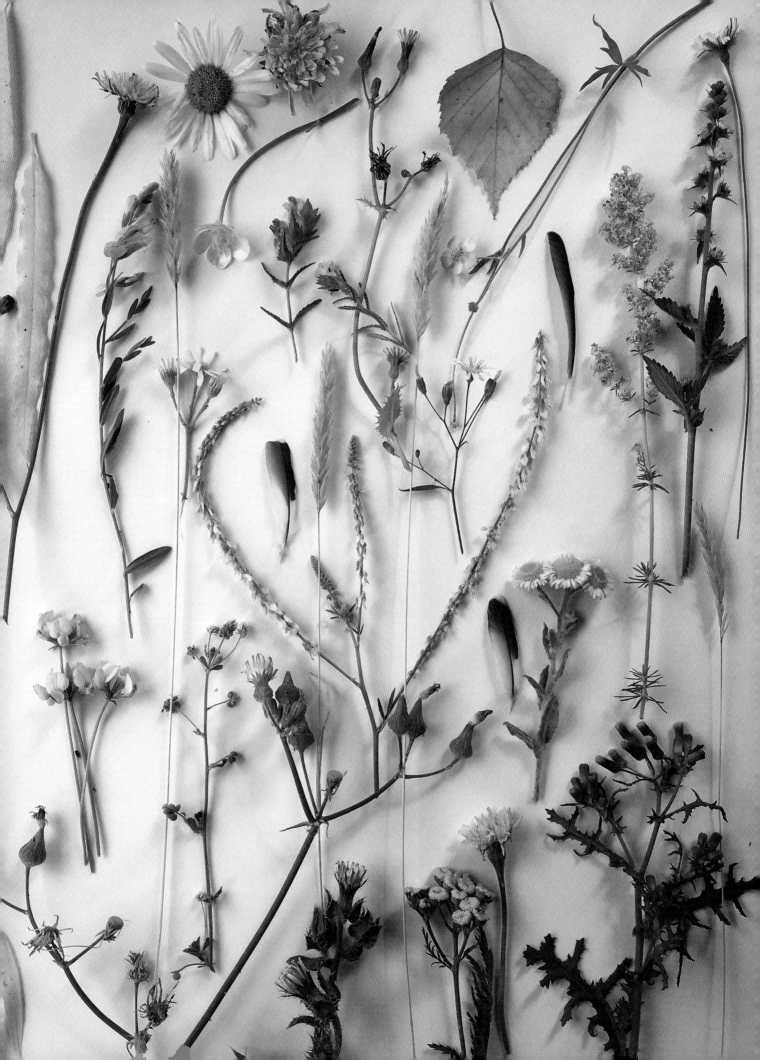

Flights of fantasy:
Miniature wild-flower birds

Pictured below we have the grass vetchling hummingbird, a rarely sighted wild species. It's also known locally as a miniature bird of paradise, owing to its favoured habitat: idyllic meadows, sweet wild-flower banks and gently tousled uncut roadsides. It is on the Otherworldly Red List, being endangered through habitat loss and lack of recognition. Field study included (right) to aid identification.

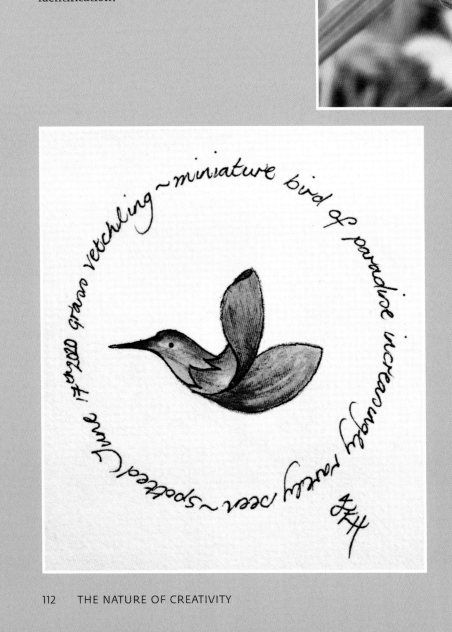

FROM MY DIARY

Making violets in the sunshine

I read that Jupiter – the mighty god, not the planet –
is believed to have invented violets to protect his lover
Io from his jealous wife. Io's name is implicit in the
flower's name: v'io'let. As an artist, I summoned the
spirit of invention to achieve their likeness in silk.

Each dainty bloom has five violet petals,
including one fashioned into a spur, resembling
a fairy slipper. A delightful folk name for violets is
'shoes and stockings', and I imagine those dainty
slipper petals explain why. An equally delightful
name is 'blue mice', surely descriptive of the way the
plant's thin, sinewy stems curl away from the blue
'mouse-eared' flowers towards the earth.

I cut my petals from lightweight habotai silk,
dyed violet-blue of course. After much trial and
error, I succeeded in persuading the central one into
a miniature slipper, giving the flower head form.
I tucked a cluster of silk-floss stamens into the centre
of the petals and drew them together on to a stem
of silk-bound wire. Holding the flower by its stem,
I then painted its delicate petal markings with
miniature brushes dipped cautiously in silk dye. In
nature, such perfect strikes of dark violet-blue must
flutter seductively at pollinators like eyelashes.

Back to my musings; being an artist, I am given
to them.

As the flower of Aphrodite, goddess of love,
violets have long been concocted into liqueurs,
potions and scents devised to beguile, intoxicate and
seduce. In fact, only one of the nine species of violet
is sweetly scented. I keep my nose to the spring air,
but have yet to detect a true sweet violet. It matters
not; I was smitten at first sight of Aphrodite's flower;
'blue mice', 'pig violets', 'shoes and stockings' …
whatever, I'm in love!

One, two, three; back in the room! Now for the
leaves. They are heart-shaped, you know.

*Two silken violets and their distinctive heart-shaped
leaves are attached to silk-bound wire stems. The leaves
are also made from lightweight silk and wired through
their mid-veins, enabling me to manipulate form into the
finished wild plant study.*

*A dainty posy of violets made from lightweight silk,
their delicate markings meticulously painted using
miniaturist's brushes. Now, if only I could replicate
their fragrance!*

MAKING
Red campion

In spring's full flourish, one may find red campion, bluebells and early purple orchids 'dancing' together in the same sunlit patch of woodland. May is very much their month, and it's a month that makes my heart dance, too. In bygone days these plants' recognized companionship resulted in folk names being shared between them. Across several counties of England all three were recorded as 'cuckoo flowers', but doubtless my favourite cross-county shared reference is 'Greggle', 'Griggle' or 'Granfer Griggle'. In Manx (the language spoken on the Isle of Man), red campion is known as *blaa ferrish*, 'fairy flower', although I would assert that surely all wild flowers belong to the fairies!

Here we take a step-by-step look at making red campion, the fairies' flower.

YOU WILL NEED

Lightweight habotai silk

Embroidery hoop

Fabric fray check

Spatula

Silk dye (fluid rather than viscous) in pink, green and yellow

Miniature paintbrush

Small, sharp scissors

Air-drying modelling medium (such as Model Magic)

Modelling tools (or improvise using feather-quill needles and slivers of bark)

Japanese floss or 'flat' silk in leaf-green and white

Wire (hair-fine for threading and medium/'stem' weight for binding)

Fabric glue

Fine needle

▲ *A single stem of red campion rests on a plain sheet of paper, allowing me to consider its exquisite detail.*

◥ *A watercolour and pencil sketch of campion growing among grasses. This is an invaluable stage of the creative process that informs what follows.*

STEP 1

With gentleness and simplicity, study the plant. Mindfully consider every detail: its beautiful heart-shaped petals, its dainty stamens, calyx and stem, the shape and changing scale of its leaves and where they conjoin. As you meditate on its beauty, gently ponder how you might go about honouring it creatively. This mindful step is doubtless the most important step of all.

STEP 2

Bring your attention into sharper focus by making a pencil sketch of the plant. It really helps to simplify the creative process. Draw each element separately and you will have a perfect pattern from which to cut.

STEP 3

Stretch some lightweight habotai silk on to an embroidery hoop. Treat it with fray check, spreading the solution as thinly as possible across the entire surface of the fabric using a flexible spatula, before allowing it to dry completely.

Trace the petals and leaves on to the stretched silk, using your drawn pattern as a guide. Make five petals per flower head. You will need to count the leaves and leaflets, gradating them in size. Every stem of campion is unique in this regard.

STEP 4

Now you have made enough petals and leaves for your stem of campion, they will need the daintiest of painterly touches of dye, mixed to the appropriate shades of petal-pink and leafy

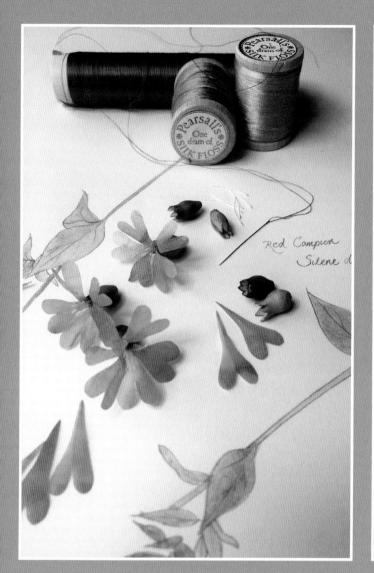

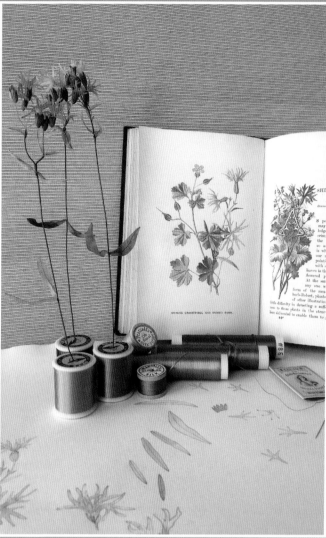

green. It is perhaps easier to paint them while they are stretched out before you, although sometimes I choose to cut them free first. With patience, you will understand which works best for you.

Either way, cut them free you must. Rest them safely somewhere – a trinket box is ideal – before considering the rest of the plant.

STEP 5

Now we come to the modelled elements. I invariably choose to model calyces for my plant studies, although in the past I've chosen to form them by simply binding the petals together on to silk-bound stems. Either practice is gratifying, but although modelling is creatively more challenging, it does honour nature more closely. With patience and a little experimentation, you will discover which you prefer.

Taking the tiniest piece of air-drying modelling medium, create a dainty form akin to its counterpart in nature. Be careful to leave a hole at the base, to allow it to be secured to the stem you will fashion later. As I work, I fancy these pieces look a little like fairy goblets. Repeat the process to model as many calyces as you need. Then form the flower buds in the same way.

Leave the pieces to harden fully (my modelling medium takes up to twenty-four hours to dry, but check the packaging to be sure of yours). Paint them using silk dyes when they are completely firm.

▼ Bringing the flowers into three-dimensional form. Here hand-modelled calyces, individual petals and resolved flower heads rest on the 'masterplan' – the watercolour and pencil sketch.

▲ A beautifully illustrated antiquarian flower guide stands on a book rest on my drawing desk, setting the scene for the handmade wild-flower specimens held in bobbins beside it. Although all but identical to red campion in colour, these particular wild flowers are in fact ragged robin. The botanical drawing underneath explores the creative consideration of the plant further.

STEP 6

To make the stamens, knot green Japanese floss or 'flat' silk and snip off each knot to leave a stamen-length tail. I have observed that most campion flowers have twelve stamens. When you have made enough, paint each one, gently touching the knots with pollen-yellow dye.

STEP 7

Now bind the wire stems. Taking suitable lengths and weights of wire, corresponding to the particular flower stem that you are studying, bind each length with green Japanese floss, touching the tiniest amount of fabric glue against the silk ends to secure them.

STEP 8

You should now have petals, stamens, calyces, leaves and silk-bound stems.

Wiring the petals and leaves through their centres will enable you to give your flower study form and poise. I use the finest wire, drawn from disused electrical cables and circuits, for the petals, and slightly heavier wire for the imagined mid-veins of the leaves. Pinch a tiny channel into the centre of each, enveloping the wire to conceal it and hold it firmly in place. Overstitch it securely with tiny stitches using thread drawn from the silk that the petals and leaves are cut from. I cannot lie, this process is fiddly and time-consuming, and takes a great deal of patience and practice to master. However, it is possible, and so rewarding if you enjoy the process. If it seems too onerous, you could consider experimenting with fabric starch or ribbon flower-making tools and techniques to create a similar form.

STEP 9

It's now time to bring all these precious flower elements together. Gather five petals around a dozen or so stamens and bind them tightly at the base with a length of fine twisted silk.

If you chose to form the calyx by continuing to bind rather than by modelling, pick out the appropriate section of silk-bound wire stem and continue to build the form up in thread to the top of the stem, being careful to cover the base of the petals and catch in the ends of the stamens.

If you have modelled the calyces, tuck the petals and stamens inside and, just pushing them through at the base, catching them together, bind the whole flower head on to the stem. Secure the binding thread with the faintest touch of fabric glue.

Repeat this process with the remaining flowers and buds.

Now attach the leaves in a similar way, catching the ends of their wires on to the silk-covered wire stems and carefully following the pattern of your drawing.

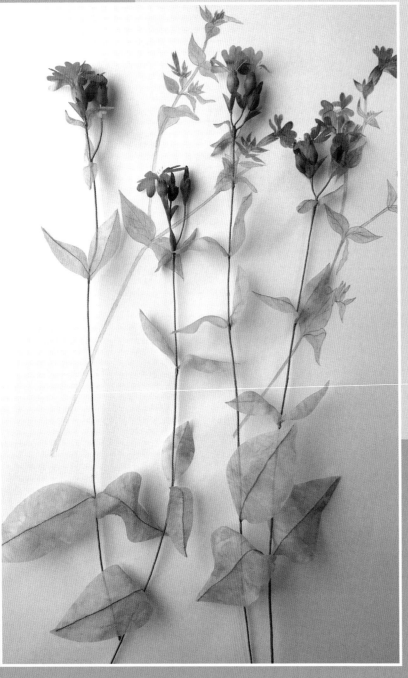

With patience, practice and creativity, you will make a complete stem, never to wither or die, upon which the magical butterflies and other insects dancing in your mind may settle and drink deep.

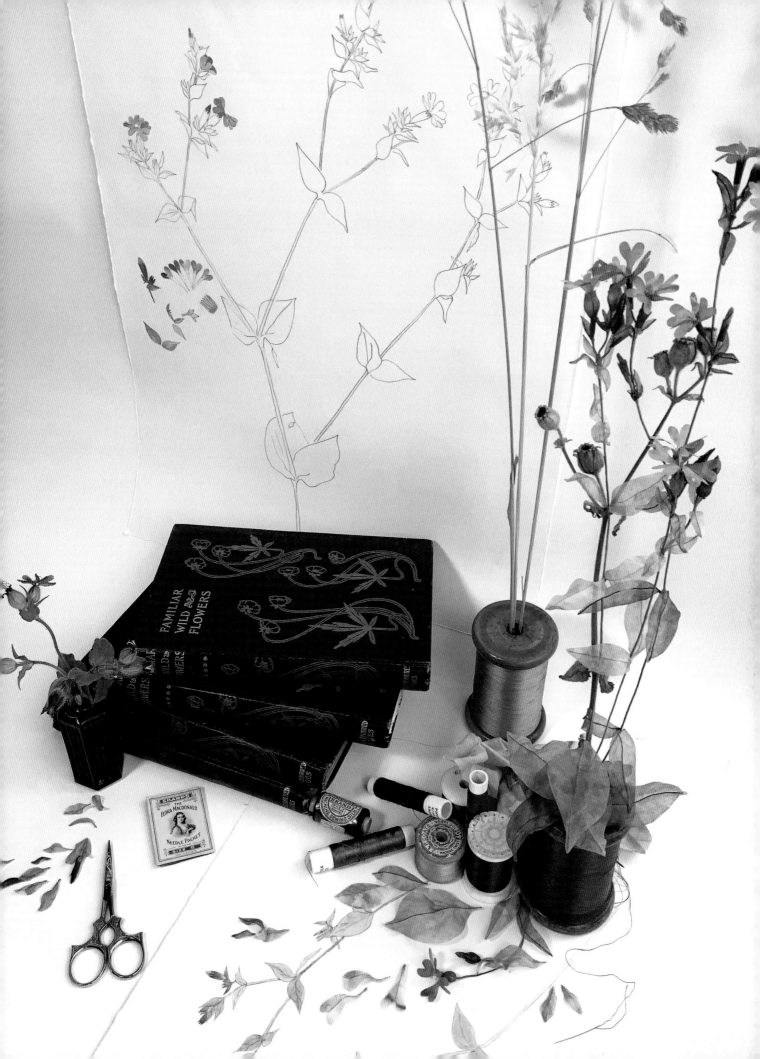

Lady's smock

▶ By dissecting a single flower, I realize my blueprint. Identifying and studying the corolla, sepal, pistil, stamen, leaflet and stem allow me to emulate, if not re-create, its beauty.

▶▶ Completed stems of lady's smock rest on a watercolour sketch of the plant.

▼ It is invaluable to capture the plant in a photo, as a practical reference. A china palette holds finished petals, and beside it are silk dyes, matching thread and a miniature paintbrush.

ady's smock, mayflower, milkmaids, cuckoo flower; all the names of this wild flower are as enchanting to me as the plant is beautiful. Indeed, saying its Latin name out loud seems rather like intoning a spell; try it: 'Cardamine pratensis!'

If you are fortunate enough to discover lady's smock in the wild (it is native throughout Europe and western Asia), visiting it there will be a joy in itself. You may well find yourself in the company of orange-tip butterflies, since the

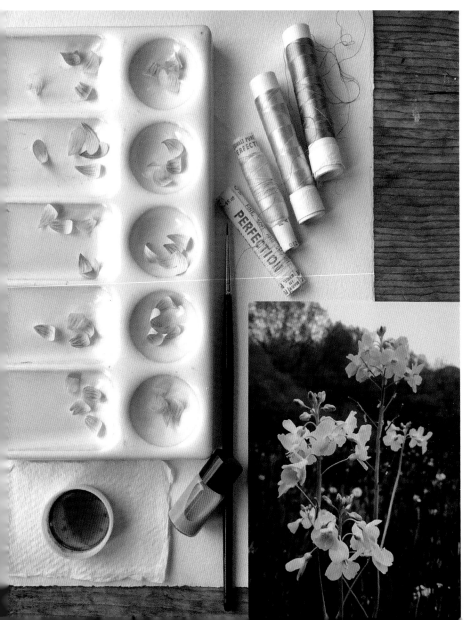

demure, dusty grey-tipped females lay their eggs beside the buds to provide their caterpillars' first food. The delightful, lichen-green youngsters go on to feast on the leaves and seed pods, as well.

A rosette of leaves crowns the earth, and growing upright from it are strong, green flower stems, several on each plant, bearing dainty pale-pink or mauve flowers. Each flower has four petals, but occasionally one discovers a double-flowered variety; Mother Nature has artistic licence just as we do!

If you consider 'making' a stem or two, it is important to study Mother Nature's pattern closely. At liberty to pick a stem, having established a bevy of these 'lovely ladies' in our nature garden, I have considered the plant as a botanist might. Dissecting and drawing every leaf, leaflet, flower bud, stamen and seed pod, measuring the stems, a section at a time, I then emulated them in silk. Using my drawing as a pattern, I painted the individual petals, detailing their exquisite veining with a miniature paintbrush. So, too, I painted the leaves individually, before cutting them free of the silk, touching their edges lightly with a medium to prevent fraying, applied with a tiny, stiff brush. I brought the petals together around hand-knotted silk stamens, binding them to the tips of silk-covered wire stems. I bound leaves to the stems at appropriate intervals, and emulated seed pods by binding them to sections of wire, before attaching them in the same fashion as the leaves.

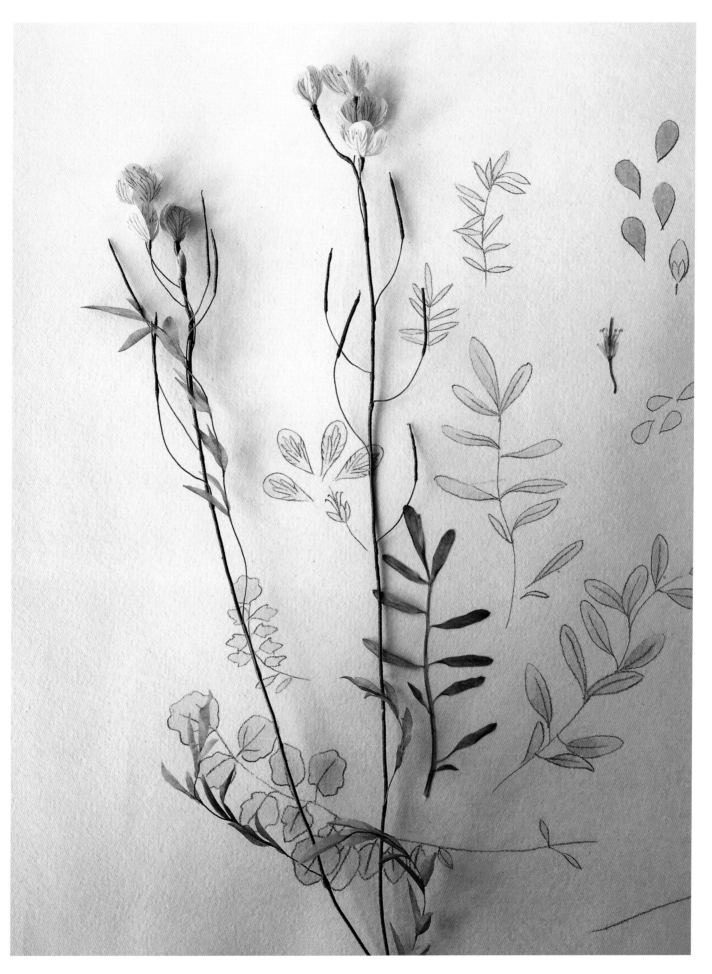

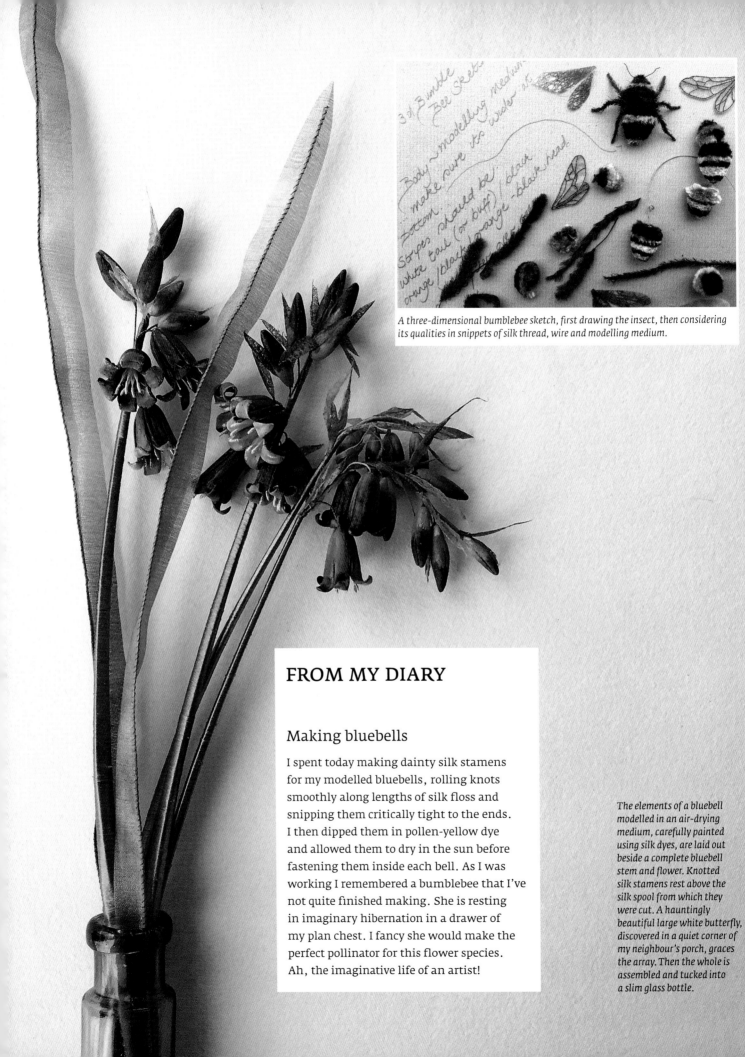

A three-dimensional bumblebee sketch, first drawing the insect, then considering its qualities in snippets of silk thread, wire and modelling medium.

FROM MY DIARY

Making bluebells

I spent today making dainty silk stamens for my modelled bluebells, rolling knots smoothly along lengths of silk floss and snipping them critically tight to the ends. I then dipped them in pollen-yellow dye and allowed them to dry in the sun before fastening them inside each bell. As I was working I remembered a bumblebee that I've not quite finished making. She is resting in imaginary hibernation in a drawer of my plan chest. I fancy she would make the perfect pollinator for this flower species. Ah, the imaginative life of an artist!

The elements of a bluebell modelled in an air-drying medium, carefully painted using silk dyes, are laid out beside a complete bluebell stem and flower. Knotted silk stamens rest above the silk spool from which they were cut. A hauntingly beautiful large white butterfly, discovered in a quiet corner of my neighbour's porch, graces the array. Then the whole is assembled and tucked into a slim glass bottle.

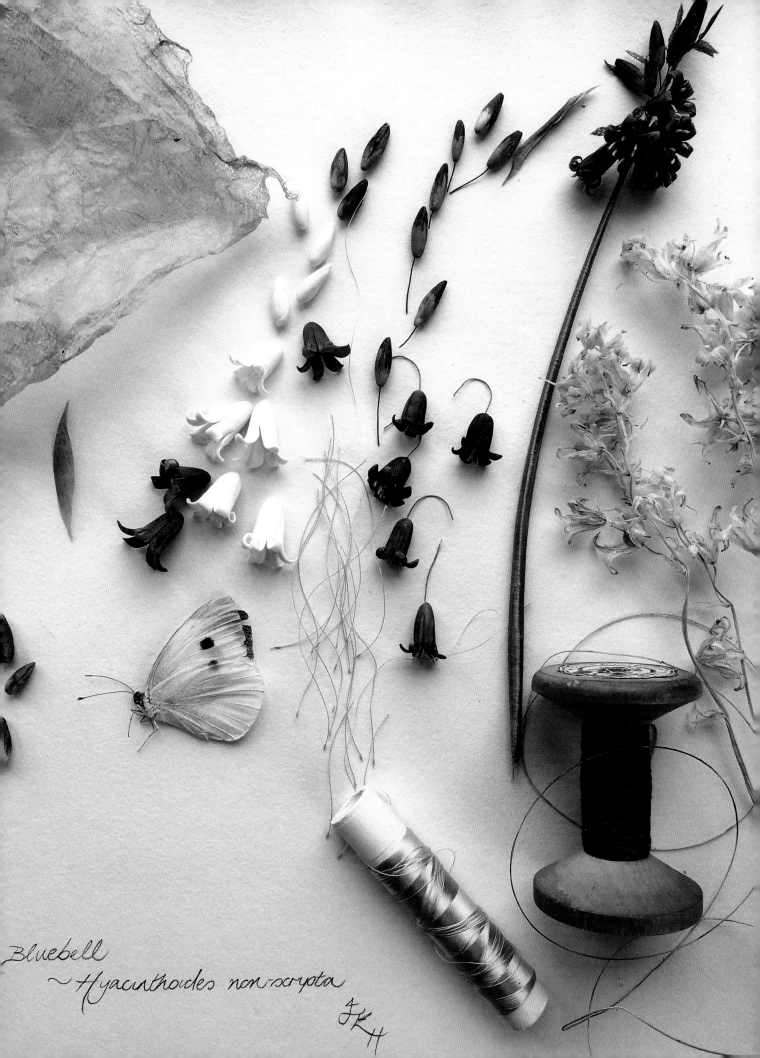

Bluebell
~ *Hyacinthoides non-scripta*

JKH

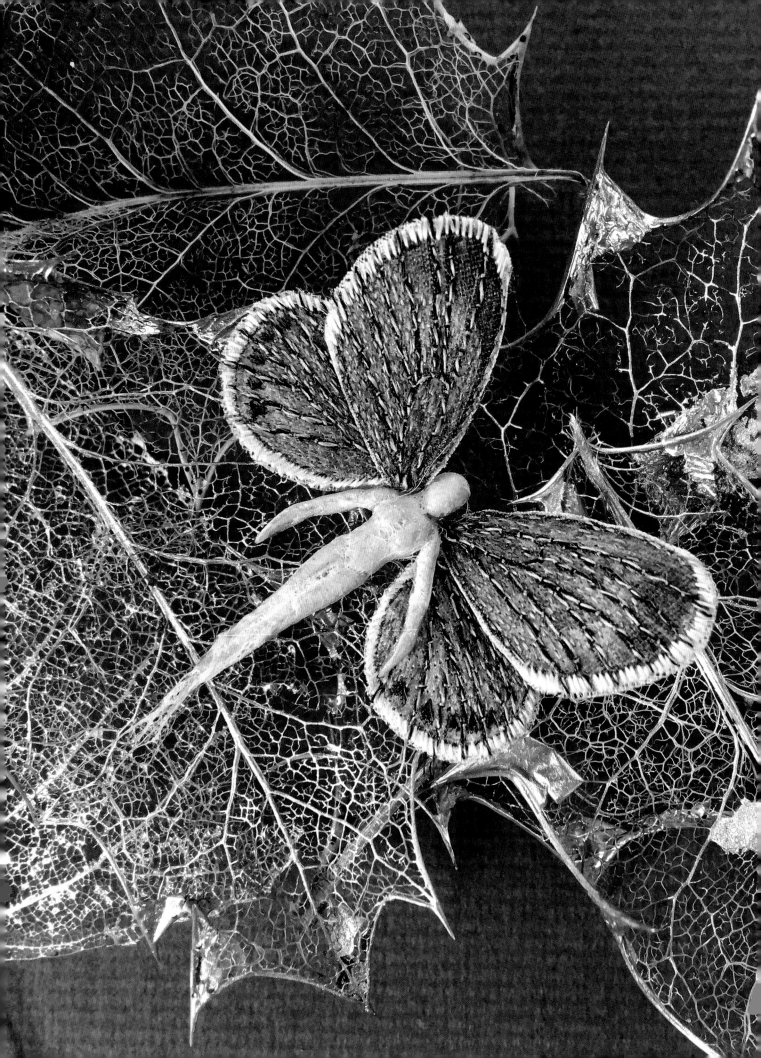

Fairies

I have always believed in fairies. Indeed, folk sometimes say of me: 'She is off with the fairies!' A quip, more often than not, intended affectionately ... I think. The truth is, I believe in imagination and, in particular, the creativity it conjures.

One may imagine anything, given the playtime or, more accurately, the playfulness of mind. I am suggesting a state of 'other mindfulness', an escape from reality and all the pressures it brings to bear. Perhaps it is true to say that in being 'off with the fairies', I am experiencing my own peculiar state of zen. Now, before you think me totally cuckoo, I am intent on showing you the way there (if you don't know it already), so that you too can experience this extraordinary alternative reality.

Firstly, we must find the key. One can find the key only by looking, very intently. You see, we are seeking the invisible, the shimmer or flicker of a fairy's wing as it flutters between worlds: our world and the world of imagination. This shimmer first caught my eye when I glimpsed it on a butterfly's wing.

I distinctly remember being told one day, when I was much, much younger than I am now, that you must not touch a butterfly's wings for fear of brushing off the fairy dust they are coated with. Since that day I have believed that butterflies and fairies are one and the same, fantastical beings hiding in plain sight. It certainly explained to me why, no matter how intently I followed butterflies about the garden, somehow they always managed to escape me, to magically disappear. In my child-mind, the narrative played out from there: 'Where have they gone ... what magic are they about? Shush; they are still here!'

I have drawn the likeness of fairies, as have many other artists and storytellers, and to my mind such depictions are substantiating evidence. I have also manifested them materially from silk fabric and thread, modelling medium, feathers, branches and moss. Here, I will illustrate just a few of these wee folk, to help you creatively invite them into your life and spend many a quietly contemplative hour in their company.

A holly blue fairy, inspired by its namesake, the holly blue butterfly, rests on skeletal holly leaves.

Making fairies

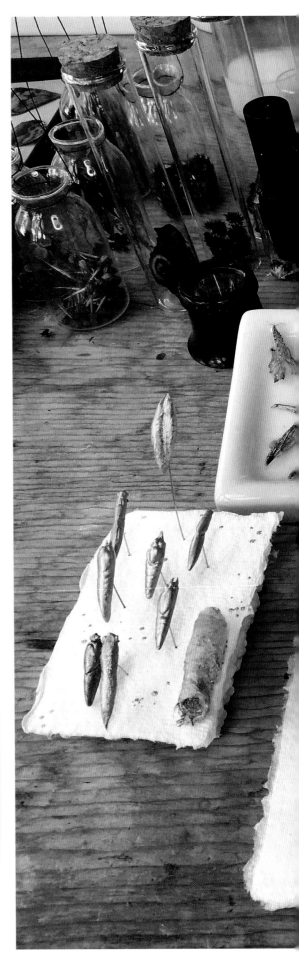

Making fairies is all about make-believe!
Once you see a fairy – be it her skirt,
in the way a wild flower curtsies in the breeze,
or a woodland sprite stretching out its twiggy
arms to embrace your imagination – you will
see them everywhere. Then you may decide to
make one, for its value as evidence, if only to
convince a doubting friend or spouse. Firstly,
an expedition is called for, out into the wild and,
equally importantly, into the wilds
of your imagination. Spend enough
time there and your creativity
should begin to flow. Follow
your thoughts as you turn these
pages, and we will begin to
manifest creative ways and
means together.

▶ *A diagram of 'fairy' form
as evolved from that of the
butterfly.*

▼ *Wild-flower fairies dance
a reel atop silk reels and
bobbins.*

▶▶ *Exploring the wonder
of make-believe. The magic
and the making of fairies
come together on my
drawing desk.*

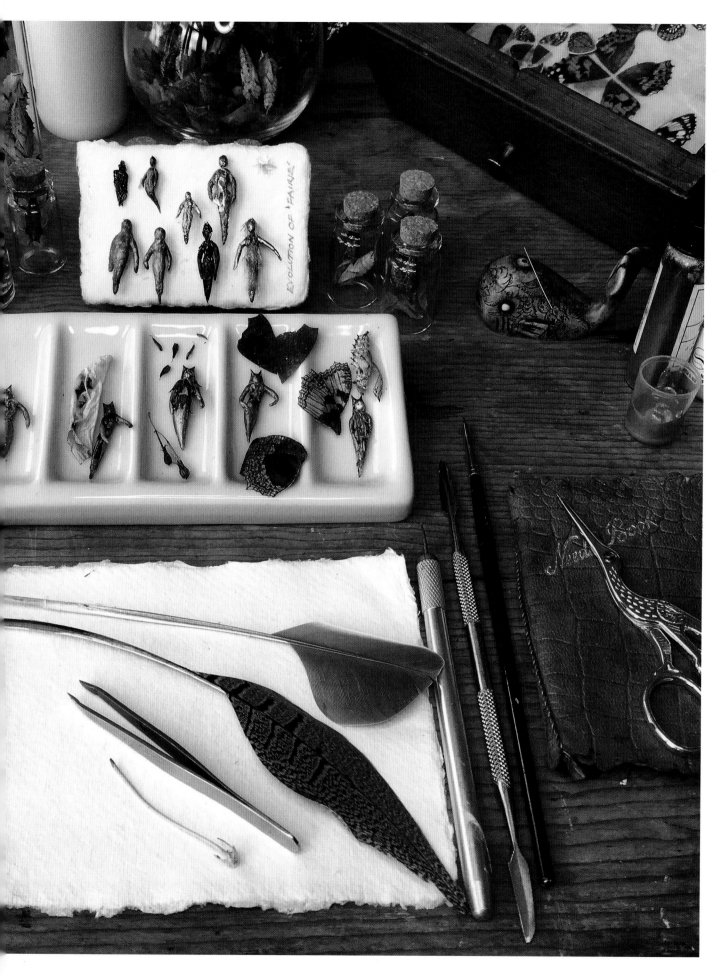

Woodland fairies

Through paying very careful attention, I have learned to find fairies in woodland (from time to time they can be found in hedgerows and meadows, too). For me it is their outstretched arms that generally give them away.

These two woodland fairies were found close to home, in Ambrose Copse, one of their favourite haunts. Of course, I was spellbound into fashioning wings for them; I am always picking up feathers that they undoubtedly lead me to discover for that very purpose. Nature rewards us in so many joyful, playful ways.

▲▶ *This rather grand woodland fairy is, I fancy, more of an angel, borne on buzzard-feather wings. His strong body and outstretched arms are formed of oak, perhaps the wisest of woods. Golden lichen covers his face and torso completely.*

◀ *Feathers, gathered from the wild and waiting for the perfect use as fairy wings, form a 'nettle-string bird'.*

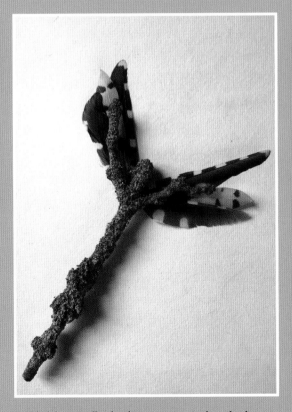

▲ *This dainty woodland sprite has a twiggy body, of hazel, I think, so we will call her that. She is clothed in the most exquisite golden and winter-green lichen, from which she has also fashioned herself a wig. Her wings are made from great spotted woodpecker feathers, attached securely to her back with a spot of glue. A moment in the imagining, but more precious in the making, and in the time spent reflecting on how magical nature is.*

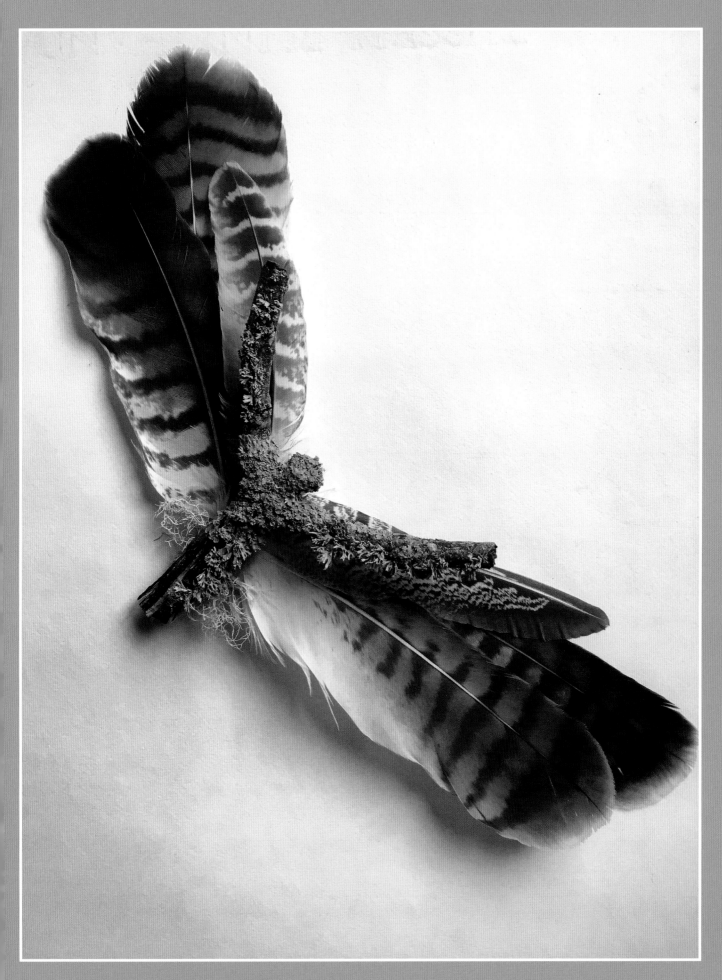

Butterfly fairies

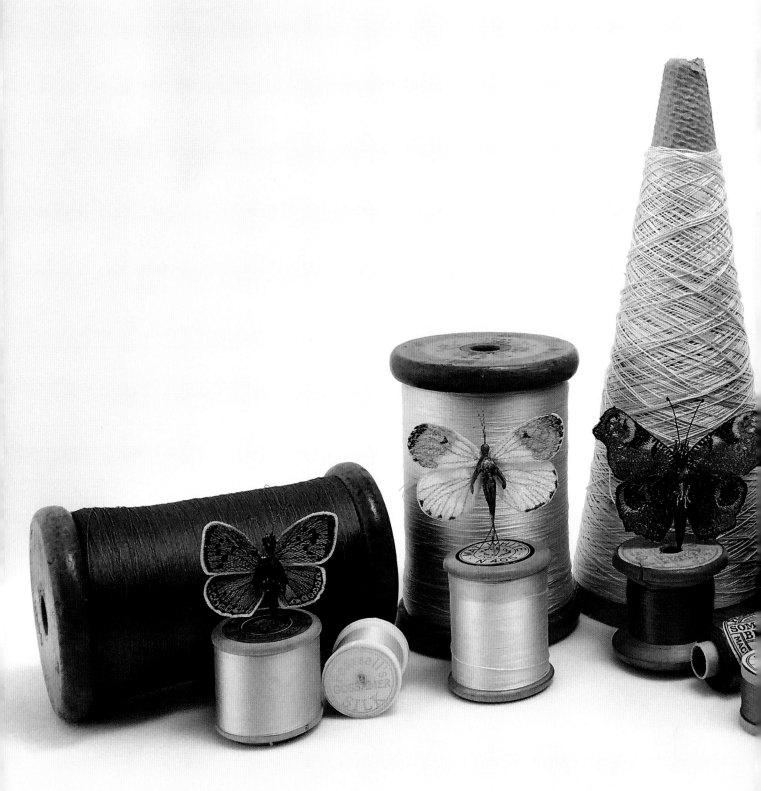

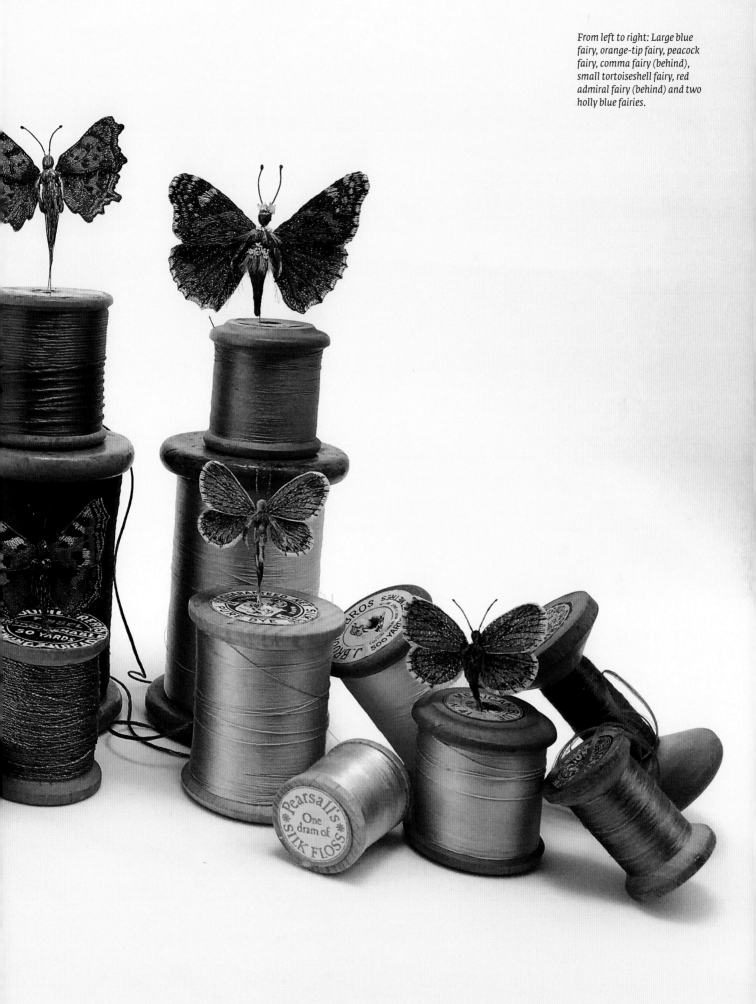

From left to right: Large blue fairy, orange-tip fairy, peacock fairy, comma fairy (behind), small tortoiseshell fairy, red admiral fairy (behind) and two holly blue fairies.

Princess peacock fairy

Hand-embroidered fairy species

This fairy has intricately hand-embroidered wings. I minutely work simple, straight embroidery stitches across wings painted on to silk. The paintings are true to scale: true to both peacock butterfly and fairy wing, that is. Throughout the painting process I strive to represent the colour, pattern and venation of the species as accurately as possible, giving me the very best guide for my stitches.

I work with handmade needles, perfectly suited to carrying the very fine hand-plied silk threads that I favour. They have a lustrous sheen, almost as shimmery as fairy dust.

A full set of fairies' or butterflies' wings can take months. I have never counted the scales on one of my embroidered fairy's wings, just as I have never counted the scales on a real butterfly's wings, but there are a good many. You see, for me, creativity is very much in the process. No matter how long it takes, the joy is in the making and the quiet, contemplative thinking that accompanies it.

No fairy would be complete without its dainty body and, of course, arms and legs to direct its flight. This princess peacock fairy has a body modelled from an air-drying modelling medium called – very aptly – Model Magic. Once embroidered, the wings are wired around their outer edges and through their centres before being attached to the dainty body by the very same wires, carefully threaded through the modelling medium when it is still pliable.

And there she rests, proof positive that one should believe in fairies. Who among us can say definitively that of all the butterflies they have ever seen, one might not have been a fairy?

Wishes, blown like kisses, falling, coming to rest, growing into dreams.

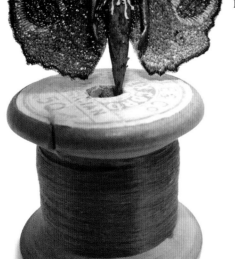

◀ *A peacock fairy sits pretty atop a reel of silk thread; surely she must be a princess!*

▶ *Plants with parasol seeds hold a special magic for me. Since childhood I have blown them to the wind, casting wishes with each puff. It is apt, then, to rest my peacock fairy among them.*

Dormouse Picnic ~ Hazel nuts nibbles followed by cobnut coffee and cookies for dormouse dessert. JRH

Fairy sailing boats

Yesterday we picnicked with dormice. Taking paths softly trodden by deer and foxes, we found exquisitely nibbled tableware scattered among the mosses, sweet violets, wood anemones and primroses. It was so lullingly lovely that for a while I wondered, 'Am I a dormouse daydreaming?' It is perhaps unsurprising that I spend a lot of time daydreaming. My endless fascination with and curiosity about the wild have led me to some extraordinary nature findings and some equally wild imaginings.

I have long been fascinated by dormice, and although I have yet to happen upon one, I have come across nibbled evidence of their presence from time to time. The dormice nibble hazelnuts (also known as cobnuts) very distinctively, in the green, making a smooth, round hole in the side of the nut, a work of art in itself. By contrast, squirrels simply split nuts in two, and woodmice are scruffier nibblers altogether, leaving toothmarks on the surface of the nut, and rather ragged holes. (I could go on: voles, woodpeckers and nuthatches love hazelnuts too.)

As I stood there deliberating over who had nibbled what, from the nutty remains I discovered scattered in the woods, I found myself wondering whether it might actually have been fairies. You see, just for a moment, one nut fragment looked just like a miniature boat. I gathered a pocketful of nibbled hazelnuts and idled away from the scene, daydreaming.

The following day, in my studio, all that remained for me to do was empty my pockets and fashion sails for one or two of these dainty vessels. To this day it remains a mystery how they became stranded there in the woods, so far from the sea, but I fancy they were carried there on drifts and tides of fallen leaves. On reflection, I suspect Squirrel the boatbuilder played a part in crafting these hulls.

I drilled each hazelnut half to take a dainty mast, variously of beech and willow. On to these dainty masts I rigged butterfly-wing sails, each wing hand-painted on lightweight silk before being cut free and wired delicately to prevent it from collapsing in strong winds. With just whispers of breath and occasional draughts, their course across my studio desk remains set fair.

What wild imaginings might you indulge in should you venture out into the woods today? Tread softly; be careful not to wake any dreamy dormice.

▲ A dormouse picnic imaginatively re-created, laid neatly with hazelnut-shell dishes (nibbled by real dormice), holding fanciful flowery treats and seeds. Violet-leaf plates present wild garlic flowers, and a teapot made from a whole hazelnut is the perfect vessel for make-believe tea.

◄ A dormouse-nibbled hazelnut shell discovered while stepping softly through the woods.

▶ Fairy boats voyage across my drawing desk.

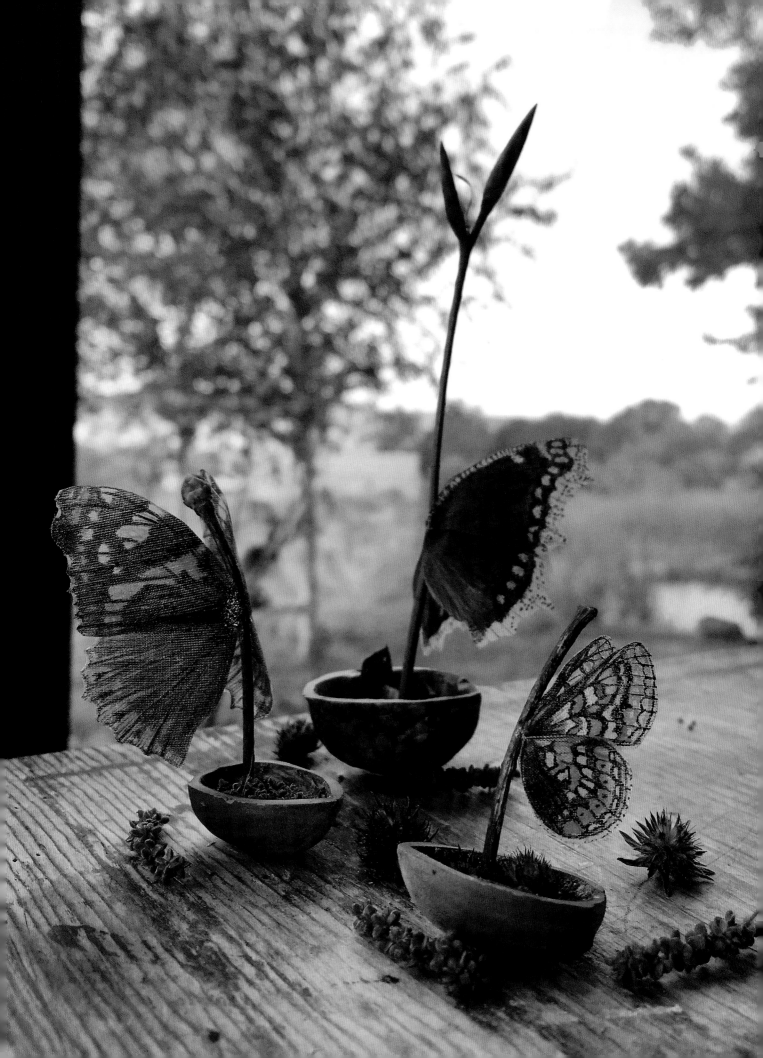

Wild-flower fairies

When I pick wild flowers – or, for that matter, pick anything up in the wild – I do so reverentially. I am mindful of their value to nature, and each one is precious to me. Plants flowering generously may afford me a stem or two, and these stems will remain in water on my studio desk for days, possibly months, as I admire and study them, watching them fade, go to seed and gently dry. In the spirit of reciprocity, invariably I return the seeds to the garden, reinvesting in our wonderful wild world.

One day, gazing across my studio desk, one such vase of wild flowers caught my eye. The faded daisies and dandelions in my spring posy had bowed their flowery heads and, like little tutus, were dancing in the sunlight. Thus the idea of wild-flower fairies danced into life.

Pinching the flower head off tight to the top of its wizened stem, I gently made a hole in its centre, pushing through where the stem had been attached. This formed the skirt waist of my dainty wild-flower fairy. I used a heavy needle, although a fine drill works neatly too. The hole had to be big enough to fit tightly the waist of my flower fairy – a dried stem. I chose a stem of wild carrot, because it dries rigid and straw-like. Rosebay willowherb makes excellently lithe fairy bodies, too, but any suitable weight of dried stem will do.

Finer stems made perfect arms, each attached with a speck of glue. A second leg was necessary, too. She stood on the first, which was attached seamlessly to her body, being the original stem threaded through her skirt. (A note on modesty: a speck of glue added at the waist before pushing her skirt up helped to hold it there just so, sparing fairy blushes.) I attached a little wild-flower ruff or bodice at the top of her body stem, just below the neck. The dainty head upon those shoulders? Why, a poppy seed head, of course, accented with poppy-seed eyes.

And there, in the creative twinkling of an eye, a wild-flower fairy stood pirouetting before me. Of course, no fairy should have to dance a reel alone, even if such a thing were possible. I have therefore gone on to create a wild-flower summer ball of dancers, poised atop bobbins of thread.

A flower fairy is revealed inhabiting the negative space in an arrangement of pressed pansies.

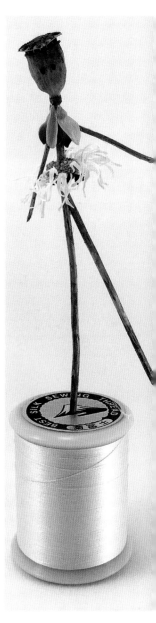

Isabelle, a wild-flower fairy, stands atop a reel of silk thread.

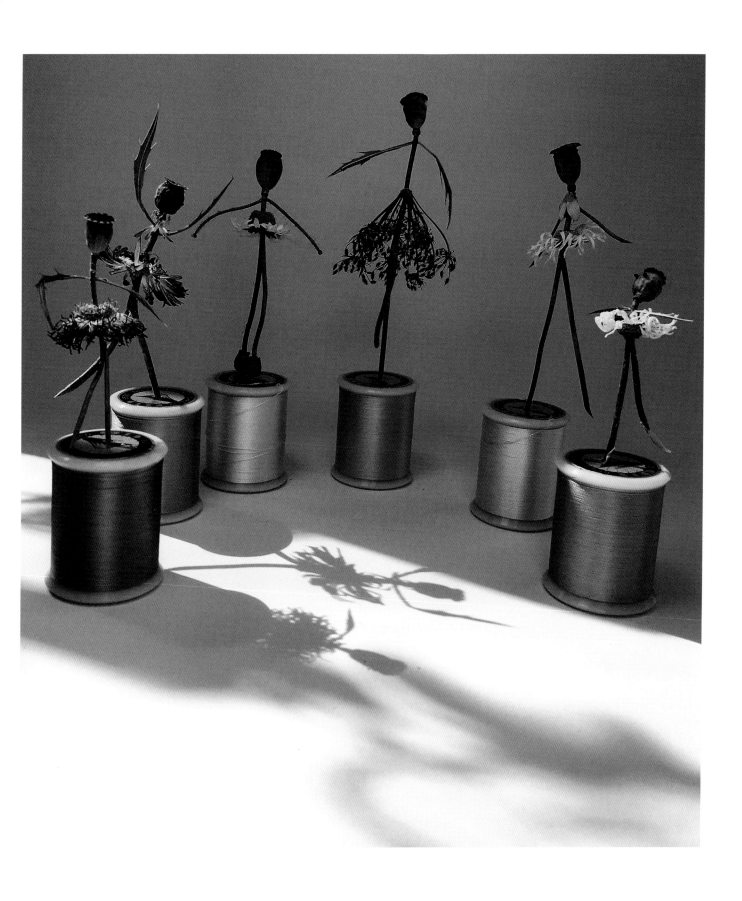

A semicircle of wild-flower
fairies dance in the limelight
of late afternoon.

Chasing butterflies

Butterflies have always inspired me artistically, and indeed I often refer to them as my muses. My artistic focus has long been to realize delicate, hand-embroidered three-dimensional renditions that honour their exquisite natural counterparts.

My creative process begins with close observation of butterflies on the wing in the wild, where their living form and lustre are best admired and where I feel most inspired. This leads to countless butterfly expeditions, or 'studying in the field', as I playfully define it. As defined in the dictionary, this phrase somewhat belies the fun of my adventures in pursuit of butterflies, gathering happy memories with precious sightings. Butterfly kiss-chase, my particular phrase, is more suitable still.

In broadening my understanding of ecology and the delicate balance that is required to sustain butterflies, I have developed a keen interest in their food and nectar plants. Rewardingly, this has flourished into the creation of a butterfly haven around my studio, providing inspiration quite literally on my doorstep.

One may be forgiven for assuming that butterfly gardening is a gentle pursuit. Given natural habitat, maintained over centuries through traditional land practices, this may be the case, but it rarely is. Much of the UK's rural landscape has been 'agriculturally improved'. Our own 'butterfly garden' was once agricultural land, managed intensively to provide fodder for cattle. Hundreds of tons of topsoil had to go before wild flowers would once again deign to grow. The chemically fertilized topsoil grew sturdy pernicious weeds, pasture grass and little else – at least little to whet the appetite of passing butterflies. Sadly, butterflies today are faced with vast stretches of 'green desert', which farming monocultures effectively are. Butterflies need specific food plants for their caterpillars to feast on, and these are referred to as larval food plants. They also have delicate tastes when it comes to the plants they choose to nectar on as adults. All that is green is not necessarily pleasant to butterfly-kind.

Months of heavy landscaping and much hefting of earth has brought about heartening results here in our butterfly garden. Wild flowers are once again thriving. One in particular, aptly known by the folk name of 'eggs and bacon', now grows profusely, providing breakfast, lunch and dinner for butterflies, blues in particular. Broad swathes of nectar-rich perennial wild flowers now extend an open invitation to countless butterflies and other insects. Indeed, all creatures great and small are welcome here. Our garden is as much nature's as our own. Dancing with butterflies throughout spring and summer, and a palace for sleeping butterfly beauties through the winter hibernation, it lifts the spirit and nourishes the soul of wild kin and mankind.

A silver-washed fritillary (Argynnis paphia), complete with intricately hand-embroidered wings, appears to have alighted on silk threads – the very threads with which its individual wing scales were stitched. The tiny handmade needle used for this task is held fast in one of the bobbins.

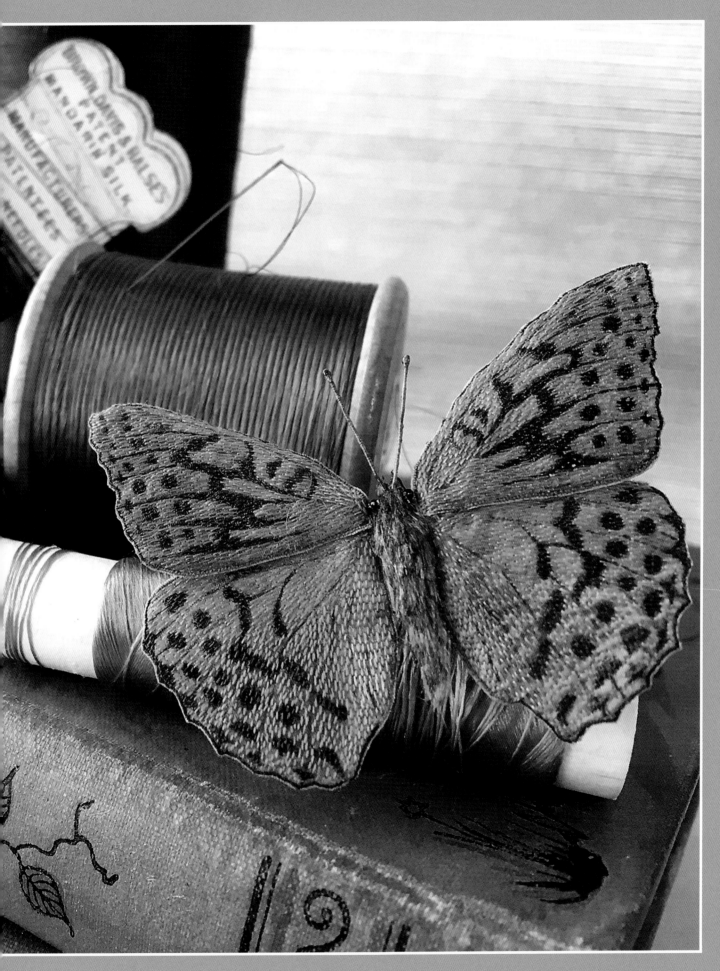

Making butterflies

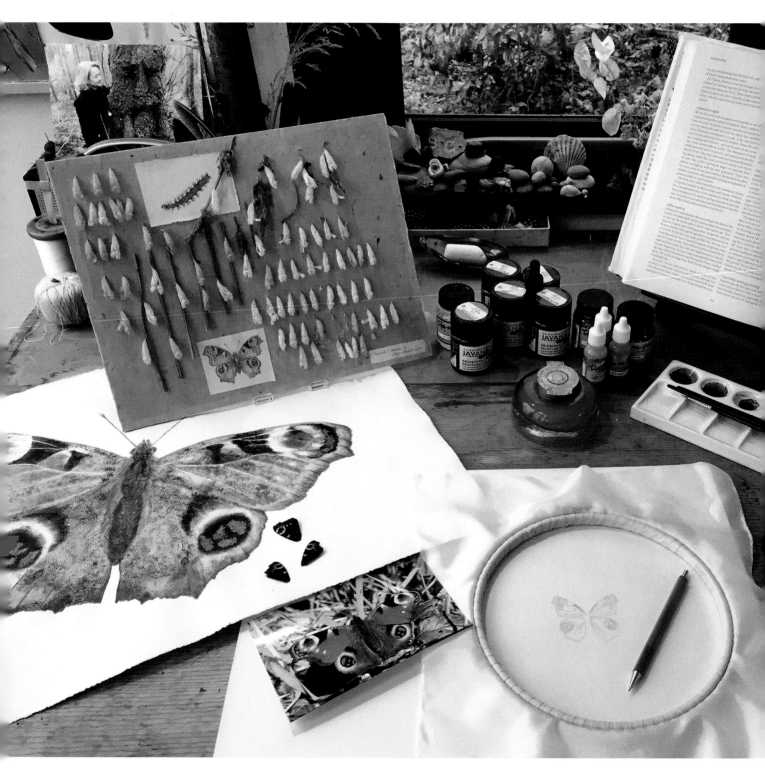

◣ *My drawing desk is set up, ready for me to begin painting a peacock butterfly's wings. The silk is held taut in an embroidery hoop, the dyes are already mixed in my favourite china palette, and accurate reference sources are close by – as is, most importantly, a warming cup of tea.*

▼*Macro photography reveals the intricate colour and patterning of a peacock butterfly's wings. In my creative imagination I still see these scales as fairy dust, just as I did when a child.*

In my studio I refine my observational understanding of butterflies through drawing and painting. Pencil sketches clarify the complex forms and patterns of individual species, guiding my interpretation of their exquisite detail in stitches. Using these as reference, I then paint their wings on to stabilized habotai silk, using miniature paintbrushes, just as a miniaturist would, with silk dyes.

Butterflies' wings are made up of countless tiny scales, as the name of their order, Lepidoptera (from the Greek for 'scaly wing'), makes clear. These miraculous miniature scales form the pattern of the wings and, through light diffraction, carry their colour and lustre. In my 'silken species', detailing these tiny individual wing scales requires the aid of magnification. Every scale is reconsidered with a tiny stitch, made by hand using the finest of handmade embroidery needles carrying hand-twisted whisper-fine filament silk. To me, each scale represents a speck of heaven.

The butterflies' bodies are worked with similar exactitude. Their form is moulded using tools fashioned from fine wire and feather quill. The hair on their backs, the crook of their legs, their dainty antennae … every minute detail is closely considered. As I work, I feel at once awed and humbled by the miraculous beauty that I seek to honour.

This process is all-absorbing, just as meditation is. It takes patience and time, too. Depending on the size and complexity of the species, a single butterfly may take up to ten weeks to 'metamorphose'. Yet, rather than finding this length of time exacting, with all my heart I feel it is time well spent, considering the beauty of my muse with every stitch.

Pondering the perfection of butterflies' colours, texture, lustre, patterns and form … mindfully respecting these qualities, and describing them through the artistic techniques that I employ … suffusing my senses with heavenly beauty, aspiring to trace and define every nuance … reflecting on miracles … Meditation it is!

By and by, even in the depths of winter, I drift into butterfly daydreams, losing myself in contemplation of their Eden: specific habitat for specific species. Perhaps a wild-flower bank, a country mile or so from home, where sweet violets (the larval food plant of the silver-washed fritillary) thrive. Or, a little further afield, Collard Hill in Somerset, where rare large blue butterflies dance, settling on wild thyme, their chosen food and nectar plant. Or far, far away to Paradise Bay, California, where I once witnessed migratory flocks of monarch butterflies roosting. Where better to lose oneself than in such daydreams?

As the seasons allow, I often step away from my study, out into the wilds of our butterfly garden, to rest my eyes on these ethereal insects. In winter I daydream of them, sleeping beauties, deep in hibernation, perhaps closer by than even I would dare to imagine.

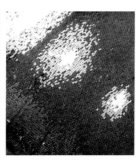

▶ Having sharpened my observation of a species using a sharpened HB pencil, I hand-paint its wings on lightweight silk. Here you see the diminutive small blue butterfly, Cupido minimus, its wings just 1 inch (2–3 cm) across. The lid of a jam jar makes a suitably diminutive palette for the dyes.

▶▶ An embroiderer's palette: the silks I will use to embroider the wings of a large skipper butterfly, a familiar visitor to our meadow.

◀ As I model the bodies of various butterfly species, considering every minute detail, their hand-painted and embroidered wings rest beside me for colour reference and scale.

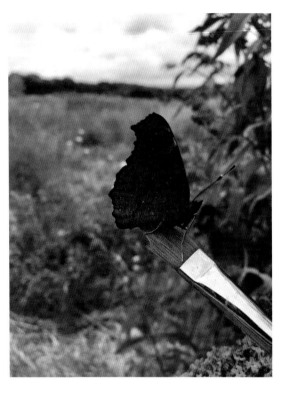

▲ I care for caterpillars in Nettles Nursery, watching their metamorphosis to life on the wing. This beauty, a peacock butterfly, is about to take flight.

▶ Simple line drawings become the blueprint for hand-embroidered specimens. Here, a completed swallowtail shadows its sketch.

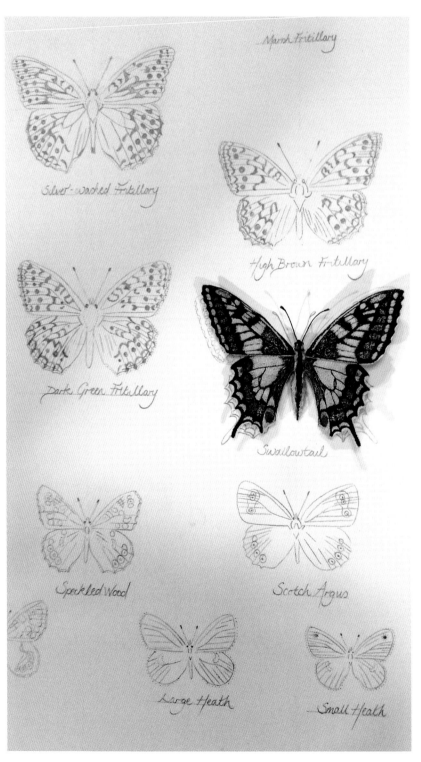

Marsh Fritillary

Silver-washed Fritillary

High Brown Fritillary

Dark Green Fritillary

Swallowtail

Speckled Wood

Scotch Argus

Large Heath

Small Heath

Mine is a field of tousled grasses, a meadow in which to play. A field of dreams where ideas and imagination take flight with the butterflies.

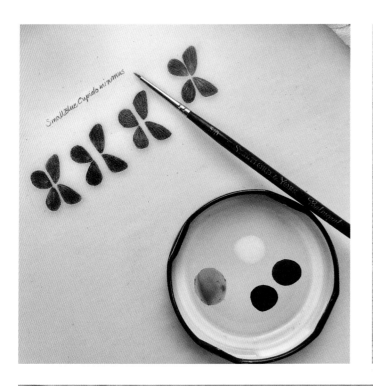

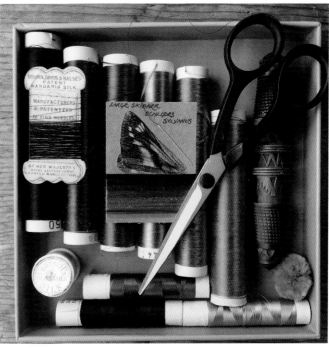

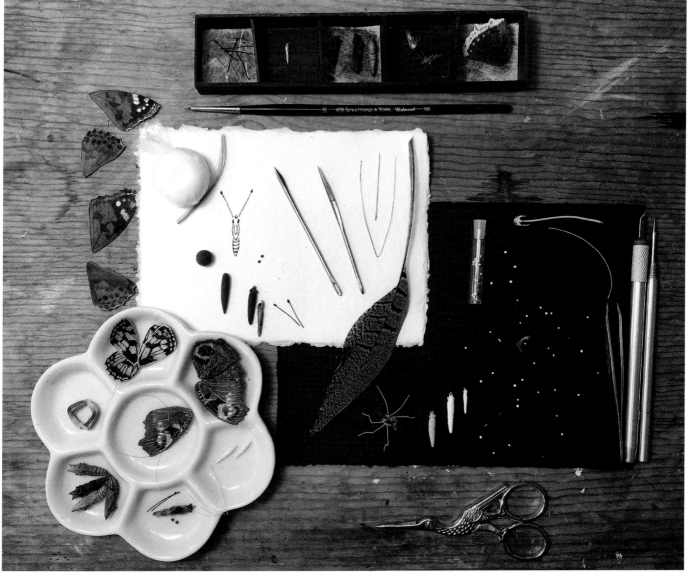

Sleeping Beauty: The peacock butterfly

In a cool corner of my studio stands a stack of wicker hampers containing lengths of silk, loosely sorted into different colours, identified by parcel tags. Tugging 'Amber and Gold' from the centre of the stack one day caused a startling tumble and an unexpected discovery. Held fast, and fast asleep, against the wall rested a peacock butterfly, the dark undersides of its wings conspicuous against the cream paintwork. Several British butterfly species overwinter as adults, sensibly spending the long, dark months of short days in hibernation, emerging in the altogether more optimistic, butterfly-friendly days of spring.

Two species in particular – the peacock and the small tortoiseshell – have determined that our dwellings are fitting abodes for this hibernation. They are mostly discreet guests, but from time to time they are discovered tucked behind curtains in cool spare rooms or stowed away in more imaginative 'hide and seek' places, such as behind the hampers in my studio. I once discovered one inside an old walking boot, retired to the shed – thankfully before I put my foot in it. They consider our quiet indoor spaces, safe from predators who may wish to snack on them, an upgrade to five stars and a sanctuary compared to woodland shared with owls, bats and shrews and other fierce beasts. The only risk they run indoors is that we are given to cosying up, increasing the air temperature too much, duping them into believing that it's spring. I have often gently suggested more 'chilled-out digs' to sleeping beauties that I disturb. There are one or two (relatively) mouse-free, bat-free residences nearby that I politely recommend.

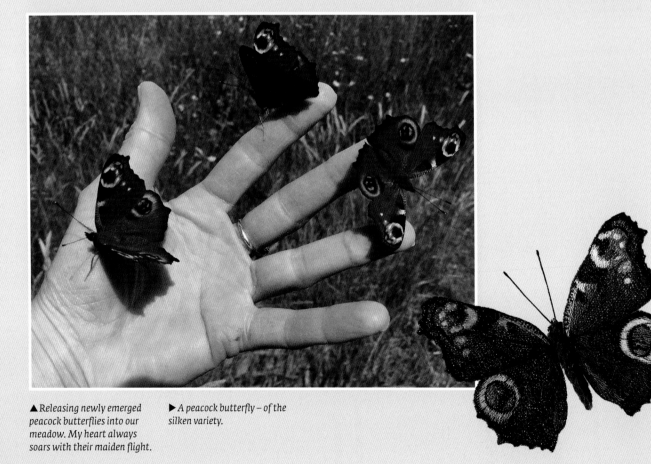

▲ *Releasing newly emerged peacock butterflies into our meadow. My heart always soars with their maiden flight.*

▶ *A peacock butterfly – of the silken variety.*

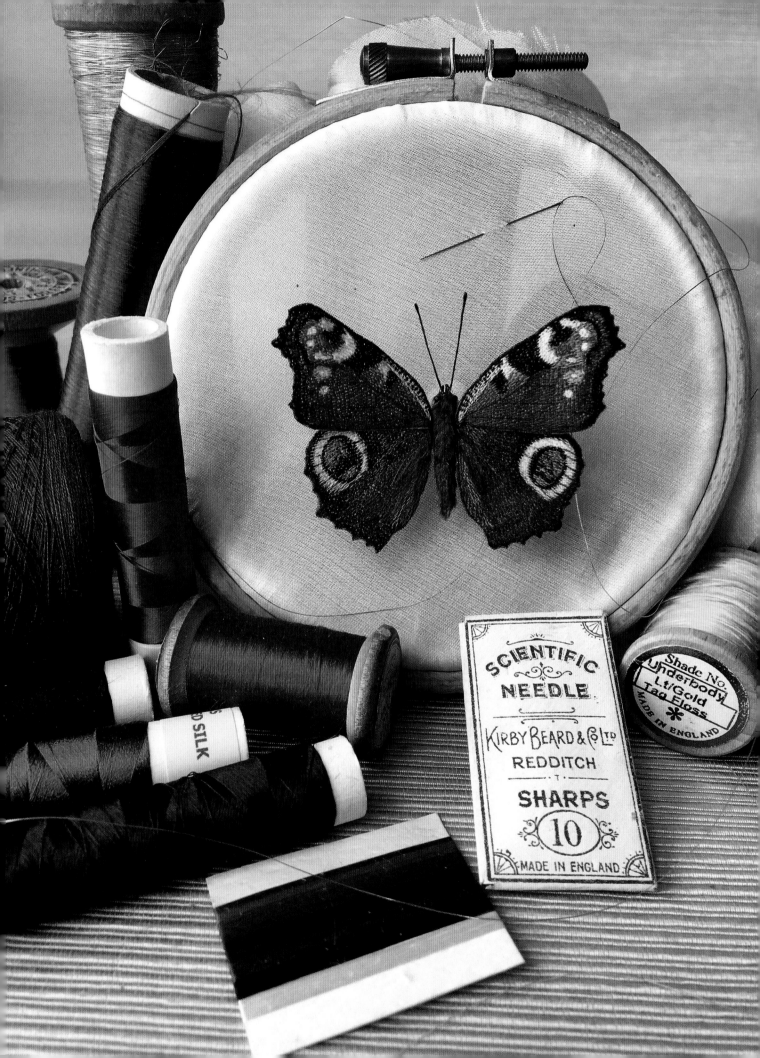

FROM MY DIARY

▼ *A male orange-tip butterfly, realized in silk, perches on the threads from which it was made.*

▶ *Paintings illustrating the life cycle of the orange-tip butterfly. The adult is painted on silk, and the primrose on which it has alighted is accented with a simple line of embroidered stitches.*

◀ *A finished hand-embroidered orange-tip rests among handmade violets before taking its place in* Psyche's Cabinet.

Orange-tip

What grows on the verge of a nervous breakdown? Nothing; no campion, no stitchwort, no vetch, no Jack-by-the-hedge (the country name for *Alliaria petiolata*, garlic mustard) and most certainly no caterpillars. The verges and hedge banks of the country lanes along which I habitually walk are profuse with joyful flowers, dancing with life. At least they were until this morning, when the growling, thrashing hedge-bank monster (a tractor with 'attachments') determined to pursue its territory, destroying everything in its path. Callously it chewed up and spat out every living thing within grasp of its jaws, including the exquisite green caterpillars of the orange-tip butterfly that I have been delighting in watching grow.

Earlier this spring I followed the butterflies' courtship dance: the demure female, with soft grey tips to her wings, leading the amorous, orange-tipped male along the garden path and down the country lanes before succumbing to his wiles. Butterfly pheromones, or perhaps simply sheer persistence! By and by she laid her precious eggs, just below the flower buds of the garlic mustard. Butterflies are very particular about where they lay their eggs, choosing specific food plants for their young. The orange-tip is no exception; she seeks out plants growing in a sunny aspect, laying her eggs singly, far enough apart that, in their appetite for life, they do not consume one another. (Their beauty belies a rather gruesome cannibalistic bent in their nature.) After hatching, the butterfly larvae feed on their nursery flower bud before moving on to the long

green seeds that form as both plant and caterpillar mature. Their camouflage is perfect, emulating the colour and form of the bean-shaped seeds, making the joy of discovering them and watching them grow all the more fun.

Even if I were not, as I suggested melodramatically just now, 'on the verge of a nervous breakdown', I still felt disconsolate, sulking for a while before realizing that while I was being so negatively self-indulgent, the hedge-bank monster could still be heard, growling in the distance, prowling its way back along the other side of the

lane. Dashing out, I gathered nine lives into an old ice-cream tub and out of harm's way before the monster could be seen coming over the hill. They now reside in my caterpillar nursery (a bespoke, bijou building that Neil made for me, worthy of being ranked on a list of amazing small spaces) in the company of tortoiseshell chrysalises and peacock caterpillars. They are, I hasten to add, out of harm's way from one another, too. Mine is a respectable establishment, not a house of horrors. Cannibalistic and parasitic behaviour is not tolerated!

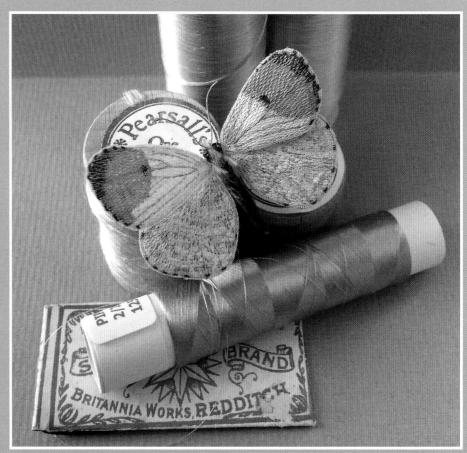

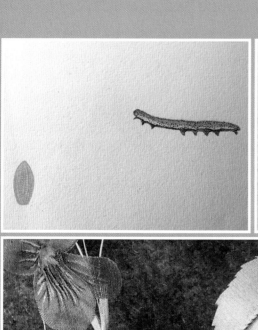

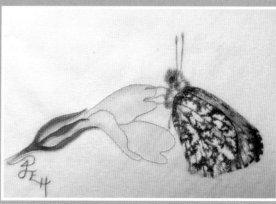

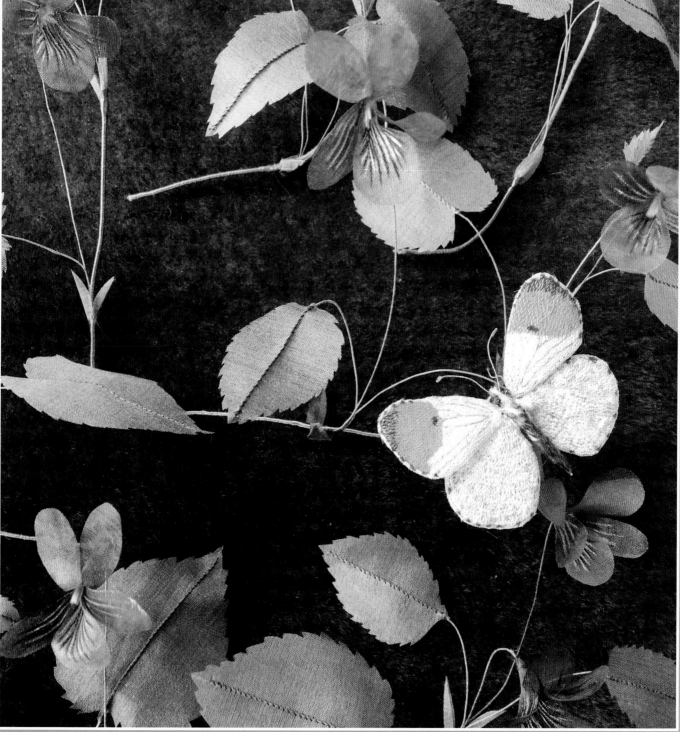

Large blue butterfly

With a wingspan of less than 2 inches (3.3–4.4 cm, to be precise), the large blue (*Phengaris arion*) is actually not very large at all, although it is the largest member of its family, Lycaenidae. Compared to the blue morpho of the Americas, with its wingspan of up to 8 inches (20 cm), it is positively tiny. However, it lives large in the hearts of many butterfly enthusiasts and lepidopterists, a sapphire star among British species.

I follow that star every year, from mid-June to July, when the adult butterflies are fleetingly on the wing. This requires that we make a car journey, with a picnic (although the latter is optional), to a beautiful spot in Somerset called Collard Hill.

The butterfly is rare indeed; in fact, it was extinct until relatively recently, when it was reintroduced from Europe. Even when we know ourselves to be in the very spot where it shines, we do not always see this elusive blue beauty. Although their flying season lasts for five weeks, each individual lives but a few days. Beauty abounds in its habitat, however, and in that sense we are never disappointed. Bee orchids and other rare wild flowers and insects also thrive there, so a visit to see the large blue is the epitome of joy.

I perpetually retell my large blue butterfly love story through the artwork I evolve, in my heart keeping the species back from the brink of extinction, and undertaking acts of devotion in miniature stitches. Its reintroduction gives me heart, proof positive that through acts of conservation, determination and love, nature can be restored.

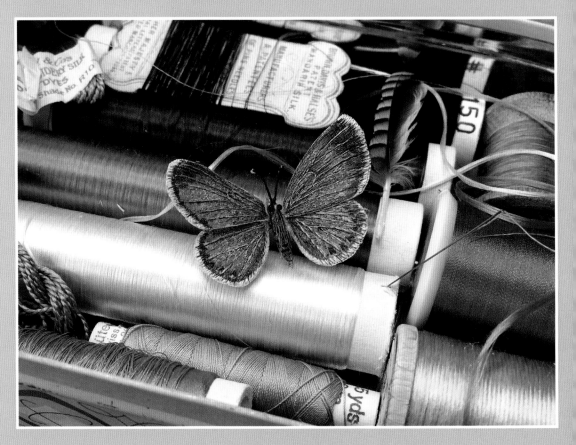

A hand-embroidered holly blue – similar in size to the elusive large blue, but far less rare – rests in a box of silk threads used for the scales on its wings. A jay's feather brings out their iridescent colour.

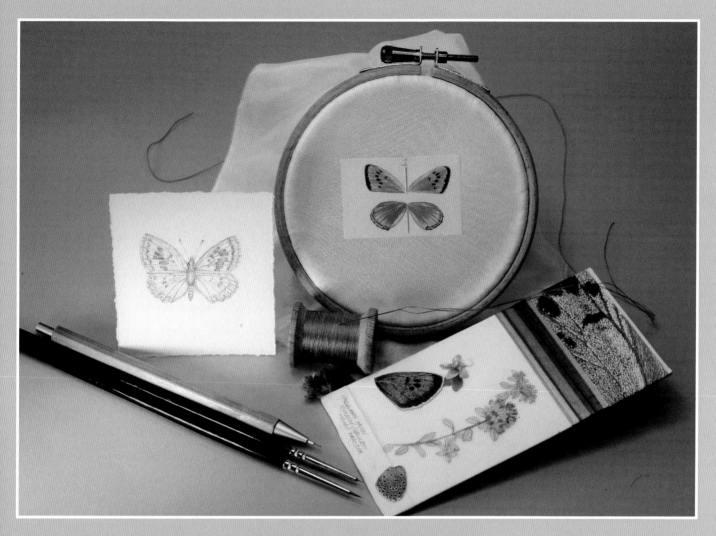

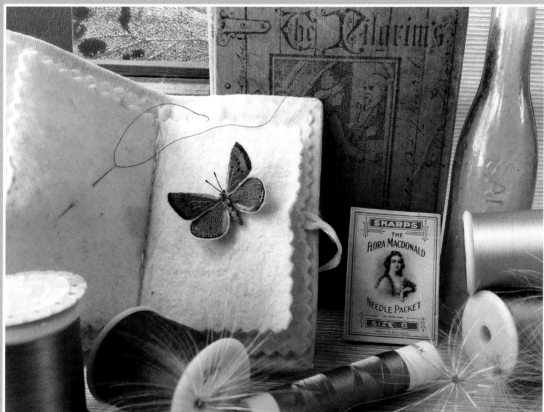

▲ A large blue butterfly, hand-painted and ready to embroider, is fixed to an embroidery hoop with the delicate handmade needle I will use. The pencil sketch informing my painting, together with a swatch collating the threads I will need, is in the foreground, together with my favourite pencil and a selection of miniature paintbrushes.

◄ My realized large blue is displayed amid the threads I used to embroider his wings.

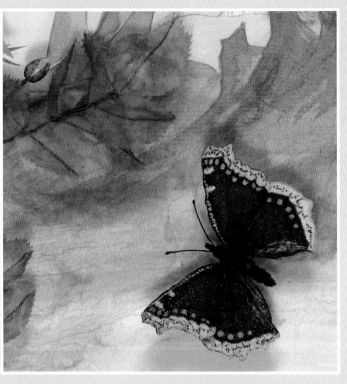

The grand surprise: Camberwell beauty

From my favourite butterfly book, *The Butterflies of Britain and Ireland* by Jeremy Thomas and Richard Lewington, I learned that the Camberwell beauty (*Nymphalis antiopa*; known as the mourning cloak butterfly in North America) was once known as the 'grand surprise'. It was prized by Victorian dealers and collectors, who suffered no qualms in pursuing and killing specimens, and pinning them into their collections.

I have one such sad specimen, loaned to me for reference. As I gaze at it now, my vision becomes increasingly blurred with tears. This 'specimen' was once a vibrant, living thing. How someone could have pursued it, killed it and stabbed a pin through its heart is beyond me. I must admit that I grow weary of the justification that some such specimens were collected for the advancement of science, particularly as I become more aware of the ruthlessness and greed of that era. I have seen collections with dozens of examples of a single species, many collected to the point of extinction, arranged casually as though they were postage stamps. It is deeply sad.

Of course, these early collections did in part celebrate the visual appeal of butterflies, which is undoubtedly what brought about their collection in the first instance. Many people regarded early butterfly collections as nothing more harmful than aesthetic arrays of beauty, a beauty so beguiling as to deny any consideration of the sacrifice these collections also represented.

We should celebrate butterflies today with equal appreciation and enthusiasm, but we must find new ways of capturing and gazing upon their beauty. We have splendid reference books to consult. We have societies that promote the conservation of butterflies, and exciting new networks of enthusiasts growing through social media. We have artists, poets and writers who illustrate and describe the splendour of butterflies, as they have done since time immemorial.

As I lift the tatty, faded specimen back into its collector's case, I reaffirm the conviction that I have for my vocation as an artist, honouring the beauty of butterflies and their precious habitats. There will be no pins through the silken bodies of my hand-embroidered specimens, and, certainly, 'no butterflies will be harmed in the making of this work.' Of course, I hope that my artistic celebration of butterflies delights the senses. But, beyond that, I hope that, unlike the collections of old, my work promotes the imperative to preserve our glorious butterflies on the wing before they pay the ultimate price: extinction. It is surely the shared hope of all who delight in butterflies today.

While I was working on my Camberwell beauty, I had to look at the collector's specimen dispassionately, with a keenness of observation not blurred by tears. The exercise was helpful in understanding the butterfly's exquisite form. Although faded and bruised, its wings retain a velvety lustre, a delicate, downy texture. Its bright blue eye spots still shimmer. Its deep-cream fringes, which give rise to the 'white petticoat' and 'mourning cloak' of its alternative names, appear exquisitely pleated. These are such mesmerizing, miraculous qualities. I approached my rendition with genuine humility and a profound sense of the beauty that I aspired to honour, acutely aware of my limitations and, being merely mortal, my inability to re-create a miracle.

It is only now, as I sit here quietly with my thoughts, having paid tribute to this supreme beauty to the best of my ability, that I feel challenged by an emotional – some would argue over-sentimental – impulse to bury the collector's specimen in the willow woods. A ghostly, once splendid thing is somehow imbued with the spirit of butterflies long lost to us. However, I have resolved not to waste another minute feeling mournful, gazing wistfully at dead butterflies. Back to feeling creatively mindful and to venerating butterflies and life!

▲ *My completed Camberwell beauty takes to the silken sky in* Psyche's Cabinet *(see pages 154–9).*

Brimstone butterfly

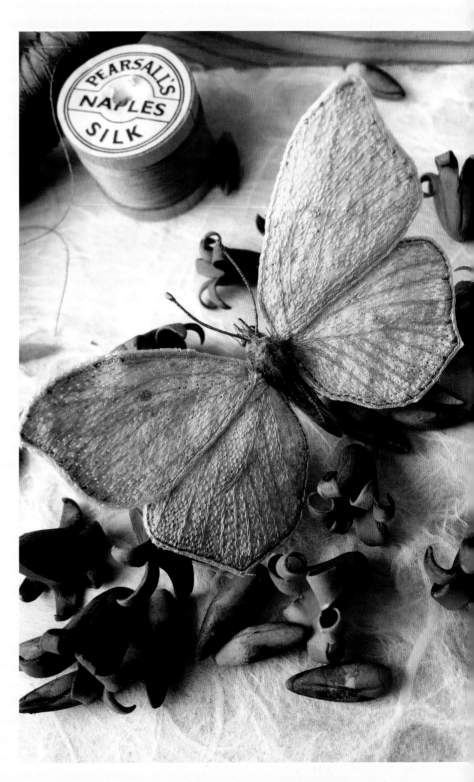

A male brimstone butterfly perches in a box containing hand-modelled bluebell flowers and buds. Bluebells are a valuable source of nectar for brimstones, flowering early in the year – the very essence of spring.

One of the first butterflies to emerge from hibernation each spring, the brimstone (*Gonepteryx rhamni*) may be seen on the wing as early as mid-February. Although considered common, they are an uncommonly beautiful sight, particularly early in the year, when they appear like sunshine in flight. In fact, they are never seen in great numbers, usually only singly. I feel it is a special 'brimstone blessing' should I see two or three together, all the more so if they are courting. Females are the palest green shade of white, with sunset-orange dots in the middle of each wing. Males have buttery, lemon-yellow wings. Indeed, the brimstone is held to be the namesake of all butterflies: *buttorfleoge* in Old English, 'buttery wing'. Therefore, for me, no annual game of 'butterfly kiss-chase' would be complete without him.

This buttery-yellow beauty rests among hand-modelled bluebells. In my imagination, they are the perfect source of nectar for my hand-embroidered silken species. It's true in nature, too, as the brimstone favours blue and mauve flowers. Having exceptionally long, delicate proboscises, they are adept at drinking from deep wild-flower chalices, and bluebell nectar is one of their favourite tipples. Later in the year I often see them enjoying a dram of teasel.

FROM MY DIARY

Swallowtail

I moved the swallowtail butterfly from his resting place on my desk today. I'd been working at my floor-standing embroidery frame for a day or two, so there was no need to disturb him. Now that I have succeeded in creating his likeness, it brightened my day to see him resting among my sketchbooks, paintbrushes and other paraphernalia, and imagine that he's real.

Glancing up from my work and catching sight of him, a daydream later I found myself in France, which is where I most vividly recall first seeing swallowtails.

In my dream state, the sound of the radio receded to a whisper and the warmth of the radiator became the heat of summer, and I found myself standing at the foot of a towering buddleia bush, gazing up through its fairy-tale spires of purple flowers. Squinting against the brilliant sun, I watched as the butterflies fanned their magnificent wings and unfurled their delicate long proboscises. Dipping them daintily into the flowers, as if sipping cocktails through a straw, they then spiralled them back into perfect miniature coils having sipped their fill, before drifting away to join the sun. I had been to France and back in the twinkling of an eye ... without a soul noticing!

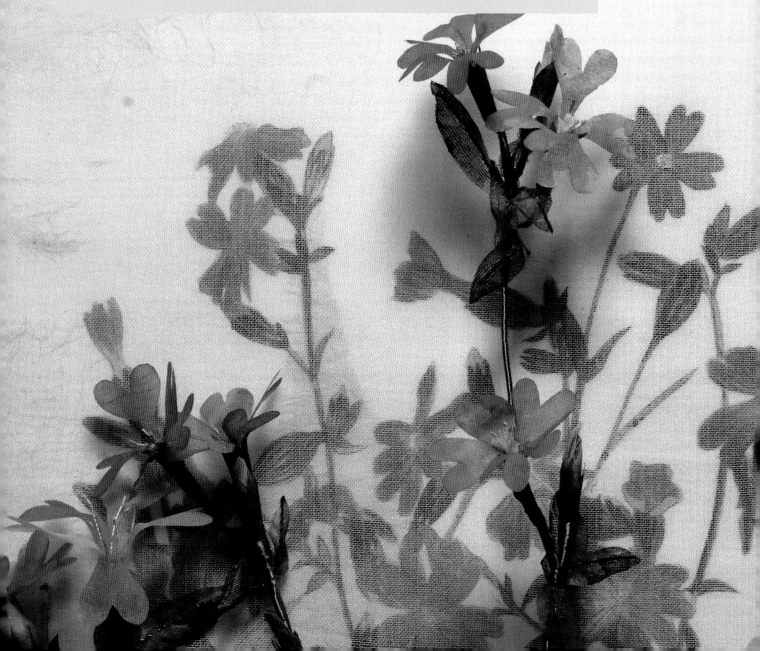

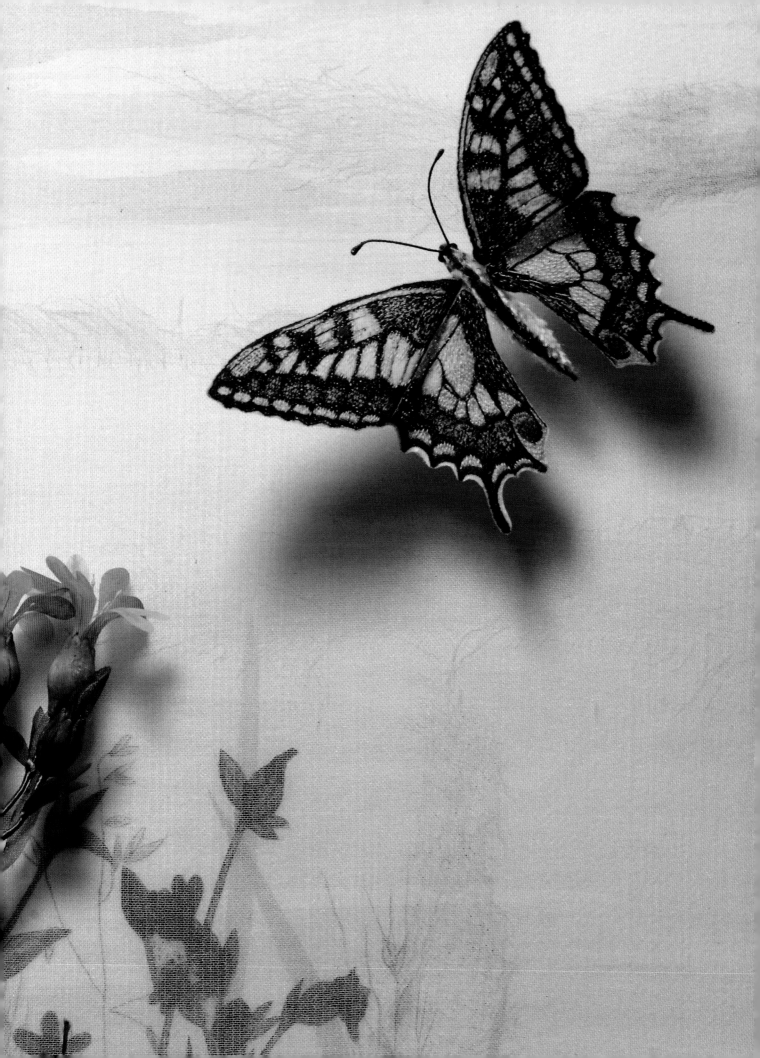

Psyche's Cabinet

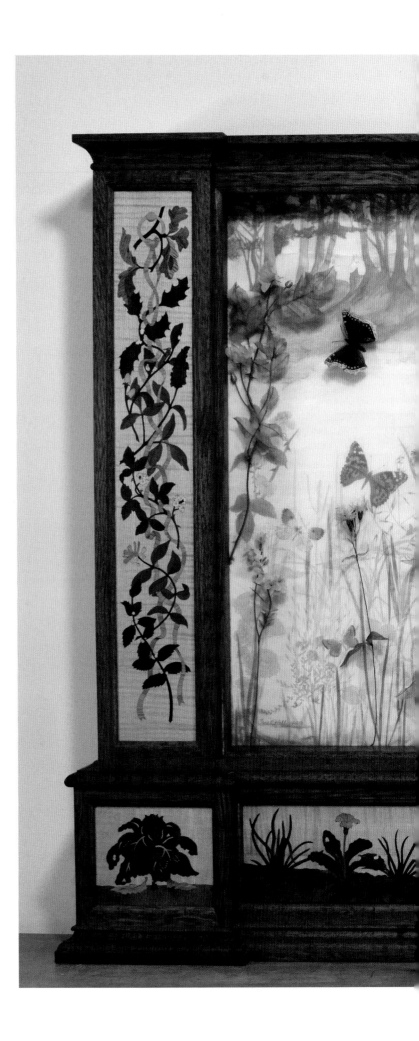

*P*syche's Cabinet rests on top of the double plan chest, my 'treasure chest', in my studio. It is perhaps my most treasured work of art to date, in that it represents countless precious moments relating to my artistic muse, the butterfly. It also contains countless contented hours of creative practice, and many mindful moments meditating on the beauty of butterflies and the beautiful habitats in which the various species thrive. In many ways it is the epitome of what this book explores, illustrative of the love of nature that inspires my entire creative process and practice.

The cabinet is a love letter to nature, and every element within it describes artistically what is beyond words. Just as it propounds creative practice, honed throughout my professional career, it also makes a plea more eloquent than anything I have ever written before, including the heartfelt messages to nature that I posted into garden hedges when I was a child.

It pays homage to the beauty of the natural world about me. Perhaps this could be seen as a little piece of Eden, a vision of a lost world, an echo of long-lost springs and summers, when nature's needs were better met. A time when its very survival was less critically in the balance.

Arguably, it is as fanciful as any love letter. Some might say it is verbose, representing more species of butterfly and wild flower than could ever thrive concurrently, even in the most unspoilt British countryside. But it is composed artistically, to delight rather than to render or describe accurately the natural world as it truly exists today. In that sense, it is a love letter to mankind, too, an artistic tender, creatively translating nature's beauty to persuade the hearts and minds of those who engage with it to reconnect, to rekindle their love of the natural world. 'Where there is love, there is hope' echoes in my mind as I work.

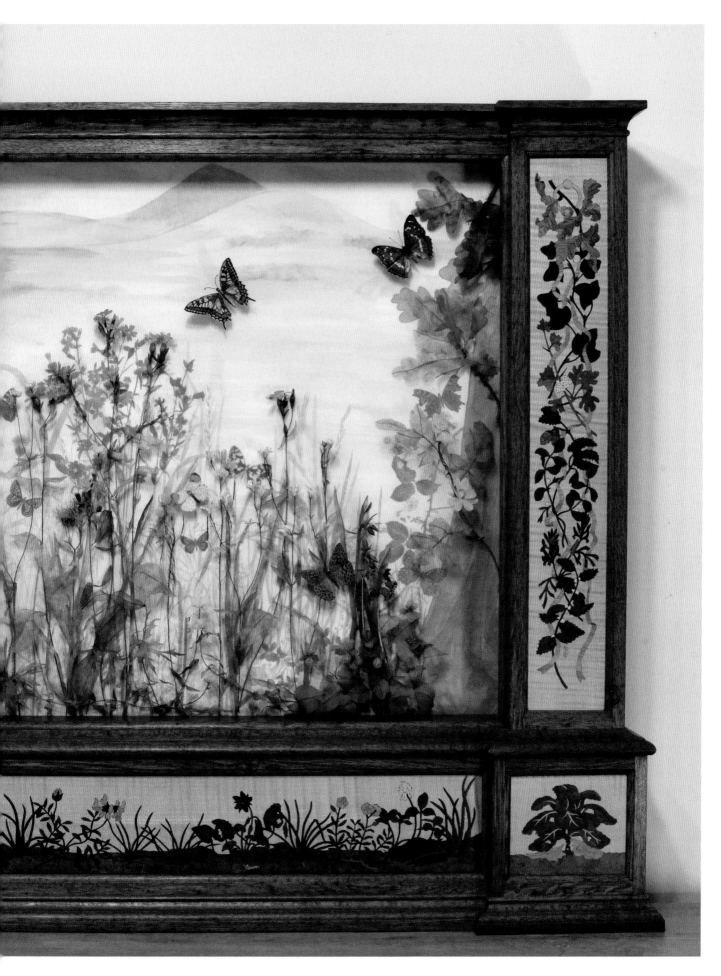

Some See Nature all Ridicule
& Deformity & ... Some Scarce
see Nature at all.
But to the eyes of the Man
of Imagination
Nature is Imagination itself.

WILLIAM BLAKE, LETTER TO THE REVD JOHN TRUSLER, 1799

Butterflies have been depicted in art, poetry and the spiritual belief systems of different cultures across the world since time began. In evolutionary terms, before *Homo sapiens*, butterflies existed. Fossilized butterflies estimated to be 200 million years old have been dug delicately from rocks in northern Germany, dating butterflies to a time before even the advent of flowering plants.

The relationship between butterflies and the human spirit or soul was perhaps laid down in the Earth's sediment or, more poetically, memory, as early as these fossil finds. It is certainly understood that butterflies have conceptualized the unbound human spirit throughout human civilization.

Perhaps nowhere in recorded history were butterflies more integral to a spiritual belief system than in ancient Greece, where they represented the metaphysic of an entire civilization. The word *psyche* in ancient Greek signified both a butterfly and the soul, so inherent was the conviction that the emergence of the adult butterfly from its chrysalis represented the flowering of the human soul. A fitting title for my 'butterfly opus', therefore: *Psyche's Cabinet*.

As I often assert, heart and soul, I have loved butterflies for as long as I can remember. My previous book, *The Art of Embroidered Butterflies* (2012), was dedicated to this love, as explored through artwork. Yet no volume could contain such love, and my muse, flying free of its binding, journeys on.

Perhaps *Psyche's Cabinet*, again, seeks to contain this love, or at least to keep it safe. Certainly, my endeavour to accomplish it draws closer to the definition of a 'labour of love' than anything in my previous working practice. I am becoming increasingly vague about when the making of this work in progress began, or, for that matter, how much longer my muse will hold me to its cause. A cabinet of wonder, an act of devotion, it is a creative contemplation spanning years.

Inside the cabinet – a bespoke case made by my friend the master cabinetmaker Rupert Brown – numerous species of beautiful British butterfly are represented, with their critically specific food and nectar plants. As I have already said, these species would not naturally thrive concurrently in the same habitat anywhere in the wonderful wilds of the British Isles. 'Artistic licence,' I proclaim triumphantly. 'This is my world!'

The ability to observe butterflies, their habitat and life cycle in our very own butterfly reserve has doubtless provided a strong foundation for this study. In accomplishing it I am effectively bringing the wonderful wilds of our outdoors 'in', expanding exponentially my sense of creative freedom and mental well-being. Even on the sulkiest November day, it is spring or summer in the world of my cabinet.

◀ *Working drawings for* Psyche's Cabinet: *Mine above and Rupert Brown's below.*

▲ *The early stages of realizing the diorama inside the cabinet: painting the scene (top) and placing the butterflies.*

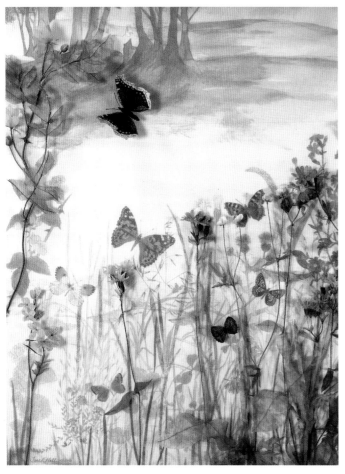
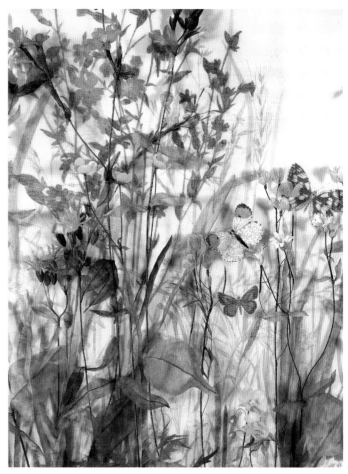
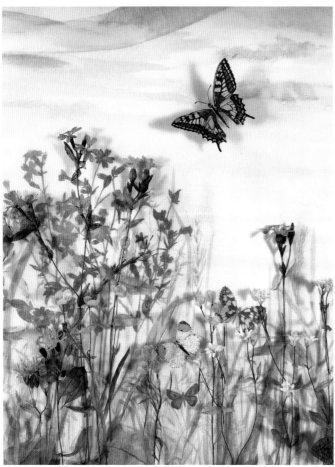
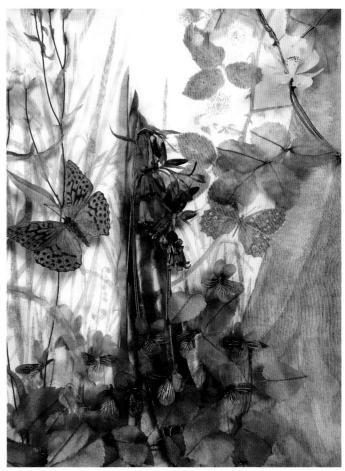

Details of butterflies from Psyche's Cabinet:

◀◀ *Left to right, top to bottom: a Camberwell beauty, orange-tip, painted lady (Vanessa cardui), small tortoiseshell, large blue, gatekeeper (Pyronia tithonus) and marsh fritillary (Euphydryas aurinia) 'dance' through the scene.*

◀ *An array of wild flowers set the scene for an orange-tip, marbled white and skipper.*

◤◤ *A swallowtail takes to the wing, casting a shadow against the silken sky.*

◤ *A silver-washed fritillary dances above its larval food plant, sweet violets, and a speckled wood enjoys the dappled woodland light.*

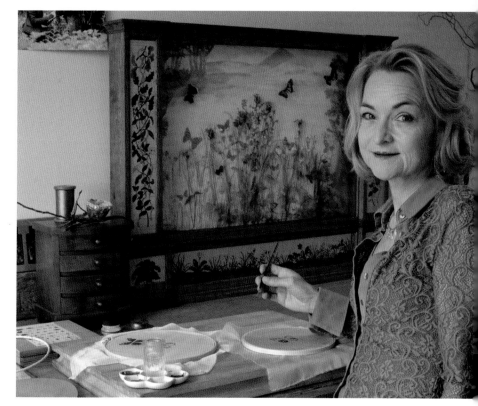

Being custodian of the delicate balance necessary to sustain the butterflies that dwell in our wildlife garden continues to school me. With practical lessons and inspiration on my doorstep, I have never been more eager to 'go to school'. Conversely, one of my greatest challenges is to stay diligently at my embroidery frame or drawing board rather than stray out of doors.

But then, I do save time travelling to find species pertinent to my creative study. Sadly, even in the countryside they are often scarcer in the wild than they are in our garden. It delights me that butterflies have found their specific larval food plants here. It informs me, too, enabling me to observe their life cycle at close hand. Depending on the season, in the time it takes me to wander through the meadow or explore its margins I often find what I am looking for. In the twinkling of an eye, I may be seated in my studio once more, a flowering stem of the plant I am studying beside me. (That is, if the fairies have not led me astray!) Throughout the summer months I chase the butterflies about our meadow in a haphazard dance. While observing them on the wing, I can also capture them with no need for a butterfly net. My camera lens holds them, without harming a scale of their wings or a hair of their heads. Who knew butterflies were so hairy ... in the wispiest sense? There is so much to discover 'playing out of doors'.

The astute may recognize some scarce butterfly species represented within the cabinet, species that it would be ecologically impossible to discover in one place, never mind in our wildlife garden. Well, an artist needs daydreams, and adventures. Adventures in pursuit of butterflies, leading me beyond the garden gate and even beyond home shores, are among my favourite adventures of all. Whatever wild whim leads you, there is a big wild world to explore!

And so, year on year my story unfolds. Contemplatively, my artwork evolves. In practice, in creating *Psyche's Cabinet*, I have perhaps proved that a box perceived as magical enough may even contain a whole world.

I wonder what paths you will choose to follow into our wonderful wild world? What will you discover, both creatively and imaginatively; what will you achieve artistically? Perhaps you will simply choose to take your sense of creative freedom out to play, seek a sunny spot in the garden and settle to making a nature mandala. Or perhaps you will choose to venture beyond the garden gate, to explore a local park or nature reserve, comb a local beach or sail a distant shore. What creative daydreams will you enjoy; what dreamcatchers will you weave?

Will you accept nature's earthy green invitation and step deeper into the wild, there to discover her secrets: hidden nests, dormouse picnics, song-thrush anvils? Or will you let your mind be carried by will-o'-the-wisp, allowing your eyes to alight on woodland sprites or fairies? Perhaps you will simply choose to pause and gaze into a swaying meadow or flowery hedge bank, whiling away the hours in counting wild flowers.

As I draw this book to a close, by the powers invested in me by the fairies, I grant you artistic licence and liberty to explore, and, most importantly, to play!

Poised with miniature paintbrush at the foot of Psyche's Cabinet, painting butterfly wings.

Acknowledgements

Thanks to my husband, Neil, for adoringly believing in me and for the practical and loving support he limitlessly affords me.

Thanks to my beloved mum, Julia, for always believing in her 'funny-ossity' and for having nurtured my imagination and creativity for as long as I can remember.

My deep gratitude to Brigit Strawbridge Howard for writing the Foreword, our mutual love of nature foremost in her mind.

Thanks to Leo De-Watts, 'for the bee' and, most importantly, for believing in me.

Thanks to Rupert Brown, for masterfully making *Psyche's Cabinet*, holding my creative devotion to butterflies safe and holding me steadfast in my artistic pursuits.

Heartfelt thanks to Andrew George, dear friend, landscape artist and designer of wild habitats, for conceiving and helping us to create our wonderful wild garden, a constant source of inspiration and solace.

Thanks indeed to all my friends, both 'old school', met over coffee, and 'new', met in the brave new world of social media. Kindred spirits, who hold nature close to their hearts, and who still believe in fairies! With special thanks to: Jo Cartmell, Venetia Jane, Jean Vernon, John Bates, Rebecca Wheeler and all my friends at Wildflower Hour, from whom I have gleaned so much knowledge of the wild. Loving thanks to Isabelle, Jenny, Rob, Val, Lisa, Lucy, Belinda, Meli, Gill, David, Andy and Wilfred for their good company on this special book journey.

Thanks to Hugh and the wider team at Merrell, for believing in me and bringing this book into the world.

Finally, thanks to the medical professionals who look after me, especially my GP, Dr Adam Smith; their help and support so often goes unrecognized.

JANE E. HALL is an acclaimed artist and embroiderer whose work has featured in numerous exhibitions and magazines. Her previous publications are *The Art and Embroidery of Jane Hall: Reflections of Nature* (2006) and *The Art of Embroidered Butterflies* (2012).

clothofnature.com

BRIGIT STRAWBRIDGE HOWARD is a wildlife gardener, naturalist and bee advocate. She is the author of *Dancing with Bees: A Journey Back to Nature* (2019).

beestrawbridge.blogspot.com

Further pursuits

UNITED KINGDOM

Botanical Society of Britain & Ireland: bsbi.org
Promoting the study, understanding and enjoyment of British and Irish wild plants.

Bumblebee Conservation Trust: bumblebeeconservation.org
Dedicated to the conservation of bees and their habitat, providing engagement and fascinating information.

Butterfly Conservation: butterflyconservation.org
A charitable organization dedicated to conserving butterflies, moths and their natural habitats.

Embroiderers' Guild: embroderersguild.com
An organization with affiliations beyond the UK, building awareness of stitch and textile art.

NaviHo: naviho.com
Specialists in habitat creation, re-wilding, wild art and landscaping.

Nearby Wild: nearbywild.org.uk Celebrating and enhancing local wildlife, be it in gardens or parks.

The Wildlife Trusts: wildlifetrusts.org
A movement made up of 46 wildlife trusts: independent charities with a shared mission to conserve and celebrate wildlife.

Woodland Trust: woodlandtrust.org.uk
The UK's largest woodland conservation charity.

NORTH AMERICA

American Craft Council: craftcouncil.org/resources/National-and-Regional-Craft-Organizations
For a list of national and regional craft organizations in the United States.

Association for Butterflies: afbeducation.org
A trade organization with a remit including education, conservation, outreach, research and advice.

Botanical Society of America: botany.org
Promoting knowledge of and innovation in the botanical sciences.

Defenders of Wildlife: defenders.org
Dedicated to the protection of all native animals and plants in their natural communities.

Embroiderers' Guild of America: egausa.org
Encourages cooperation and the exchange of ideas among needleworkers throughout the world by fostering a high standard of design and technique.

National Wildlife Federation: nwf.org
Dedicated to helping wildlife thrive in a rapidly changing world, including by connecting people with the nature around them.

Rewilding: rewildingglobal.org
Harnessing the power of people to re-wild the Earth.

Rewilding Earth: rewilding.org
Offering a bold, scientifically credible, practically achievable and hopeful vision for the future of wildlife and human civilization in North America.

Sustainable Forestry Initiative: forests.org
Dedicated to the survival and well-being of forests in Canada and the United States.

WORLDWIDE

Conservation International: conservation.org
Highlighting and protecting the natural world in more than seventy countries.

The Nature Conservancy: nature.org
A shared vision of caring for nature worldwide, founded in research.

Xerces Society for Invertebrate Conservation: xerces.org
Conserving butterflies and their habitats all over the world.

First published 2022 by Merrell Publishers, London and New York

Merrell Publishers Limited
70 Cowcross Street
London ECIM 6EJ

merrellpublishers.com

Photographs and texts copyright © 2022 Jane E. Hall, except photographs of the artist: © 2022 Neil Hall-McLean
Design and layout copyright © 2022 Merrell Publishers Limited

All rights are reserved. No part of this publication may be reproduced, stored in a retrieval system or transmitted, in any form or by any means, electronic, mechanical, photocopying, recording or otherwise, without the prior written permission of the publisher.

British Library Cataloguing in Publication data: A catalogue record for this book is available from the British Library.

ISBN: 978-1-8589-4701-3

Produced by Merrell Publishers Limited
Designed by Nicola Bailey
Edited by Rosanna Fairhead
Proofread by Barbara Roby

Printed and bound in China